Michael Sorkin Studio Wiggle

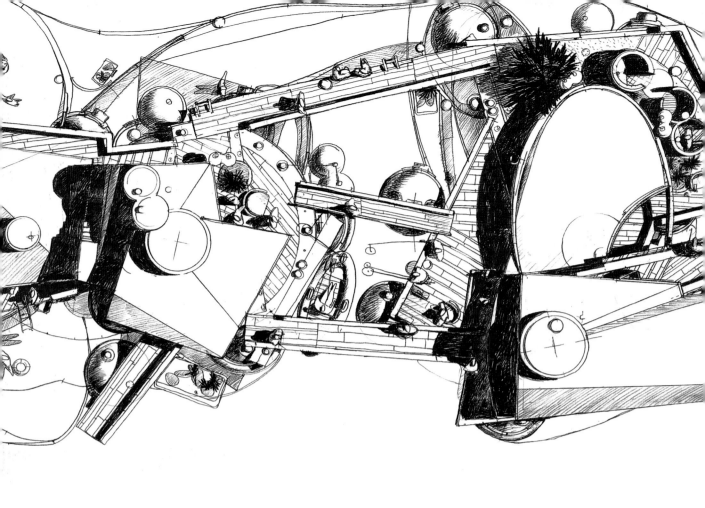

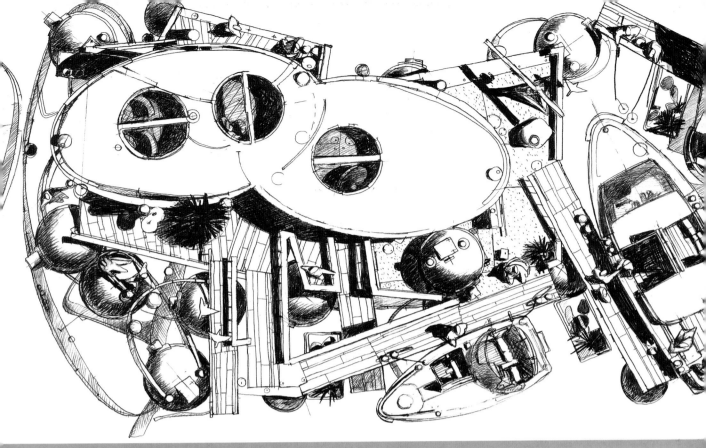

MICHAEL SORKIN STUDIO WIGGLE

THE MONACELLI PRESS

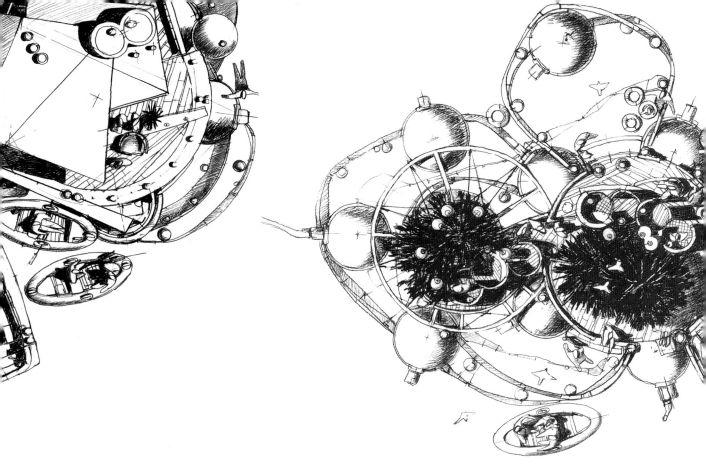

FOR MY PARENTS AND, AS ALWAYS, FOR JOAN

First published in the United States of America in 1998 by
The Monacelli Press, Inc.
10 East 92nd Street, New York, New York 10128.

Library of Congress Cataloging-in-Publication Data
Sorkin, Michael, 1948– .
Michael Sorkin Studio : wiggle.
p. cm.—(Work in progress)
ISBN 1-885254-25-3
1. Michael Sorkin Studio. 2. Architecture—Research. 3. Architecture—
Technological innovations. I. Title. II. Series: Work in progress (New York, N.Y.).
NA737.S593A4 1998
720'.92—dc21 98-18254

Printed in Hong Kong

Pages 1–4: Floating Islands

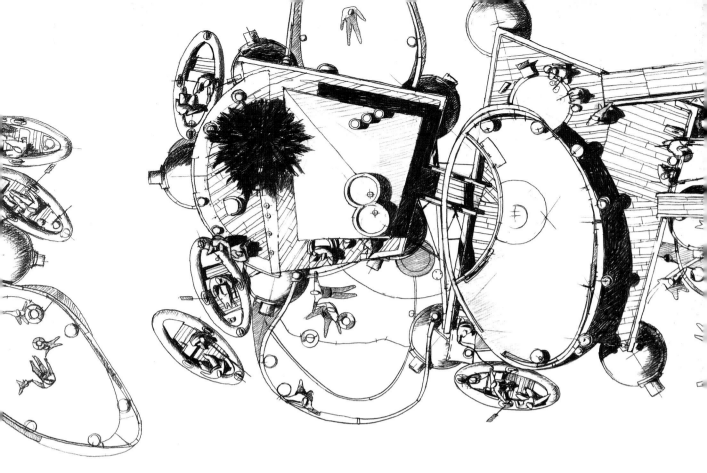

Contents

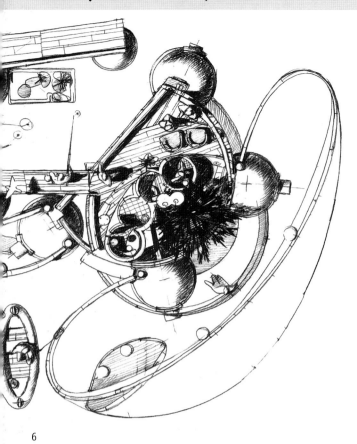

6

Architecture is a useful coincidence of form and life. Building reveals these relationships, occasionally invents them. Attempting to invert this is a formula for trouble.

The city is architecture's primal scene. I don't believe in the Albertian Big House, the idea that cities simply enlarge the architecture of the family. There is something both fruitless and corrosive in trying to read all of consciousness and culture into the tiny signifiers of home. The legibility of the social demands the complexities of numbers: public scale is bound to the urban.

Any fantasy of urbanity that wants to be built should be a fantasy of desirability. Cowed by the anathema heaped on the disgraced project of planning, the most arresting images of the city born of the past twenty-five years have been dystopian. This is a tragedy for urbanity. Our project is to invent happier forms.

Weed, AZ, is a proposal for a small new city that grew out of an investigation of the possibilities for conversion of the American military economy. The project began as I watched the victory parade up Broadway following the Gulf War, pursued for months at a cost of a billion dollars a day. Row upon row of attractive, well-trained, well-equipped, young people—a rainbow of diversity—made their way to Canal Street before dispersing to the fleshpots of Soho. Why, I wondered, couldn't they simply keep walking, up the island to Harlem and the South Bronx, and get to work, building, teaching, and looking after things?

The urban project is not simply a suitable object for the focused energies of the nation; it is—in cities from Fort Wayne to Fort Worth—part of the way we have described and settled the country from the first. We have a national myopia about this, disclaiming an urban policy even as we produce the circumstances—through highway construction, loan guarantees, or the defense investments that have over the past thirty years consolidated the fortunes of the so-called gunbelt—that invent our cities.

Weed is optimistic, about the constructive use of energies already being expended by the military-industrial-development complex, about converting one great national enterprise to another rather than the bomber-plant-to-fridge-factory scenarios that characterize so much of the debate about conversion. Instead, why shouldn't the military make its exit by creating something of enduring value that might absorb both culture and labor in a stirring task: building cities? This scheme is also meant as an economic proposal —a way of paying down America's enormous deficit. After all, there exists no more effective way of valorizing territory than building a city on it.

Located on an existing artificial lake created by a dam on the Colorado River, Weed occupies a small piece of territory appropriated from the enormous Yuma Proving Ground and adjoins a large, irrigated agricultural area. The town is dimensioned by the bearing capacity and character of the land, by proximity to the water, and by a neighborhood structure loosely configured to a ten-minute walking radius. A series of intersecting, branching spines provides pedestrian streets, an element of order, and surfaces for different styles of movement, including a slow-motion public transit system. Automobiles are relegated to the periphery of the city.

N

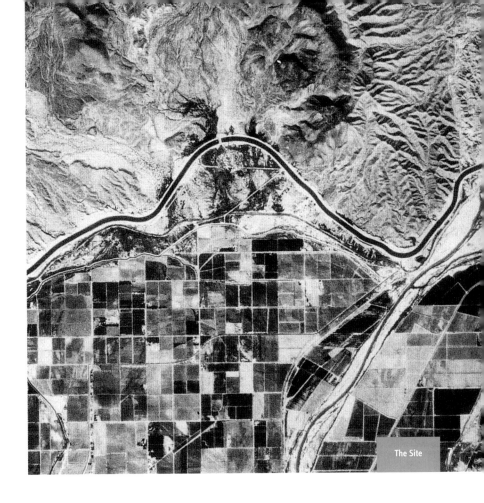

The Site

This urban morphology is meant to be responsive to the fresh possibilities raised by ecological consciousness, by new modes of knowledge-based, small-scale, flexible, craft-intensive manufacturing, by specialized agricultural production, and by the radical reordering of relations of proximity brought on by the advent of electronic space. Arizona, in particular, is a state currently experiencing an enormous migration of people who have abandoned large cities and bureaucratic employment for smaller towns and telecommuting.

Weed is predicated on a fantasy of compatibility, on the waning of zoning by use or by class. Given a generally benign and sustainable industry, and a social situation in which locational choice is free, the main issues for use-related typology in architecture in such post-technological environments will be the compatibility of sizes (some uses will, of course, require much larger, more directly contoured spaces). Weed's architecture investigates the integration of a generic, day-lit, walk-up, cross-ventilated condition with buildings of larger scales and with those predicated on formally demanding uses—theaters, stadiums, hospitals, and so on. The predominant architectural type is the loft (indeed, the whole city is structured like a loft), and we've tried to suggest a wide

variety of configurations that are meant to be be both flexible and resistant. Weed explores new ratios between built, green, and blue space. While the availability of water makes possible extensive greening of the territory within the city, the absolute density of the town means that the total area of green space is small, certainly relative to the extravagances of the sprawl typical of desert cities, such as Phoenix. Weed is also meant to be as sustainable as possible. This implies the goal of self-sufficiency in such areas as agriculture, water, energy, oxygen waste treatment, recycling, jobs, and education.

Weed is just one look at a new kind of city, located at a particular convergence of landscape, culture, technology, and architecture. Dense and pedestrian, laced with water and greenery, Weed seeks to offer non-coercive variety, spaces to support activities both predictable and unenvisioned.

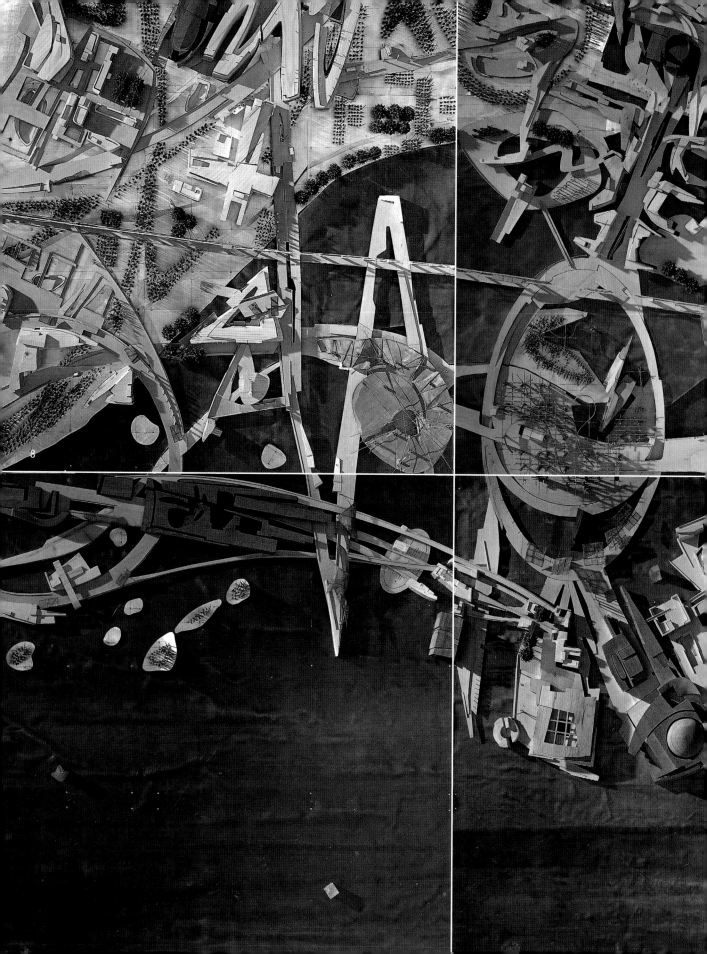

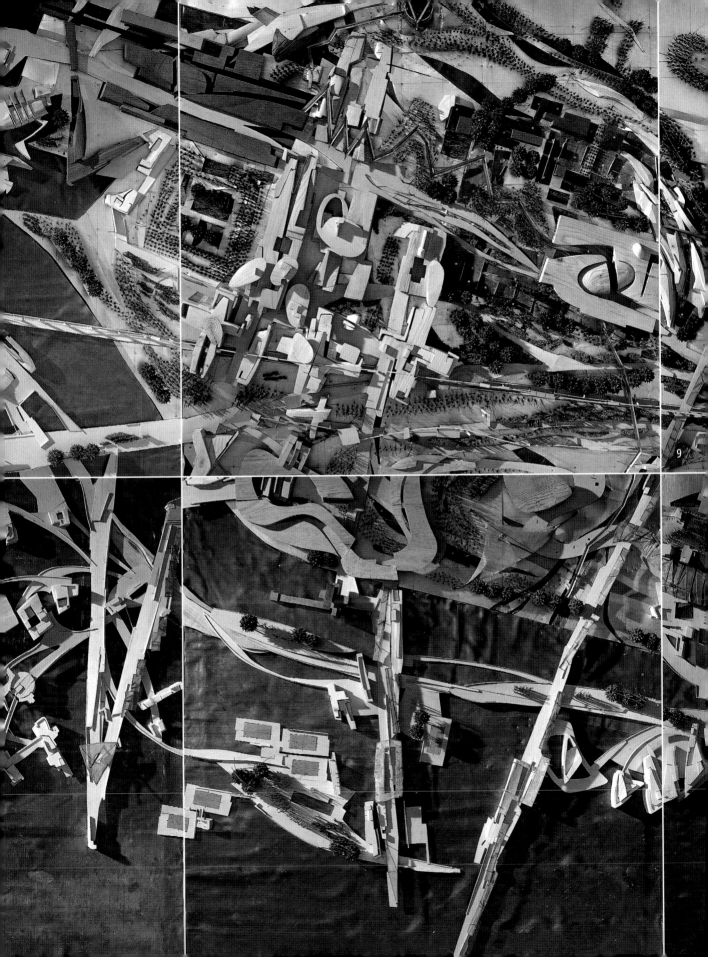

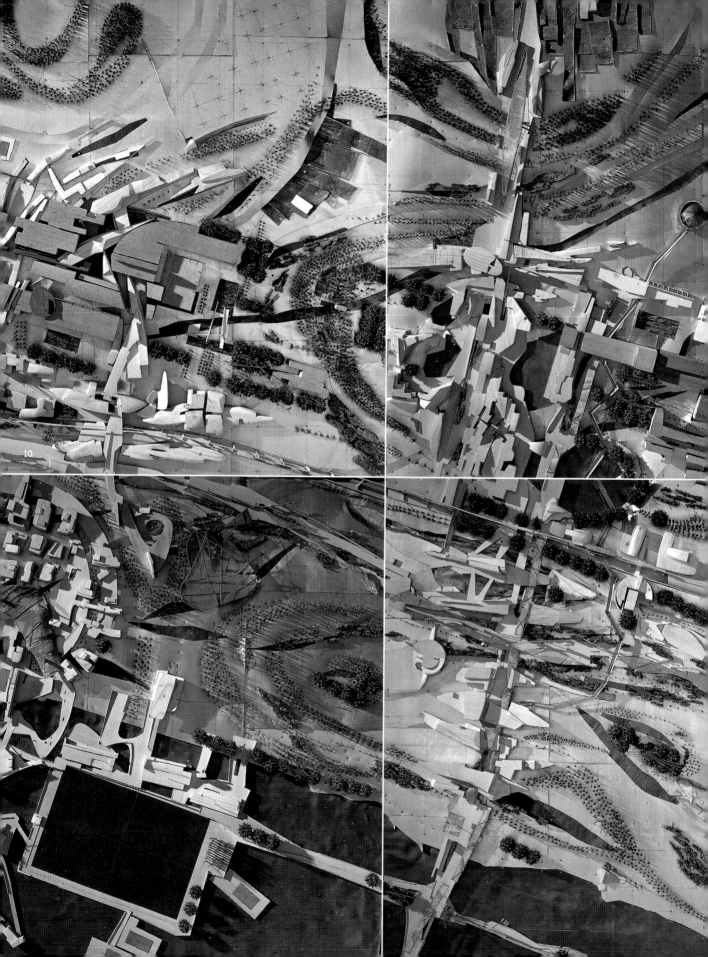

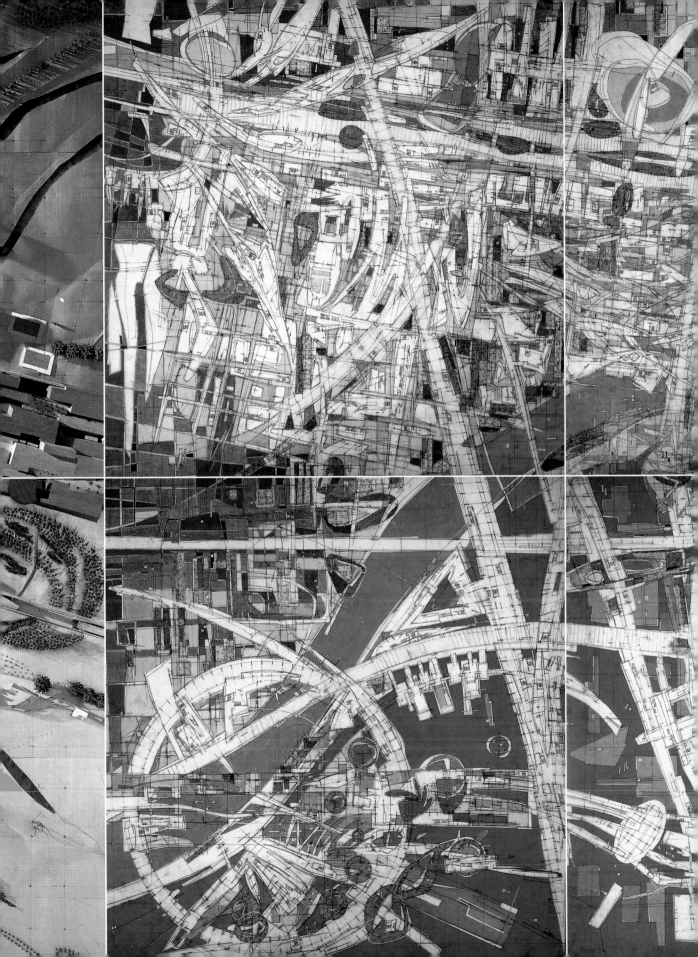

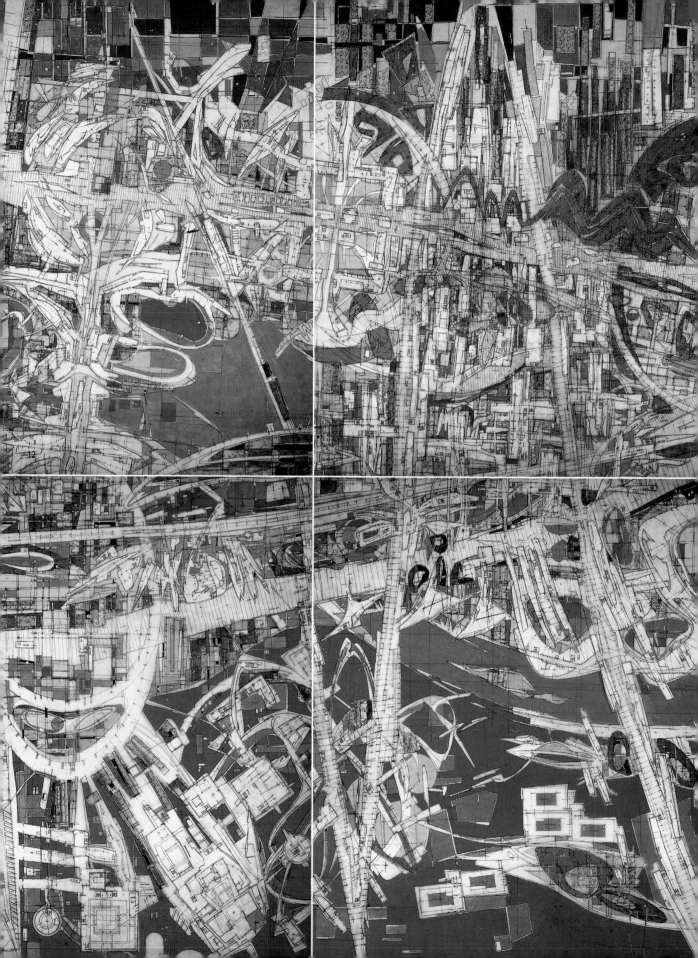

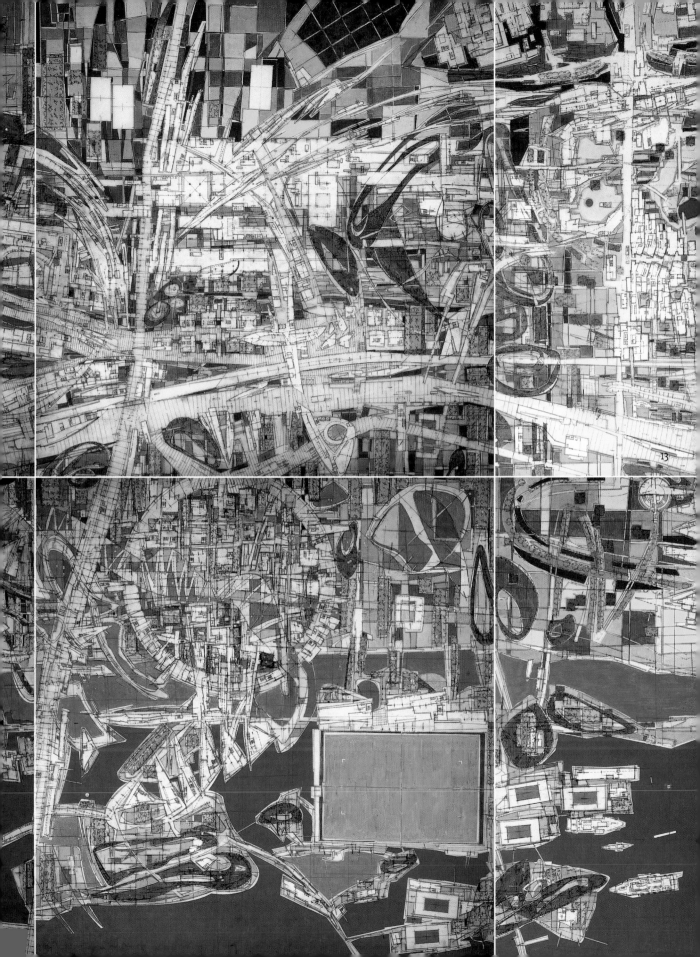

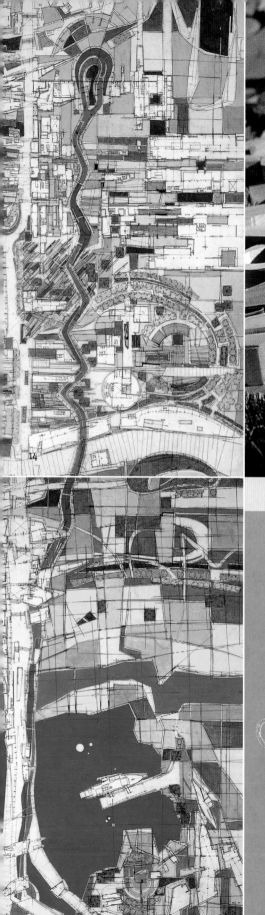

14

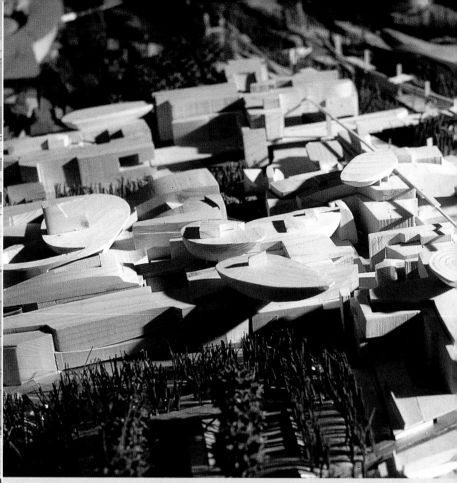

BUCHAREST 2020 COMPETITION

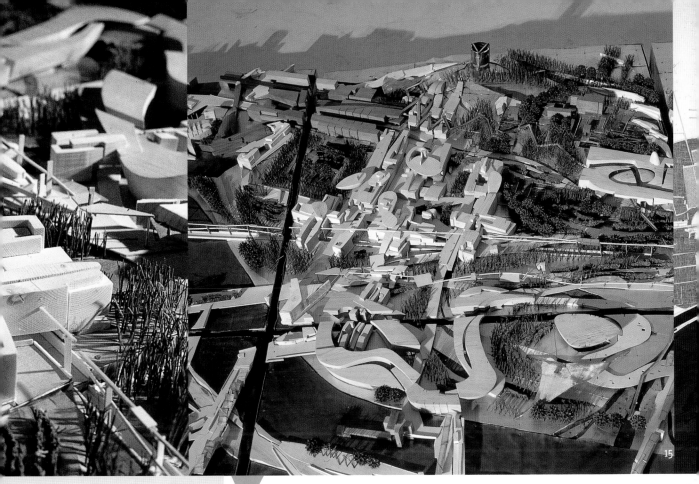

1996

Like Disneyland, Ceaucescu's Bucharest is monstrous but not charmless. Half-constructed, it's cut-rate ruins. This is what Disney does so well, economizing on time, economizing on space. How to recycle the thing? The buildings—taken one by one—are harmless enough. They simply need to be deprived of their sterile autonomy, their precincts rescaled, and other sizes and uses thrown into the mix. The problem is especially acute around Ceaucescu's own pad at the end of the endless axis. Clearly, what was called for was demonumentalization, conservation, repair, and endless infiltration.

This project begins to relayer the available scales, to build self-centered neighborhood increments, to reinforce and expand green areas, to revert to a paradigm of complexity and even mystery. We also wanted to convert the ersatz river (which conceals a sewer beneath) into a genuine artery, useful for transportation and recreation. At the largest scale, we sought to clarify a series of edges both around and within the city, to remix traffic by adding fresh means, to reduce dependency on the automobile for commuting and local circulation by deradialization, and to green dramatically.

The grand scale of Ceaucescu's plan makes a legible but intractable center. Our aim was to break this down into many local neighborhood centers linked with a new layer of pedestrian circulation, all tied to the revivified river and a series of new lakes. By enlarging the water surface near the river, we've attempted to convert the one-directional monumental axis into a lush, green recreational space. This, in turn, is meant to rotate the axis 90 degrees, withdrawing emphasis from the palace and putting it on the park.

We're not exactly shy about the master plan—what else so succinctly clarifies intentions, propagandizes for vision, gives small decisions an extra logic? Our goal for Bucharest was to let greenery flow through the city, not to cut it in half but to give it a sense of limit and to join it to its territory. We also meant to radically reduce the cars entering the city and have suggested sites—the small circles—for a number of car deposits that ring a newly deautomobilized center.

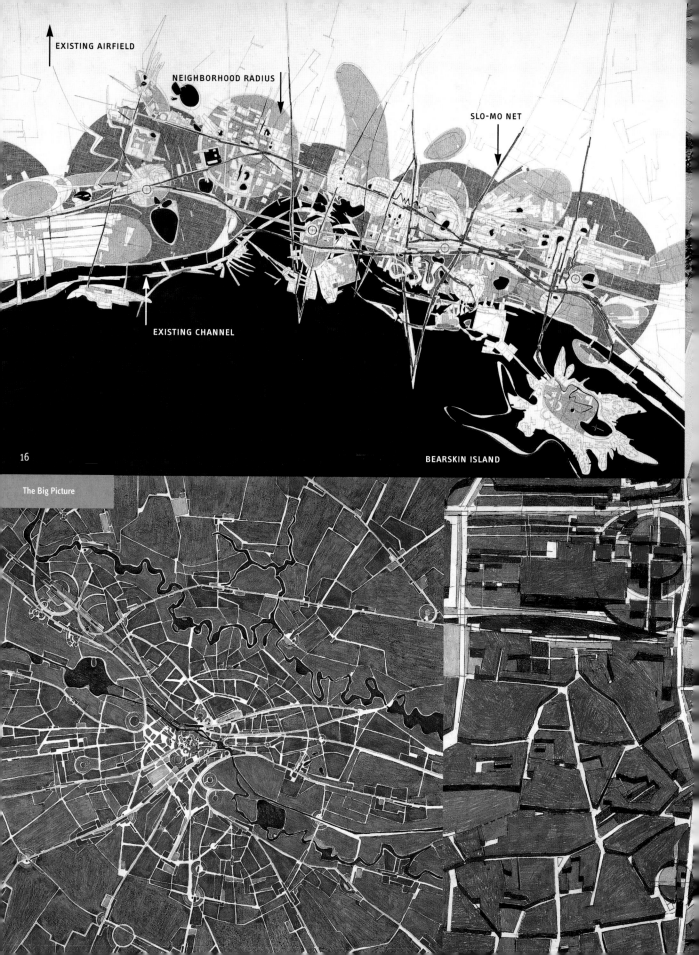

EXISTING AIRFIELD

NEIGHBORHOOD RADIUS

SLO-MO NET

EXISTING CHANNEL

BEARSKIN ISLAND

16

The Big Picture

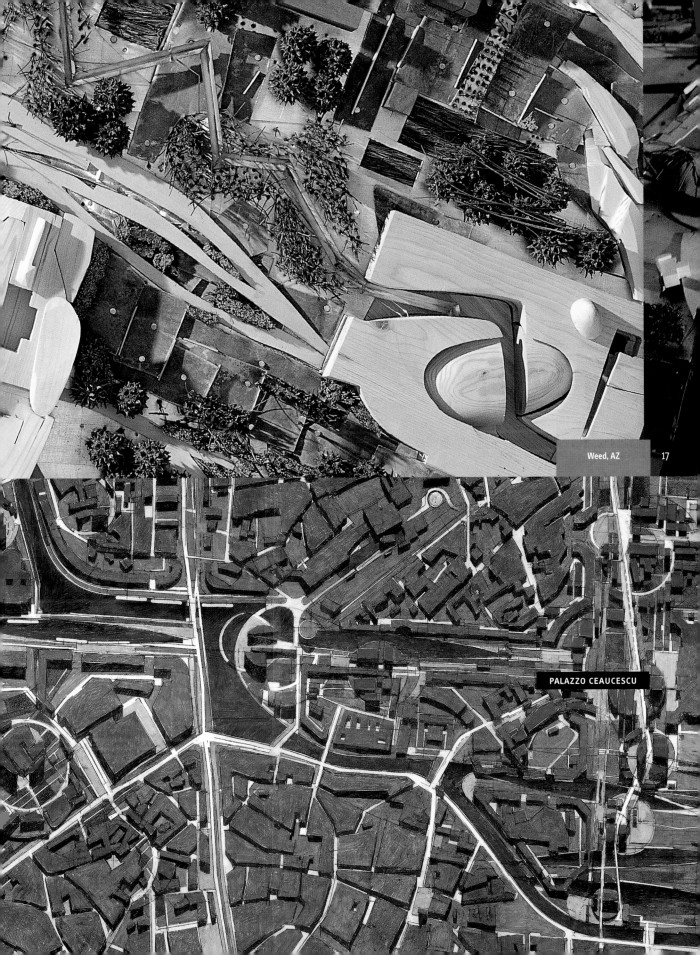

PALAZZO CEAUCESCU

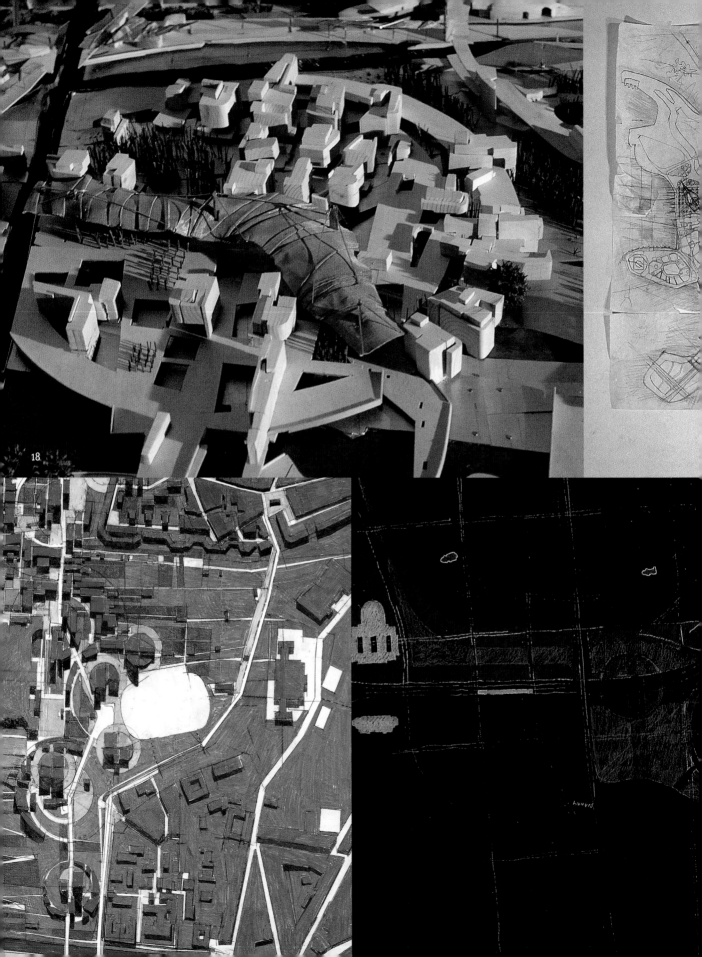

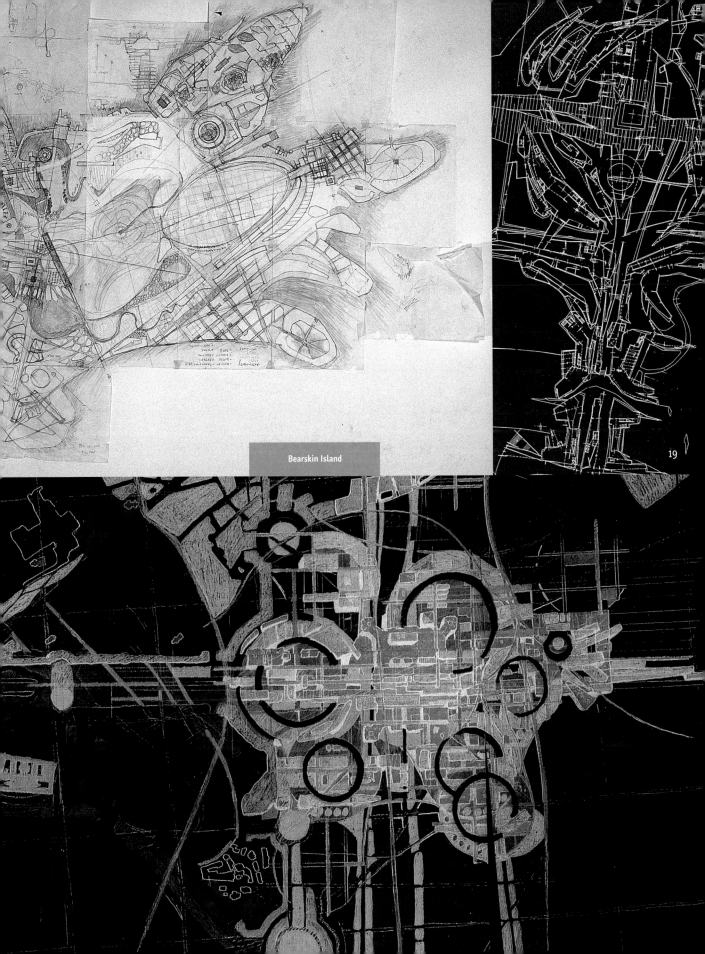

Bearskin Island

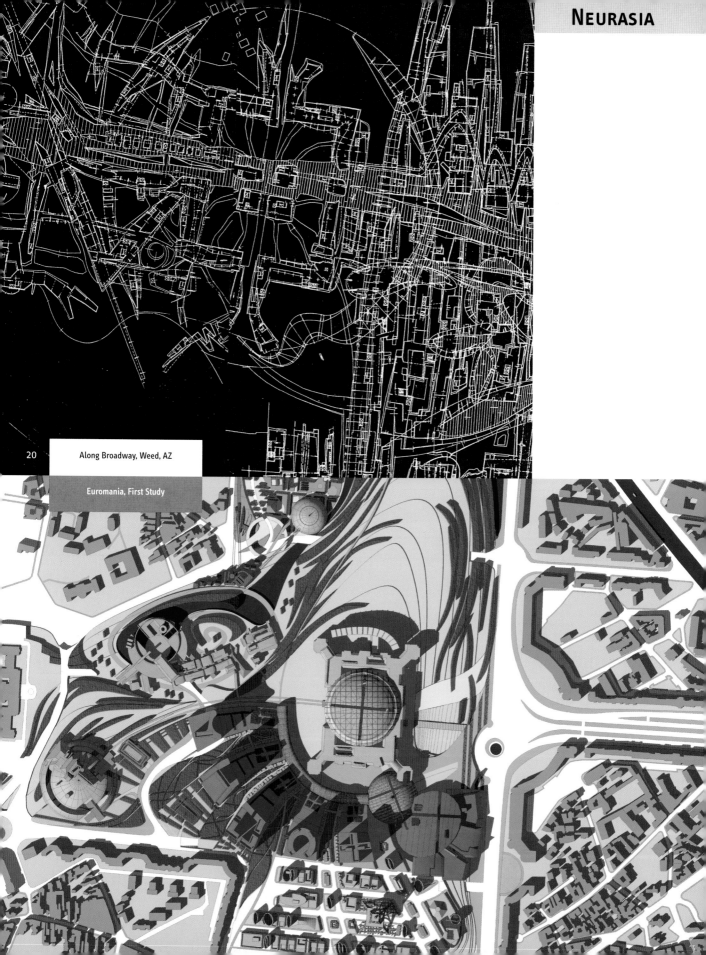

20 Along Broadway, Weed, AZ

Euromania, First Study

The epiphany came in Osaka. Driving through a densely built-up part of the city, I was struck by the sight of small agricultural fields among the buildings. While the reasons for this have more to do with the convolutions of culture and an artificial economy than with any vision of urbanism or ecology, the fact of the condition was amazing. Added to southeast Asia's sights of packed towns with their labyrinthine tactics of mobility and laced with water and gardens, an urban fantasy began to emerge.

Neurasia was the result, an imaginary city somewhere on a line between Hong Kong and Hanoi. The town is organized in a series of village-scaled increments, each distinct. A priority to pedestrians is achieved with an intense layering of means of motion. Within the city there is an abundance of small-scale agriculture, sufficient to support its population. Complex networks of green and blue space serve farming, recreation, oxygen production, environmental cleansing, and thermal regulation. At the center of the city, reflecting Asian tradition, is a void.

The fantasy of the single city is extended to a network of cities along the line, which becomes an armature for trans-portation, organizes transfer among modes, and isolates disruptive uses. Cities blossom along this line when the local environment is fertile and receptive. Distance between towns (D_x) is calculated to enhance local self-sufficiency, maximize unbuilt space, and respect the bearing and artistic capacities of individual sites. If the MagLev leaves every five minutes, two hundred miles isn't inconvenient.

The growth, arrangement, and extent of these cities answer to the notion that the location of cities in relationship to the environment and to each other must be shaped by sustainable values.

Here is a real chance for a scientific urbanism: the quantification of necessity rather than desire.

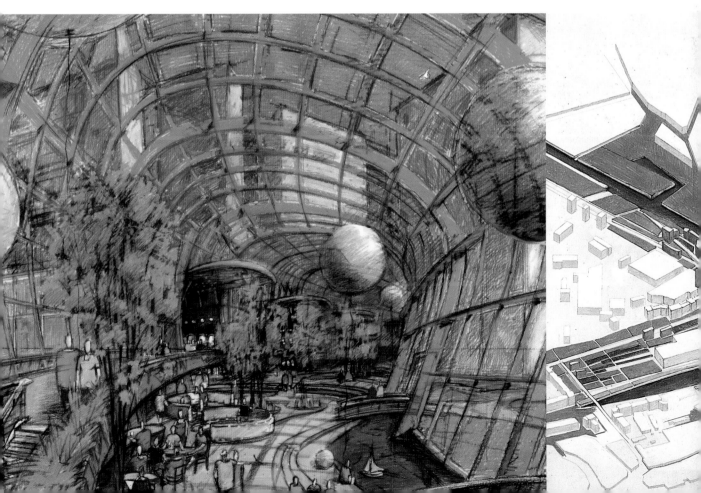

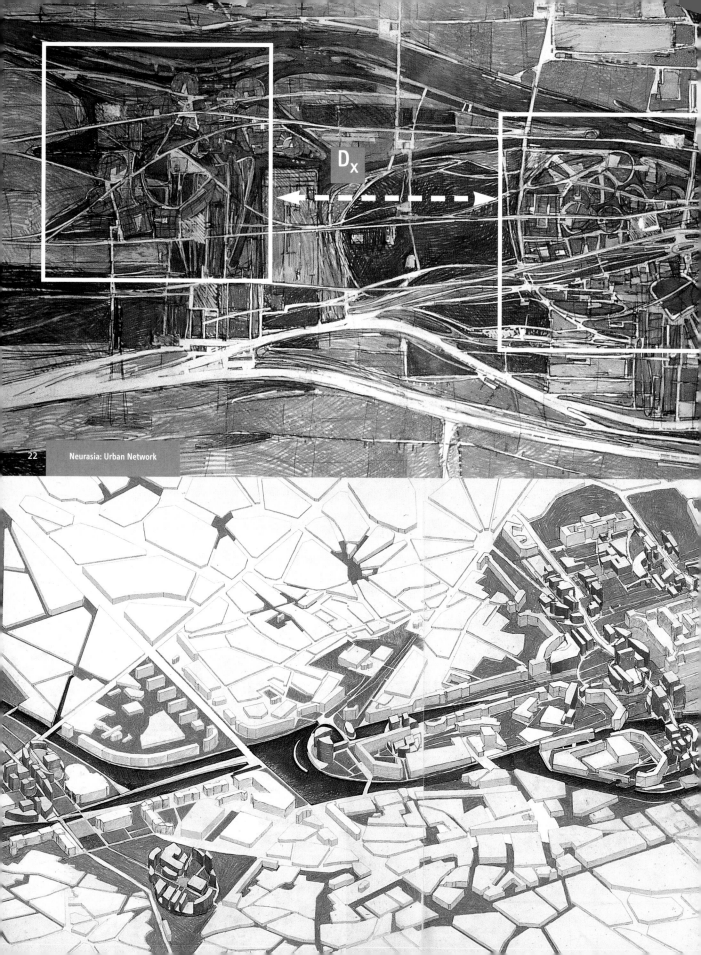

D_x

Slo-Mo Vehicle

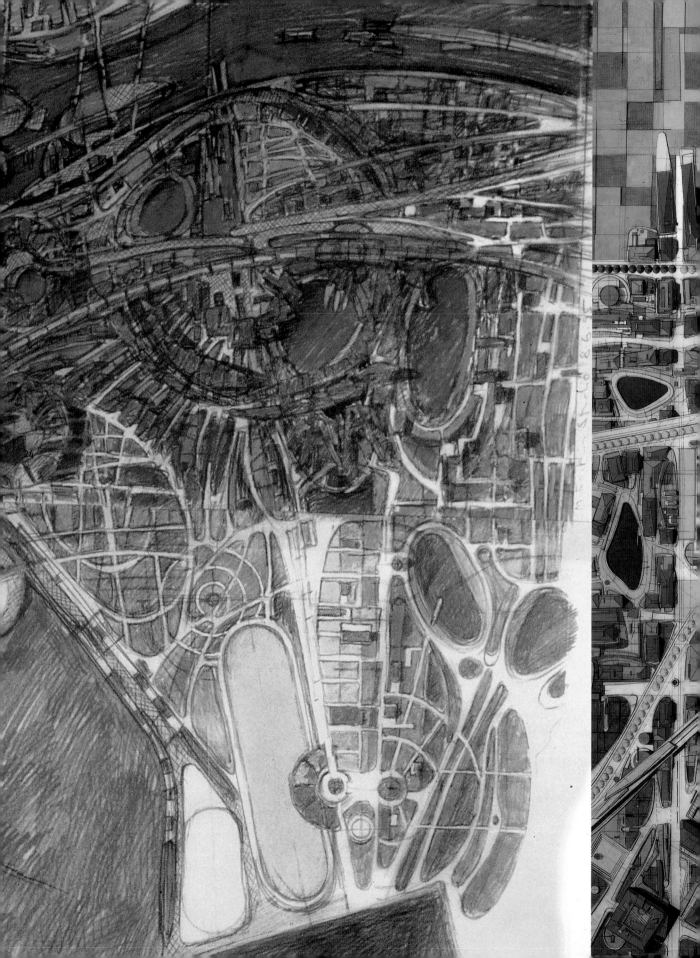

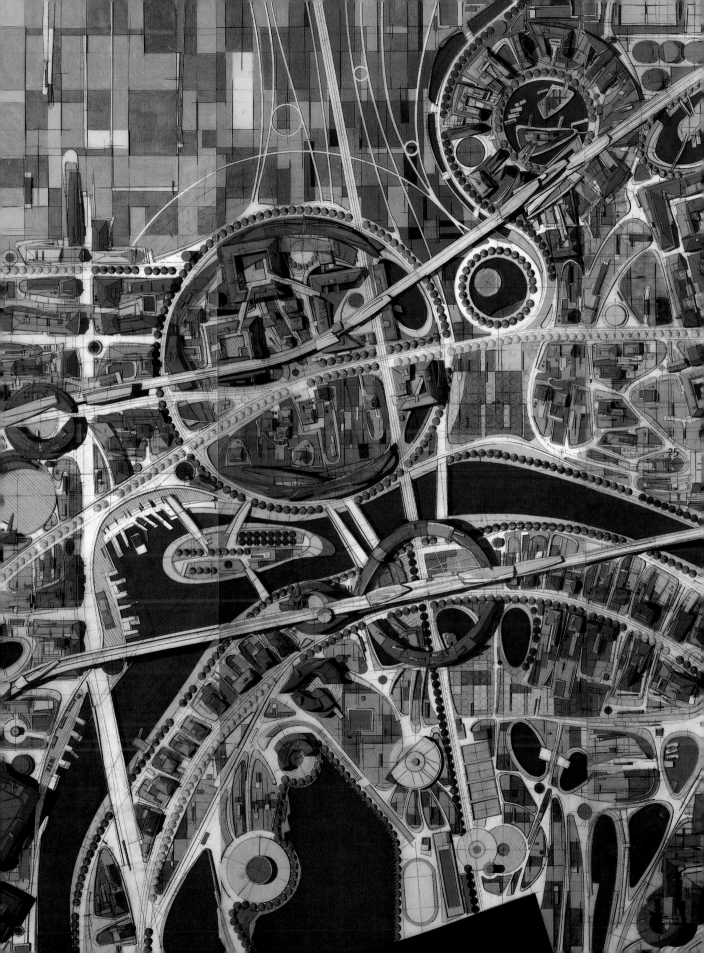

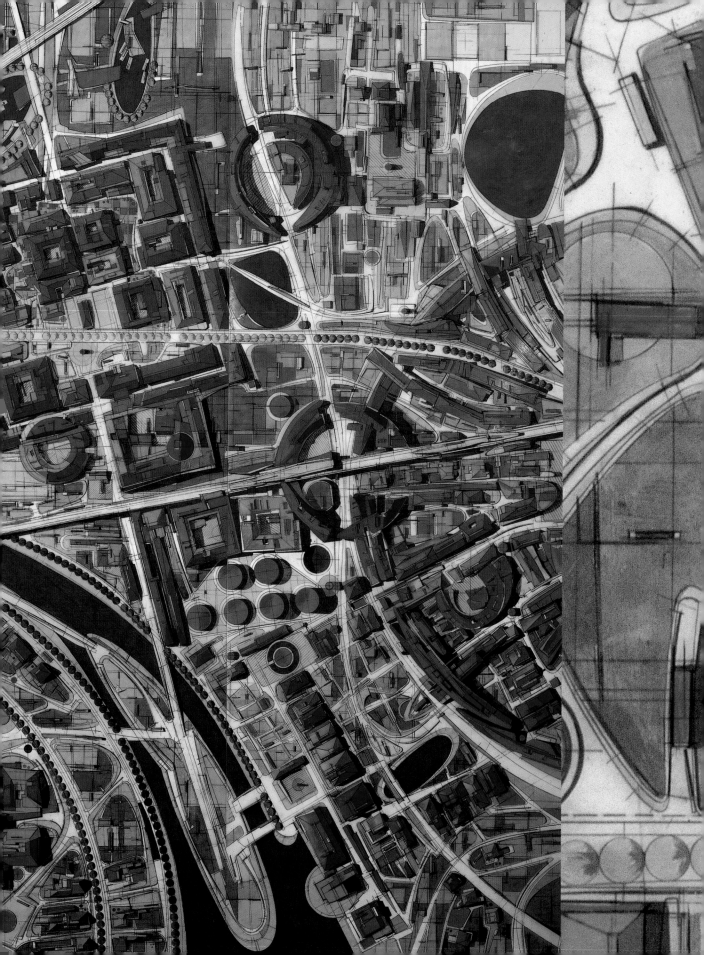

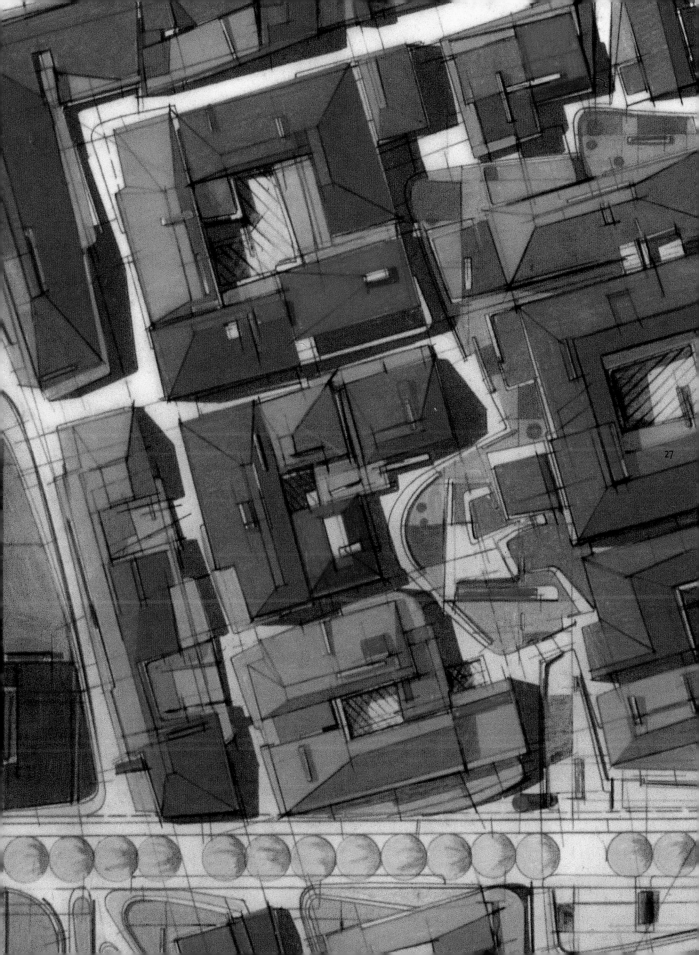

27

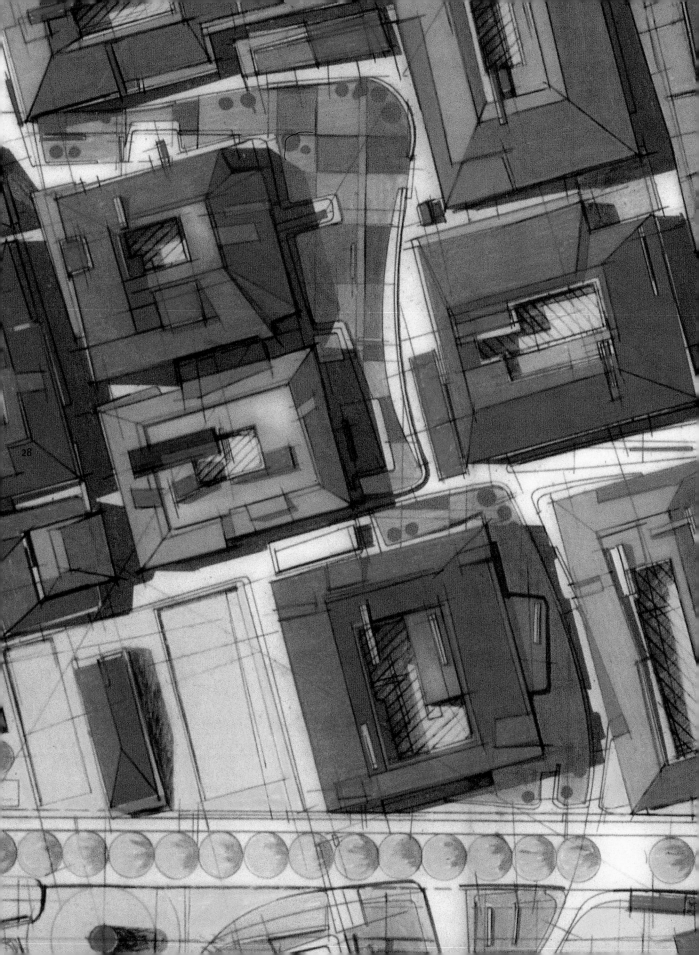

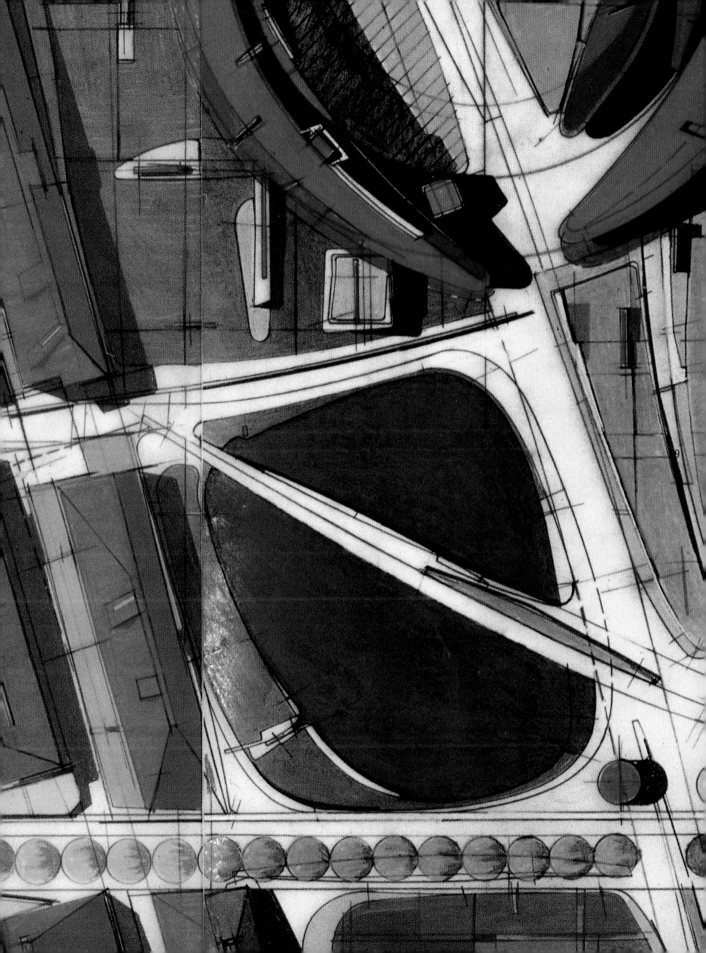

When the Hungarian film industry fell under the regime of privatization it was quickly discovered that the property on which its studios sat was worth more than its product, inspiring plans to find a new site in the countryside. A Hungarian-American entrepreneur we know became involved and suggested the addition of a Universal Studios–style theme park to act symbiotically with the production facility. Disdaining the themoid route, we suggested that the whole thing be augmented to the proportions of a town by adding housing, commerce, recreation, schools, and other facilities necessary to support a local community. We also added another major use to the mix, one with a long history in the region: a spa.

Tokaj is to be a town of pleasure and health. Its workplaces are the thermal spa, casino, hotels, medical facilities, concert and theater center, parks, film studios and academy, and cinema museum. This extraordinary program of leisure is supported by a rich apparatus of normalcy. The town—as any new town should be—is at once prototypical and practical, fantastical and exigent.

The center of Tokaj—bounded by a sinewy canal—is to be car-free and linked to Budapest by a light-rail connection. Vehicular traffic would circulate at the town's perimeter on a ring road that feeds parking lots and service tunnels. Tokaj is to be expanded in two phases to a radius of 1,500 meters. At build-out, the town would include two additional neighborhood centers in addition to the use-centers of its main activities, all fronting on the central plaza. Greenery would penetrate in strong vectors to the center of town, allowing walks from backyard to open countryside and beyond.

Our work on Tokaj gave rise to a now enduring fantasy in the studio. How, we wondered, would the form of a city be altered if one of its building regulations stipulated that every resident might step from a door in her building into a greenway and be able to walk, unimpeded by traffic, to Paris. And why not? The city exists as both an exception and a complement to its territory, continuous with the rest of the planet.

Consider the architecture that might be induced if the equivalent of 50 percent or 70 percent or even 100 percent of the surface area of a city were green. The house and garden (at whatever scale) is only the most preliminary expression of this relationship. In a world of cultural homogenization, bioregional particularities offer a crucial vector of differentiation—of individuality—for cities to come.

30

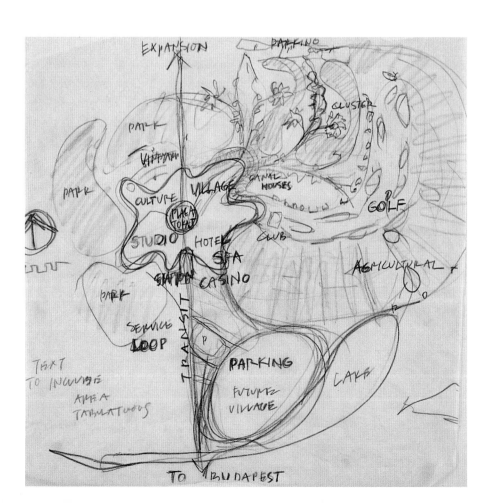

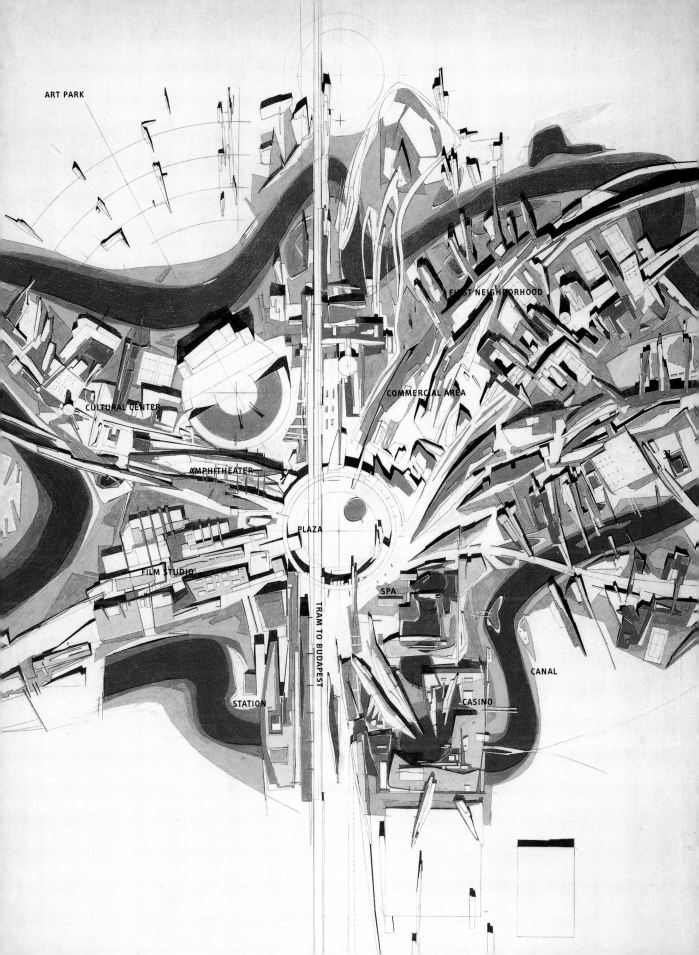

ART PARK

FIRST NEIGHBORHOOD

COMMERCIAL AREA

CULTURAL CENTER

AMPHITHEATER

PLAZA

FILM STUDIO

SPA

TRAM TO BUDAPEST

CANAL

STATION

CASINO

GOLF

Tokaj: Phase 1

BROOKLYN WATERFRONT BROOKLYN, NEW YORK 1993–94

A spectacular site on the Brooklyn waterfront opposite lower Manhattan and below the Brooklyn Heights Promenade has recently been relinquished by the Port Authority, setting off a debate about future use. Like so many others, the conversation is hemmed by the current dimensions of the municipal imagination. Indeed, it seems the only available models for the urban waterfront—revealed in virtually every plan proposed to date for locations along New York's six hundred miles of coastline—are either parks or developments on the Battery Park City model. Neither of these is deficient in itself, it's simply that the Olmstedean paradigm and the residential promenade do not seem to embrace the full range of possibilities for waterfront renovation. The proposal on the table at the time we did this scheme was for a grassy park on most of the site with a small convention center at the upper end, near the Brooklyn Bridge.

This counterproposal is—given the likelihood that this will be an intensely trafficked place—to ratchet up the mix. The conference center is maintained to the north, augmented with a hotel on a deconsecrated cruise ship or aircraft carrier. A series of brick loft buildings fills out the northern end of

the site and lines its eastern flank. Further down, a large amphitheater faces the fabulous view of Manhattan. At the south end, we propose an industrial use: a barge-building yard. These barges would be fitted out as gardens, sports grounds, restaurants, and community facilities for use as constituents in the rest of the project. They might also be floated to other parts of the city to seed development of other stretches of the waterfront.

The remainder of the site is given over to an intensive mix of uses, a kind of park-bazaar, suitable for use by large numbers of people pursuing a vast number of pleasures. The water's edge is treated amphibiously, dissolving into an archipelago of pier fragments, islands, walkways, barges, and marshes. The actual constituents of this portion of the park would be constantly in flux, responding to tides, seasons, and the shifting desires of users.

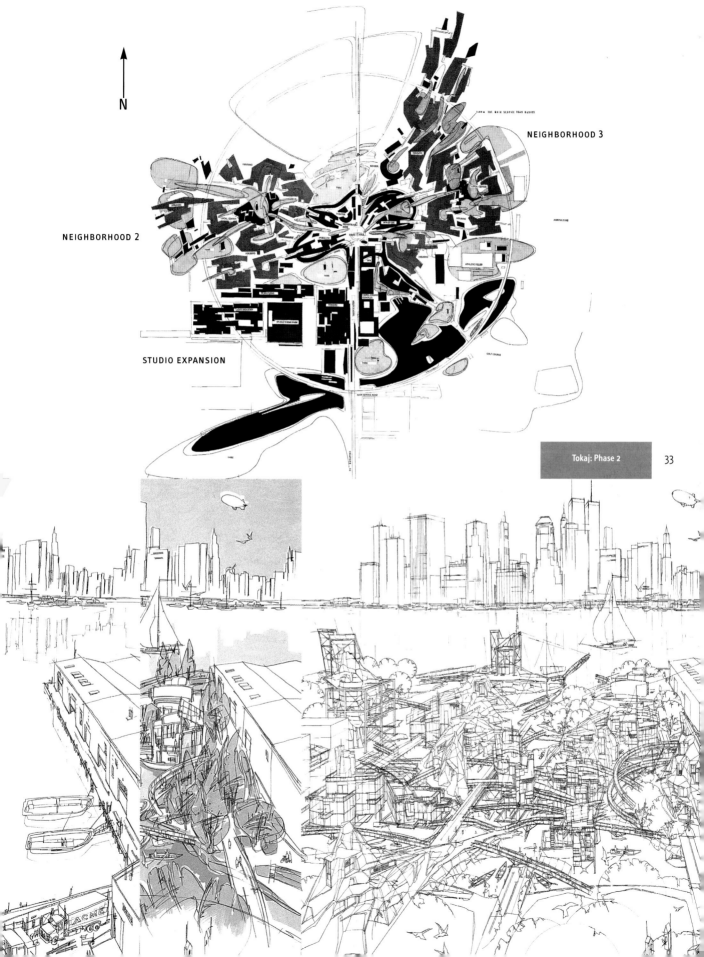

NEIGHBORHOOD 3

NEIGHBORHOOD 2

STUDIO EXPANSION

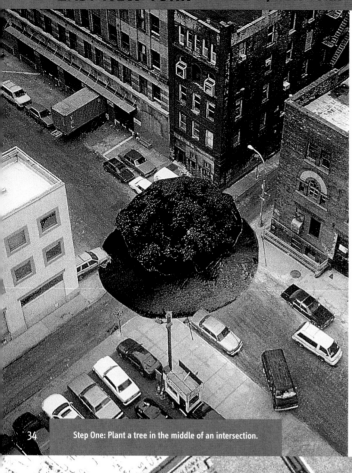

Neighborhoods are the center. A successful neighborhood is founded on comprehensiveness—the location of the conveniences and necessities of daily life within an easy walk of home—an idea of sustainability—a maximization of economic, social, cultural, and environmental self-sufficiency —physical autonomy, and equity—a fair share of the benefits and responsibilities of the metropolis.

These are speculative proposals for an area of East New York, Brooklyn, not far from Kennedy Airport. The area is socially, topographically, and ecologically (though not economically) rich, descending from bluffs and ending in wetlands and shore. It holds factories and canals, rail lines, and a huge neo-Corbusian middle-class apartment enclave. It is also a museum of virtually every failed social housing typology in the American experience. We wondered how East New York might be transformed not by urban-renewal-esque demolition or by historicist completion—the fulfillment of some turn-of-the-century developer's fantasy of original intent—but by the addition of new layers of circulation, of

34 Step One: Plant a tree in the middle of an intersection.

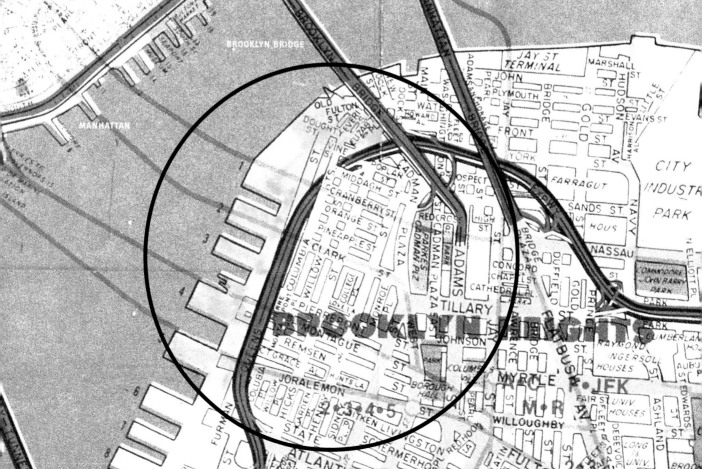

use, of green space, and of form. First studies show a flow of these green animals, of parks, of agricultural space, of small buildings, of new differences working their way through the neighborhood.

As the project progressed a question arose: what might be the minimum initial intervention necessary to get this going? The answer, we decided, was to plant a tree in the middle of an intersection. This "acupuncture" might have a sequence of consequences. First, the excess of public space devoted to automobile transportation in New York would be reduced. (Parenthetically, I do believe that the only way to control automobile traffic in New York and cities like it is to radically reduce the space available to cars and that neighborhoods must take the lead in opting out of the system.) The instant creation of four dead-end streets would surely have a calming effect on traffic. That tree in the middle of the street would also oblige traffic to find alternative means of circulation. The analogy that comes to mind—filled with my own midlife anxieties—is with the coronary arteries. Often, when a blockage occurs, the body is able to develop "collateral" means of circulation, small veins that shunt the blood around the obstacle via a complexification of the system. Our fantasy

was that the street blockage would be the initiating event in the invention of a new green system for the neighborhood.

Finally, we hoped, the effects of the blockage would return to the street. East New York is a place that simply has too much of the street, its sparse commerce uselessly attenuated, killing centers. The final effects of our fantasy would be to induce a series of consolidations of street density, creating neighborhood-scaled commercial and social centers that would restore legibility, convenience, and conviviality to a precinct ragged and overlarge, inaccessible for its failures of "where."

One of the reasons we prize historic cities is for their tractable dimensions, their measure by walk-time. Extent— the coalescence of scale, density, dimension, and activity— is crucial to a comprehensible, malleable urbanism. The body must remain the central measure of the city. The spaces of urban encounter are the spaces of embodiment and they measure not just convenience, they measure our rights.

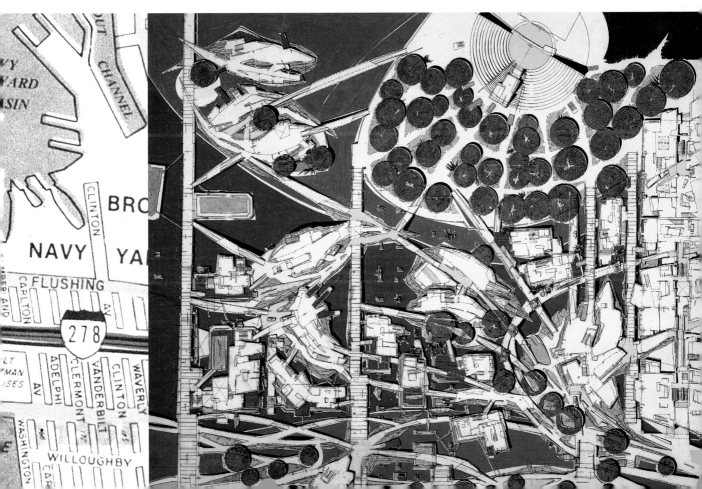

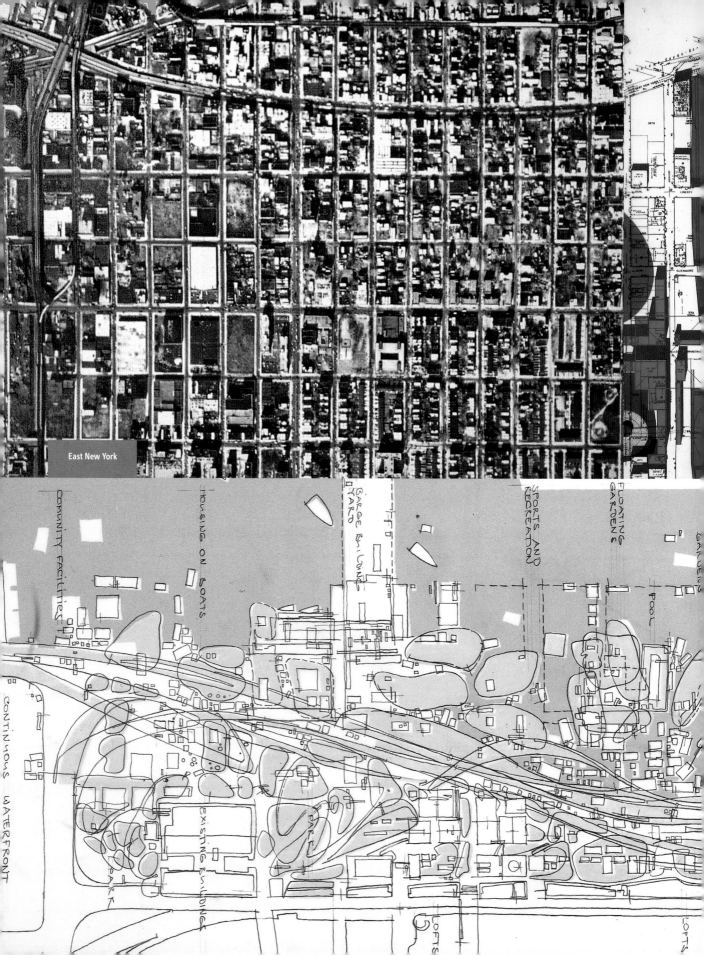

East New York

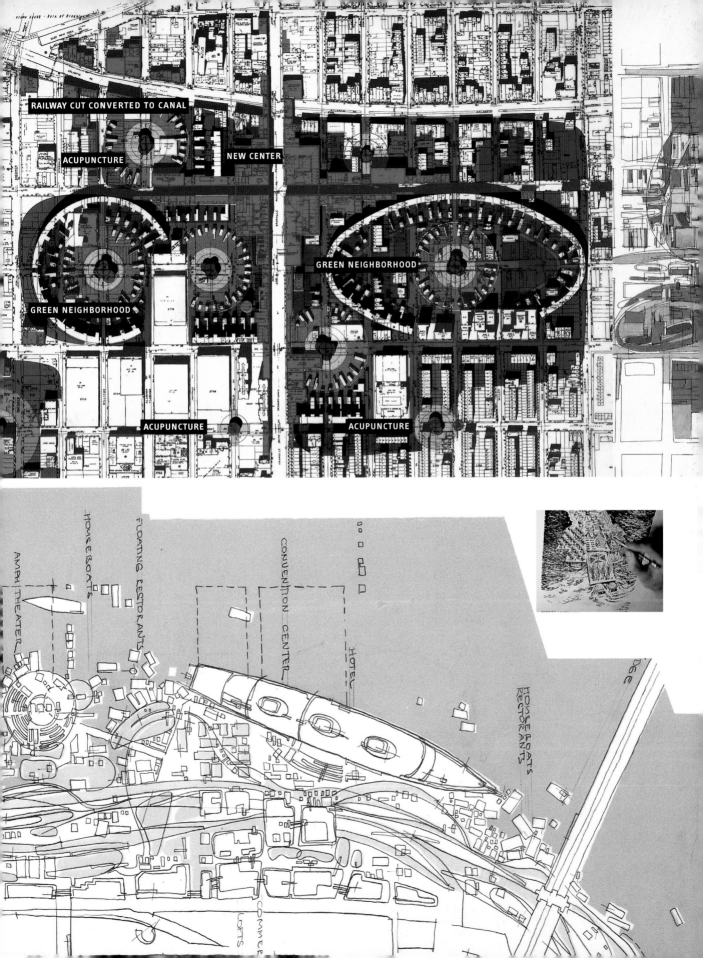

RAILWAY CUT CONVERTED TO CANAL

ACUPUNCTURE

NEW CENTER

GREEN NEIGHBORHOOD

GREEN NEIGHBORHOOD

ACUPUNCTURE

ACUPUNCTURE

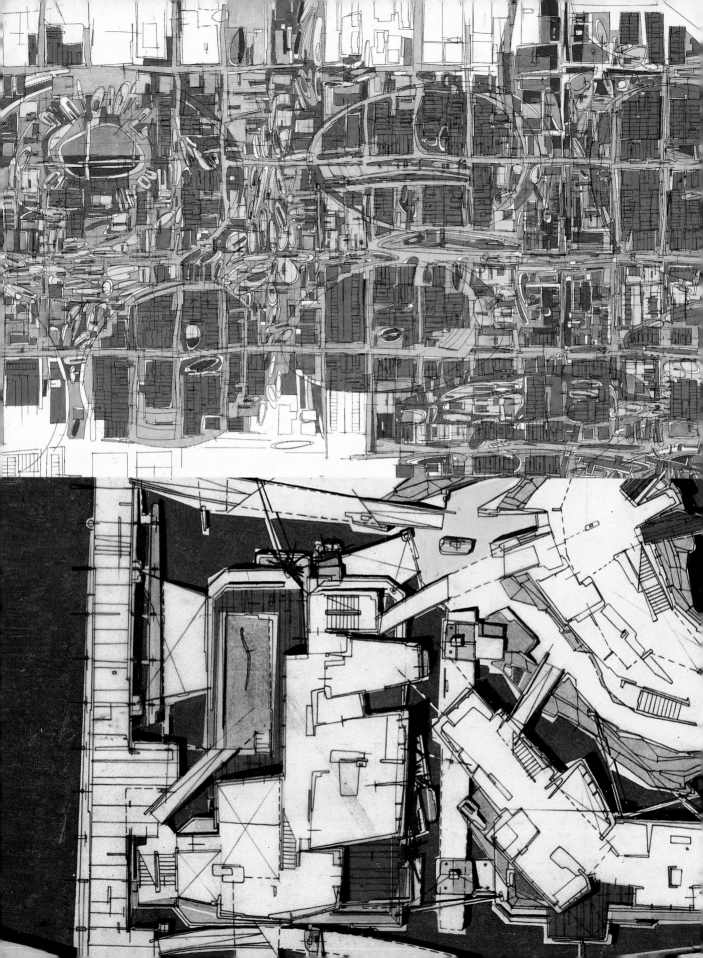

This spectacularly sited island has been remaindered by the Coast Guard and is currently up for grabs. Clearly, the future of the island is going to get brokered as a deal. Federal charity is unlikely and there is thus bound to be a self-financing aspect. These studies are not specific about exact activities save that they be dense and public. Scale is substance in an urban proposal.

Actually, we've gone through various forms and schemes (including an Apple Dome to house Steinbrenner's team while a new neighborhood-friendly club—the repatriated Dodgers?—plays at what will always be Yankee Stadium) and in the end decided that a "University of the Earth" devoted to environmental science and policy would make a fine project, the island in the harbor standing in for the planet's own situation in the universe.

In addition, it seemed appropriate to include a variety of water-related and recreational uses—sailing clubs, boat yards, fish restaurants, house boats, etc.—as part of the mix. The round buildings are brick-walled lofts, inspired by the circular fortress across the water at the Battery and its angular companion on the island. In the sketches shown, these loft buildings have hollow cores over which domes would

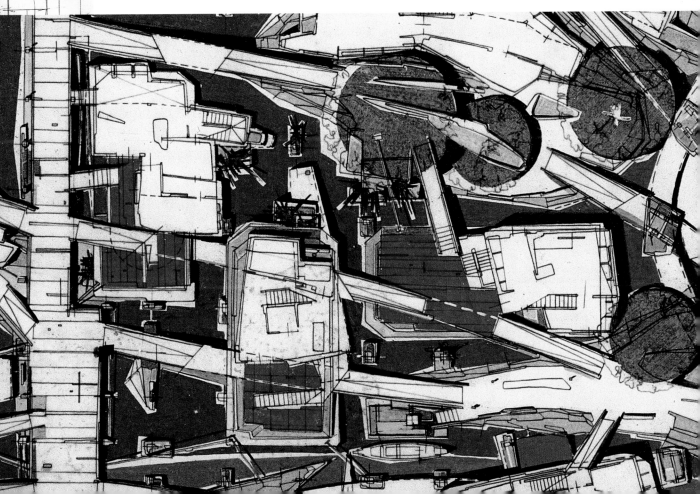

grow during the winter to allow continuous use. The island has been slightly reshaped, recalling its origins as fill.

We've tried to use the redevelopment of Governors Island to leverage the addition of a new layer of transportation on the water. The site is a likely node for a water-borne transit system linking waterfront communities in New Jersey and New York City. In particular, the opportunity to use the island to stimulate the development of Red Hook, just opposite in Brooklyn, struck us as very important.

As with any such place in a city like New York, Governors Island must serve a most heterogeneous population. This argues for an intensity of use that can only be achieved through variety. We intend not a condenser but a mixer.

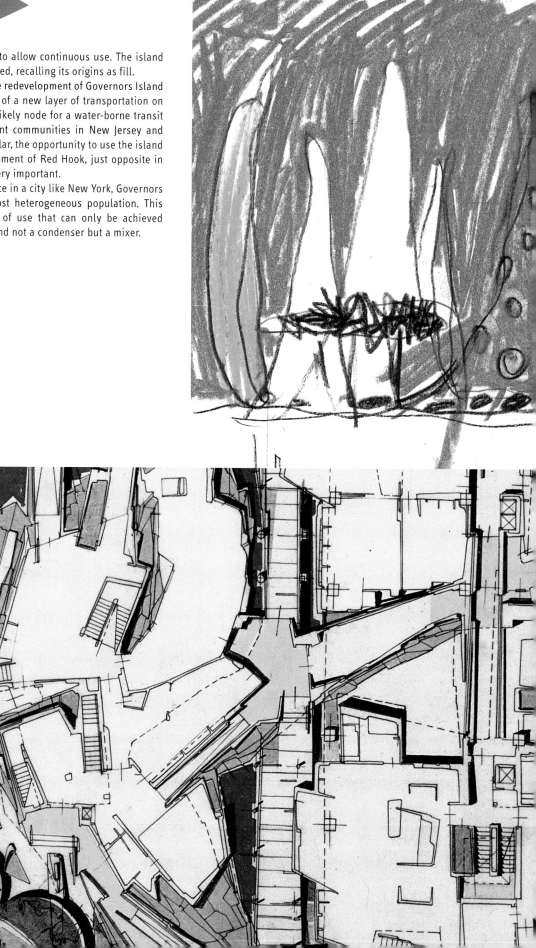

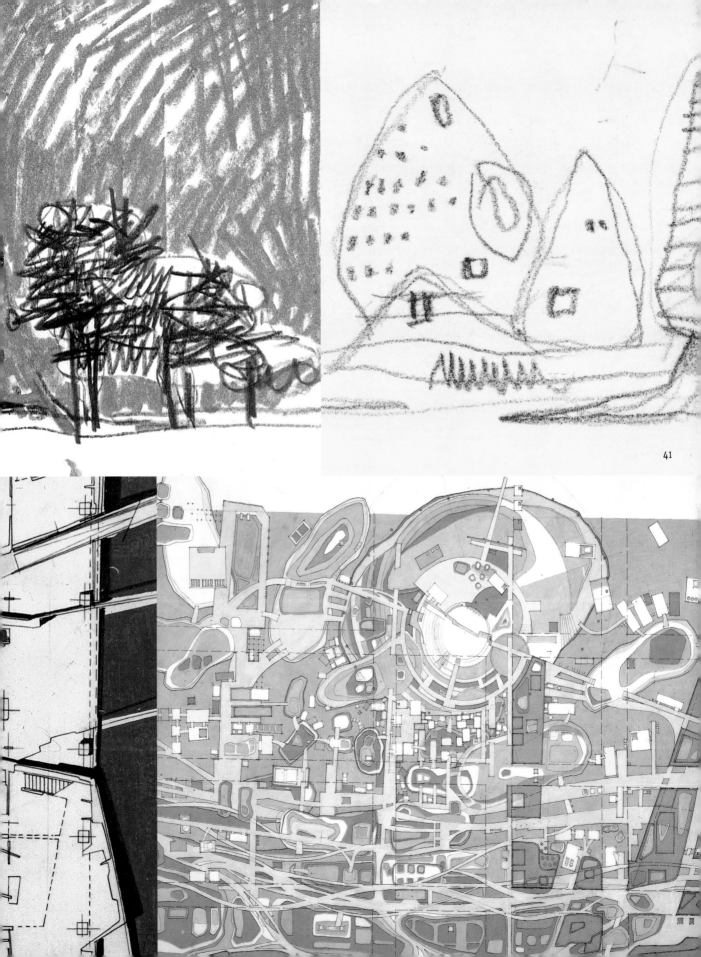

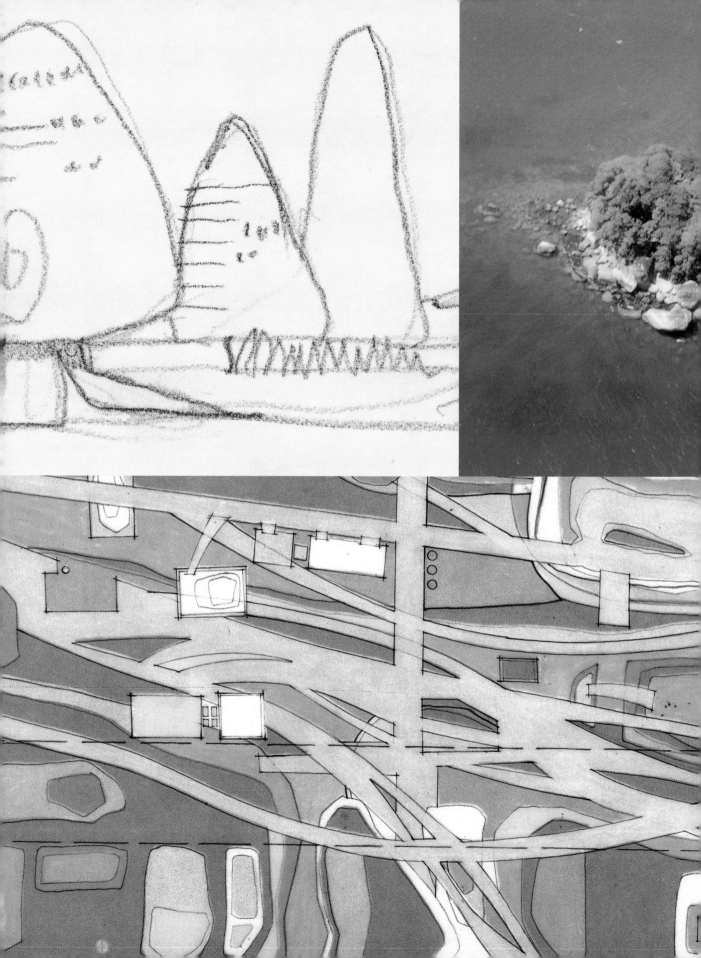

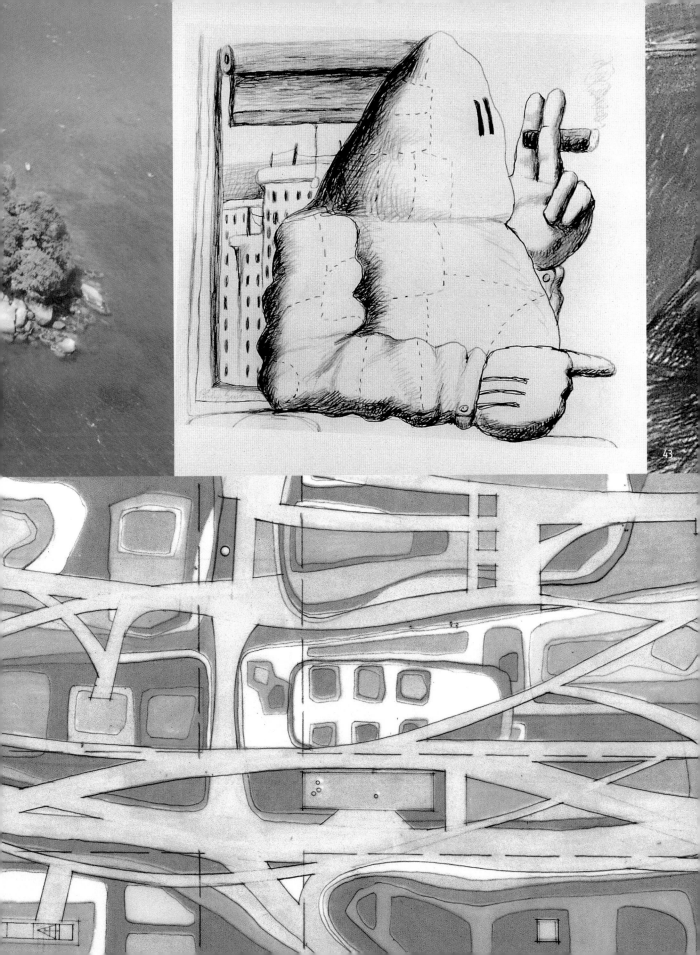

43

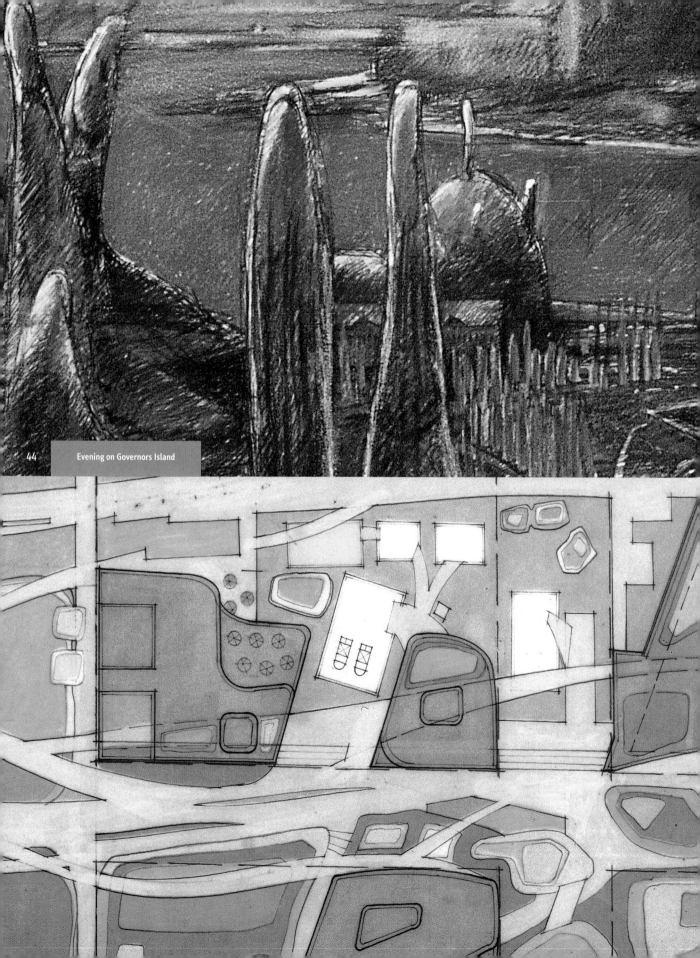

Evening on Governors Island

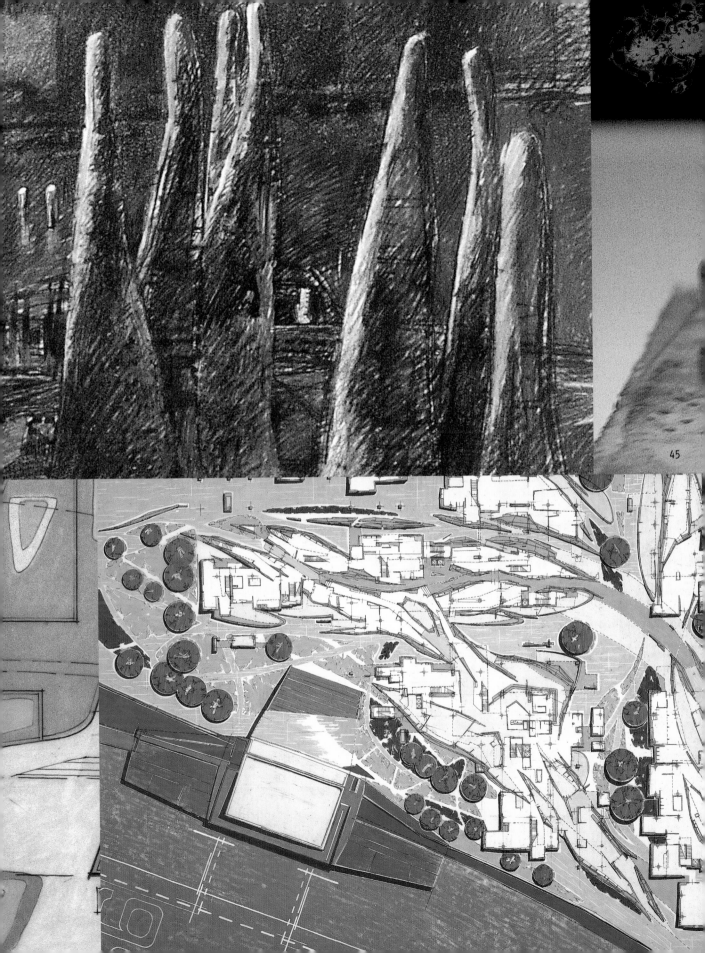

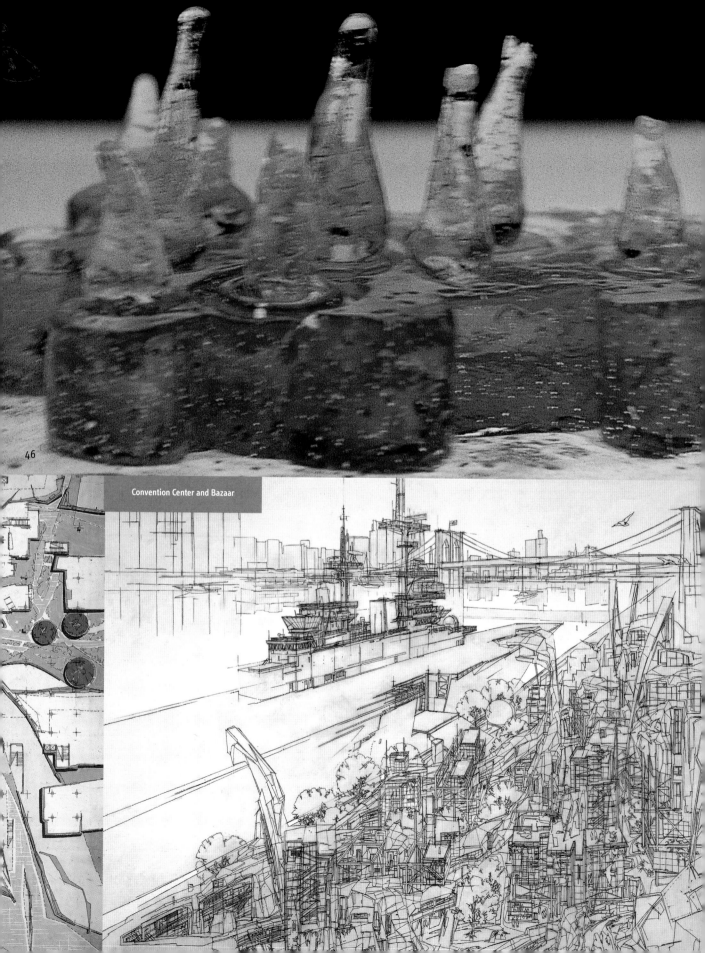

46

Convention Center and Bazaar

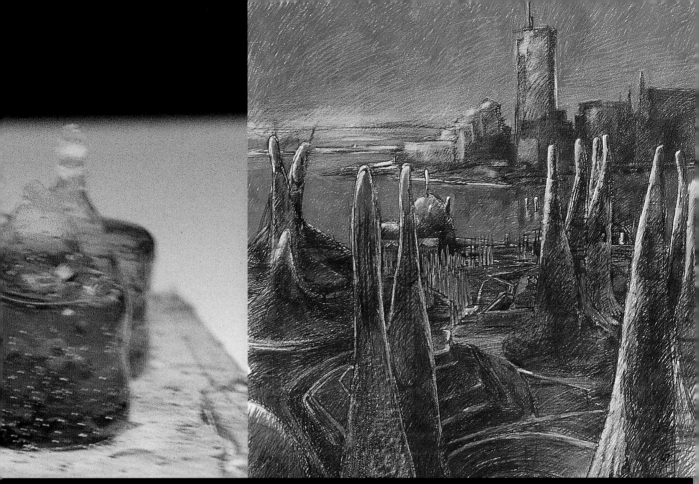

HANSEATIC SKYSCRAPERS HAMBURG, GERMANY 1989

We fantasized these skyscrapers for sites in Hamburg, just visited for the first time. Pickle has the distinction of having observation platforms on both top and bottom.

Off-Shore Skyscraper

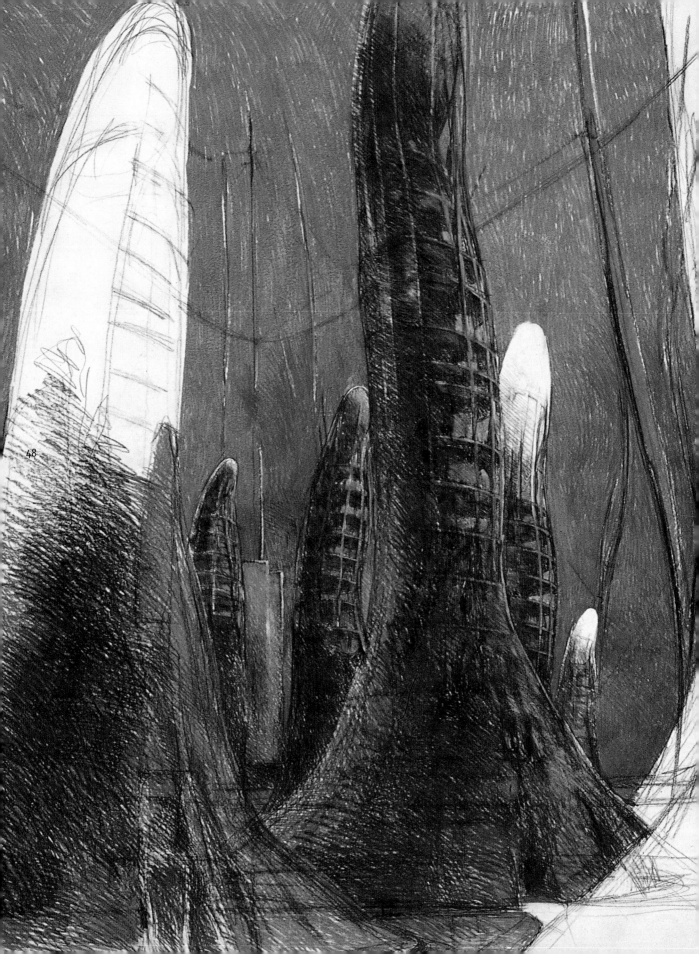

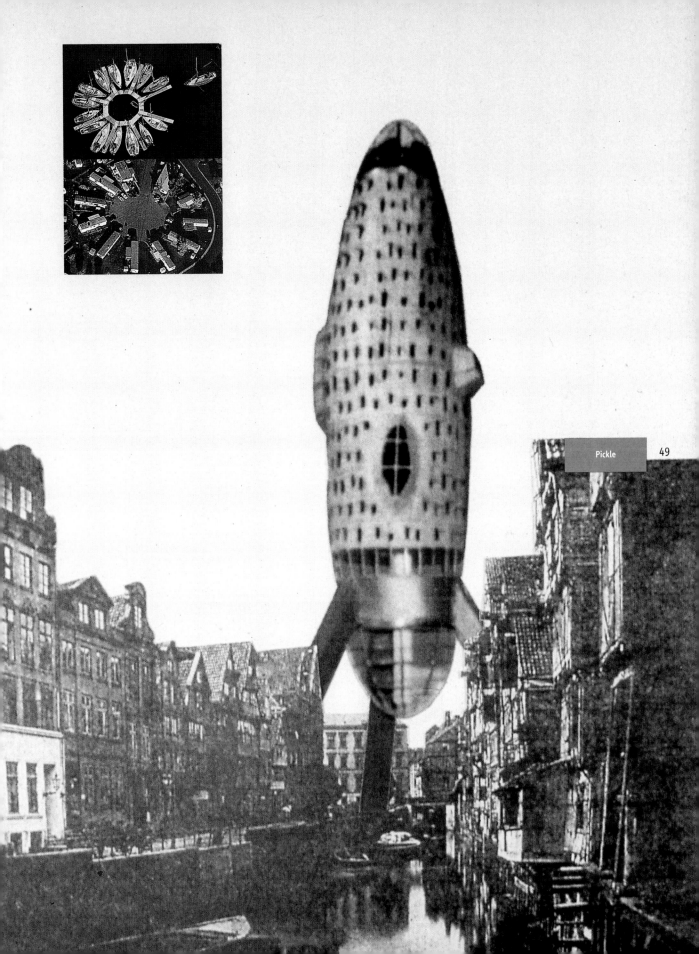

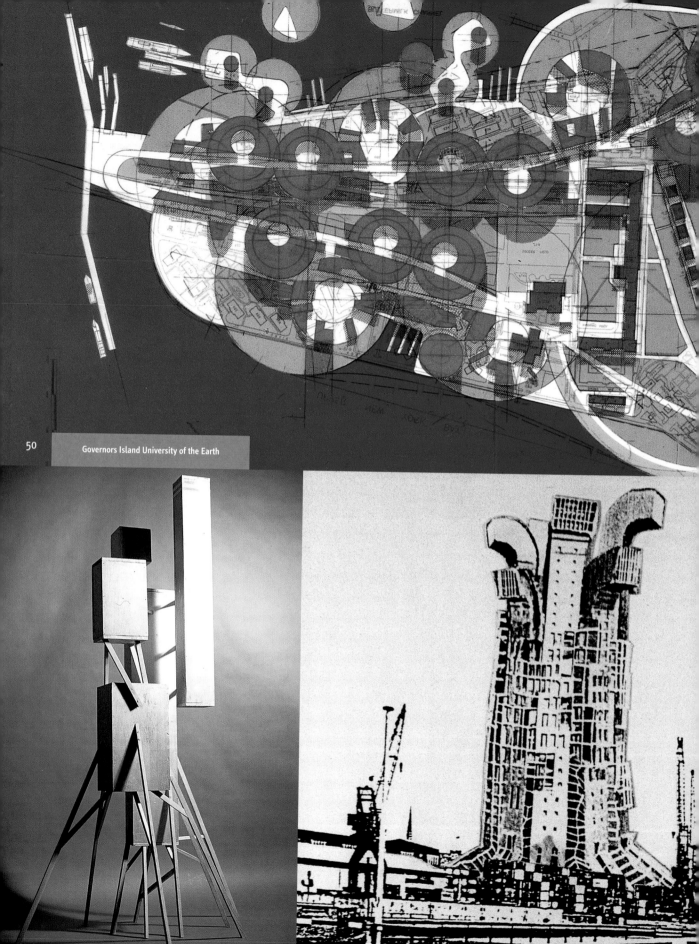

Governors Island University of the Earth

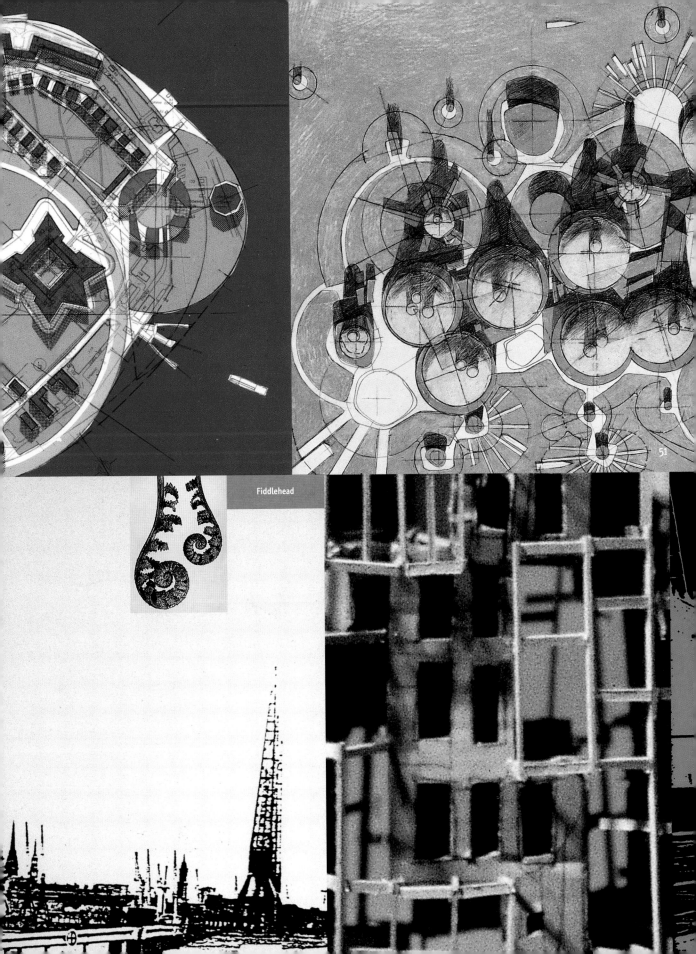

Fiddlehead

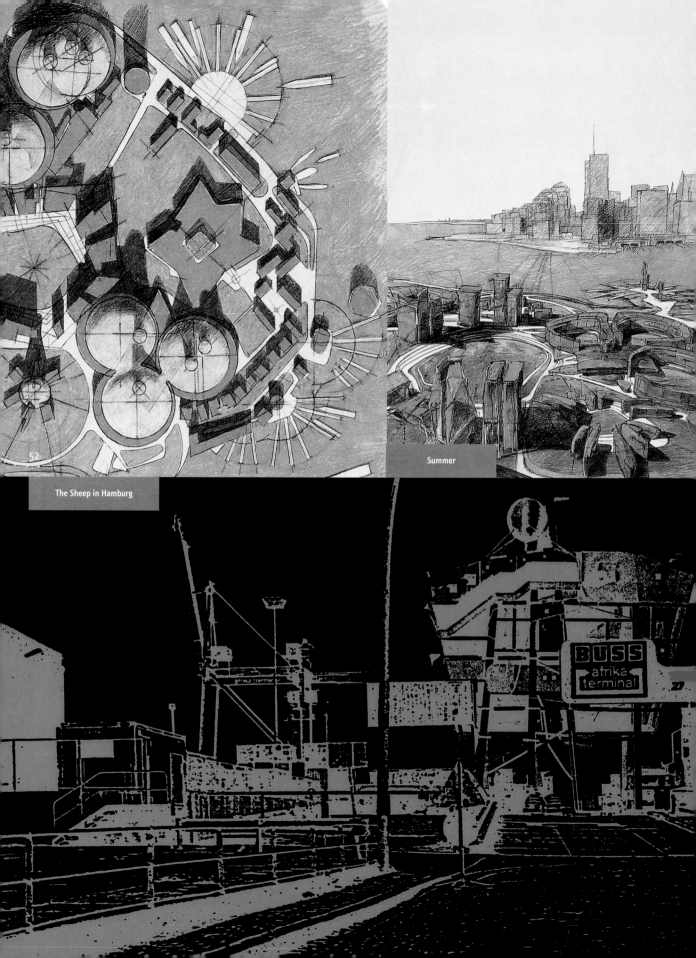

52

The Sheep in Hamburg

Summer

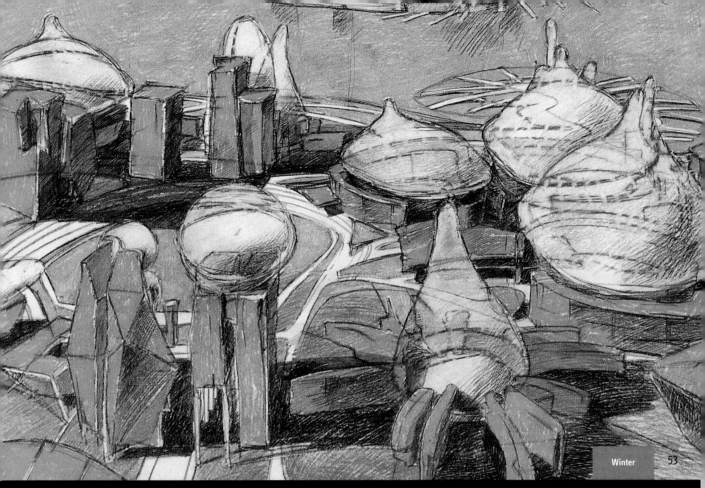

MASS MOVEMENT　TIMES SQUARE, NEW YORK　1987

A replacement for the existing Times Tower and a first exercise in the use of the computer. The program is entertainment, and each element, skewered on the shish-ka-bob—bar, disco, theater—rotates at a different speed and direction from its neighbors. Never appearing the same twice, the building is meant as a high-tech Amiens Cathedral as well as a giant timepiece. The big canopy covers a huge opening to the subway and the circular ferris-wheel-like building across Forty-second Street is a revolving hotel.

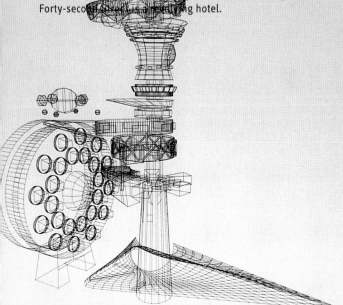

7:14

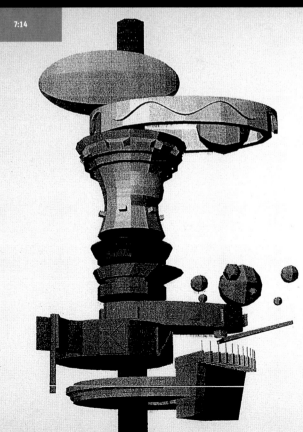

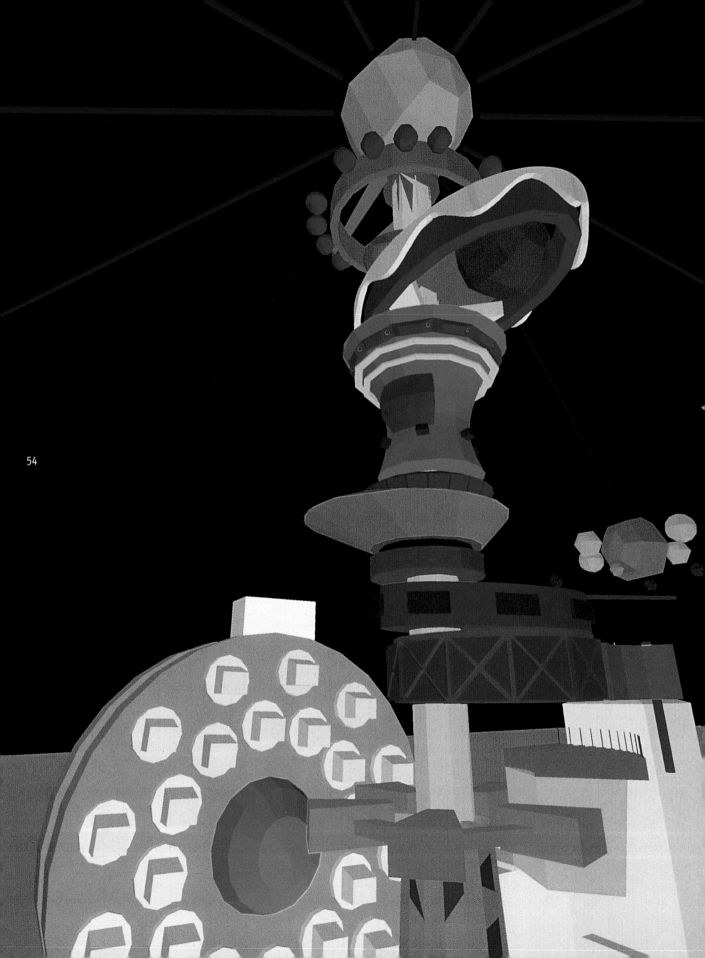

Several years ago, before ever having visited Tokyo, I decided that before my delirious vision of the place was contaminated by the rigors of actual observation, we'd better do a project there. Although we've called the building Godzilla, it isn't meant to be sinister, just large: a building with presence. Perhaps it would seem less threatening had we called it Barney.

The project's affinities with Godzilla, however, are not merely morphological but conceptual. Just as that monster (I mean the term not pejoratively but genetically) stands for a certain intensification of Japanese post-nuclear anxieties, so this building represents, for me, an intensification of Tokyo-ness. In it, the tangled skein of the city finds a critical mass and erupts into form, a verticalization of what I took—from my distant vantage point—to be the fundamental (dis)order of the city.

Godzilla is meant as a strategic blockage, thwarting and then reorganizing traffic. It is a center of dissemination for green, blue, and car-free vectors, for the expansion of a zone of pedestrianism, and for the insinuation of fresh tendrils of form and materiality. The site is a composite and certain modifications may be required when we get to the construction phase.

55

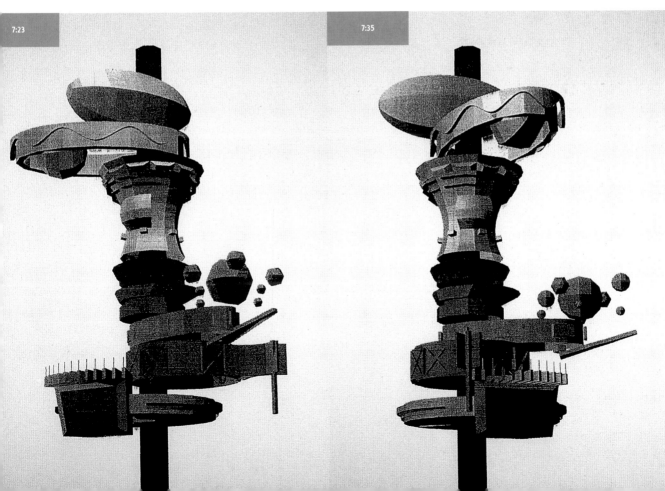

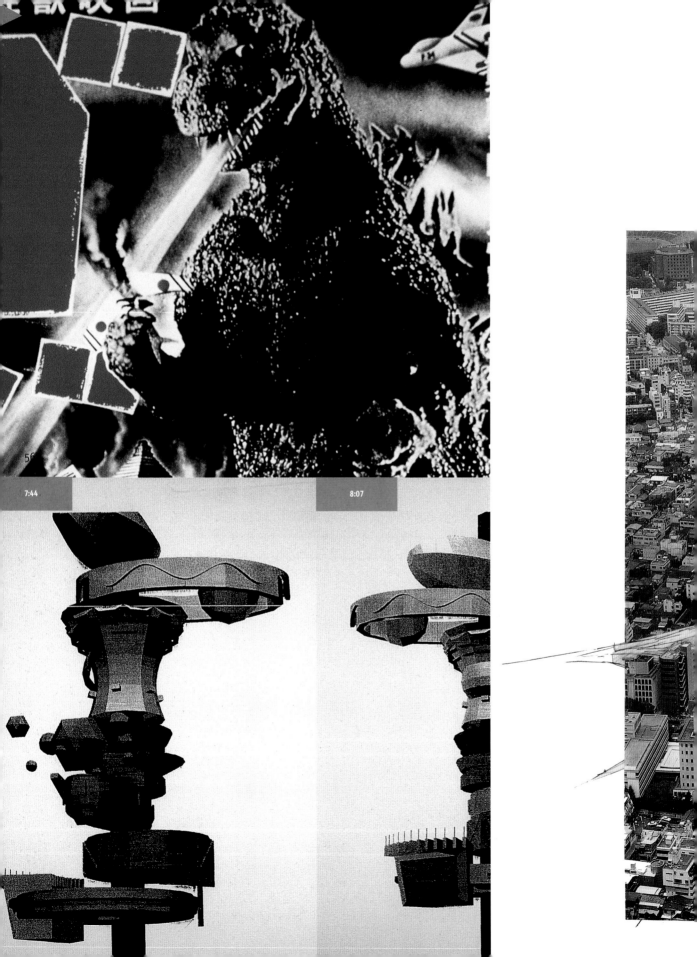

56

7:44 8:07

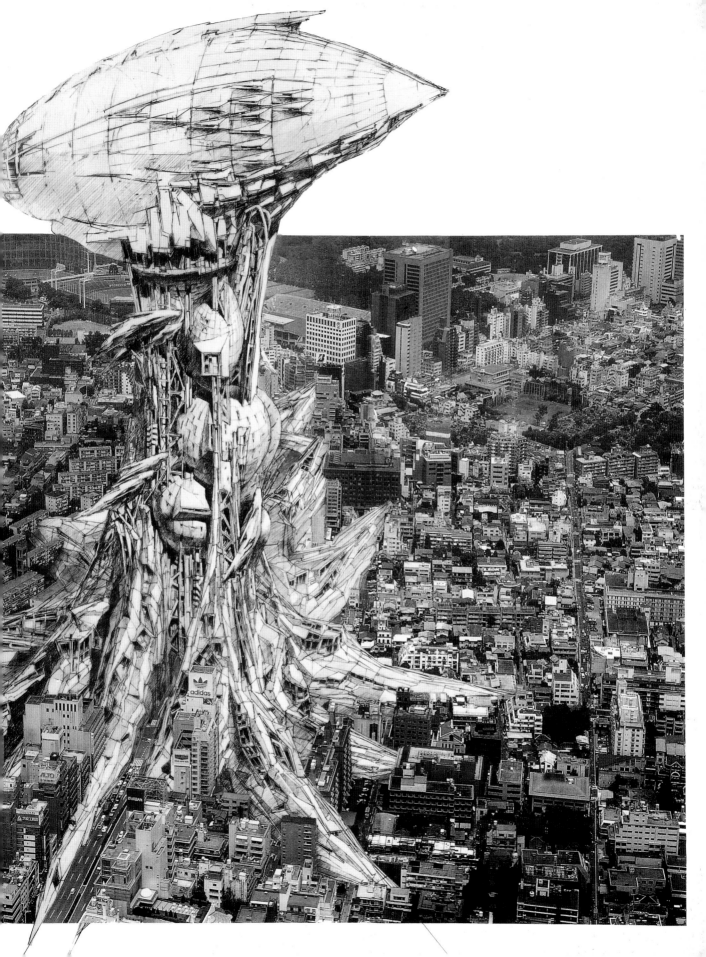

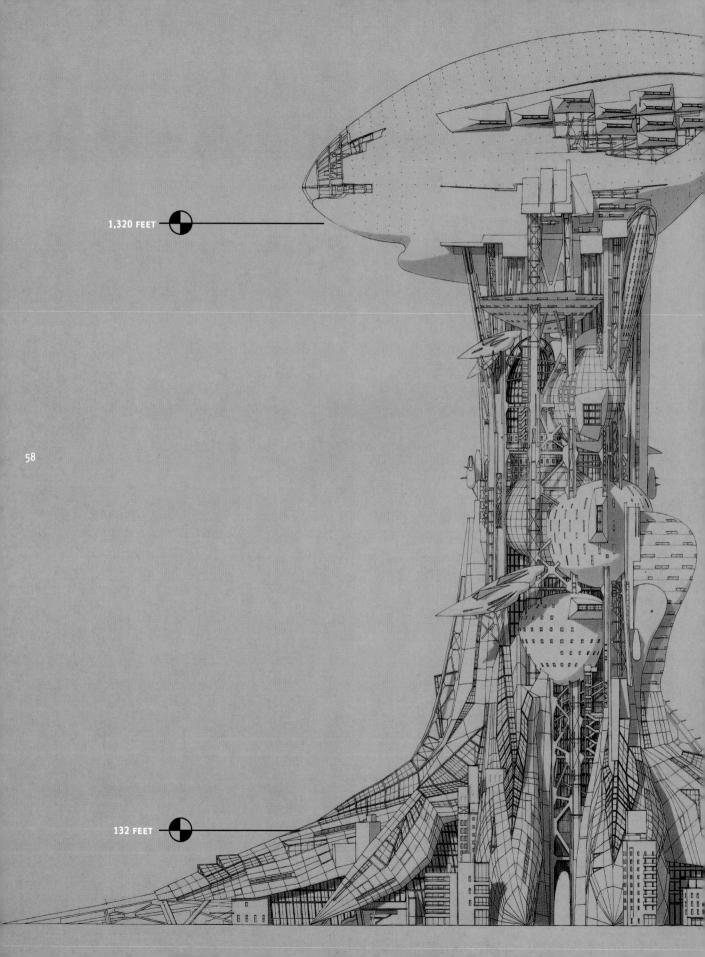

1,320 FEET

58

132 FEET

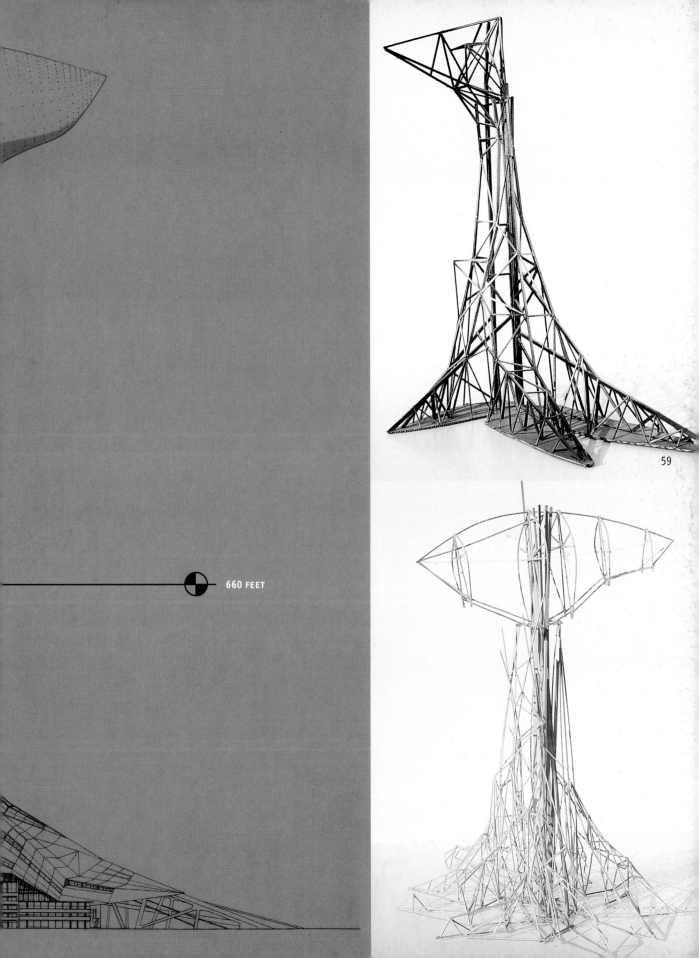

660 FEET

59

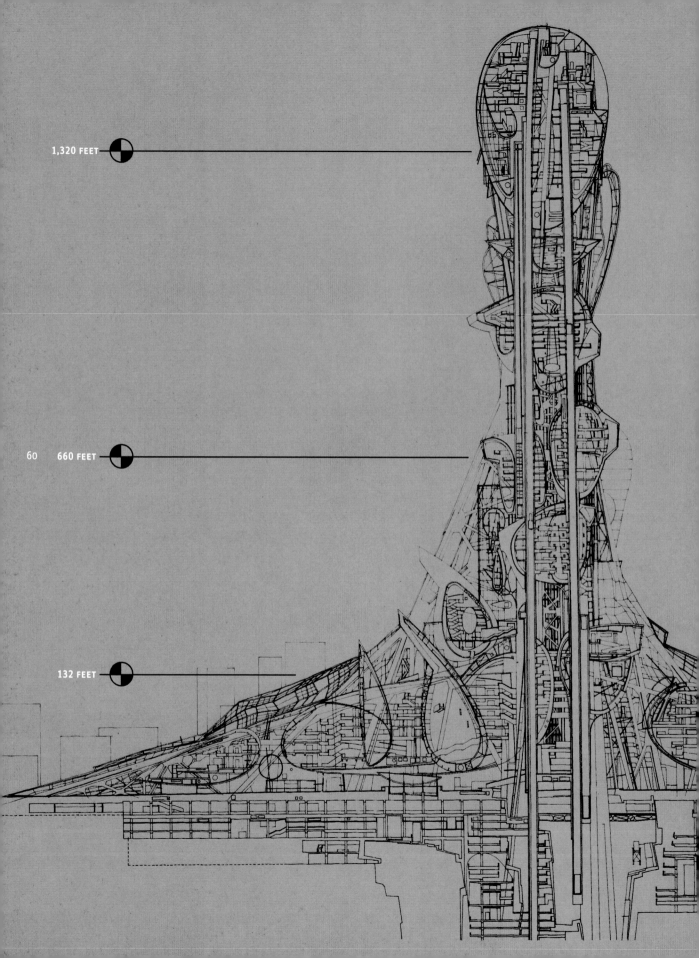

1,320 FEET

660 FEET

132 FEET

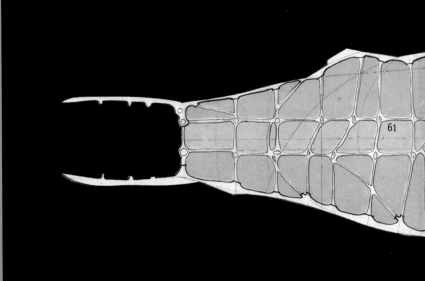

61

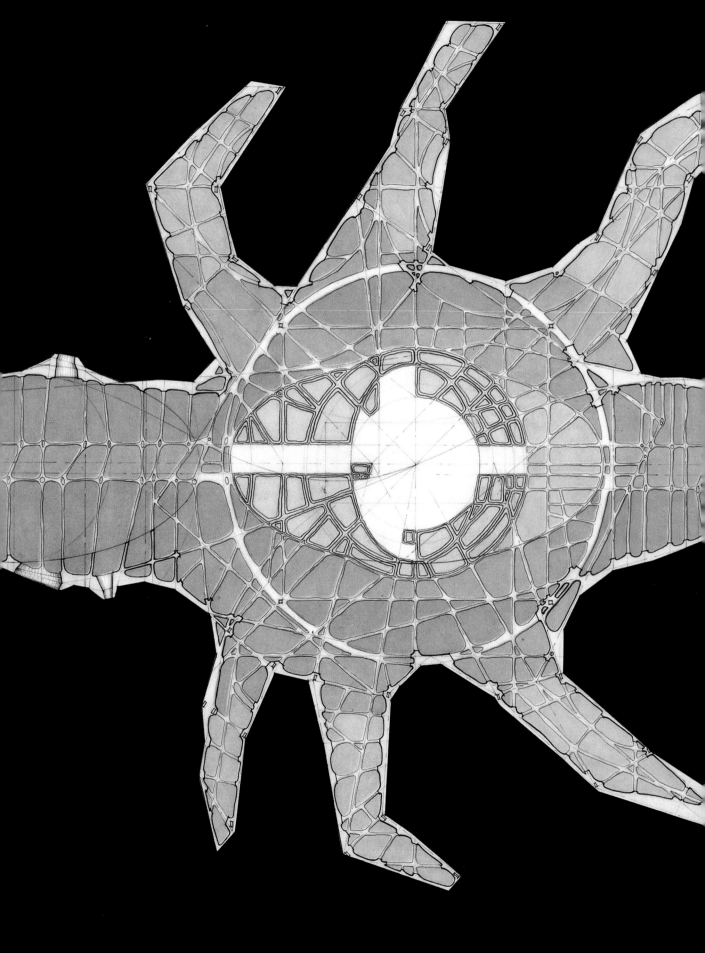

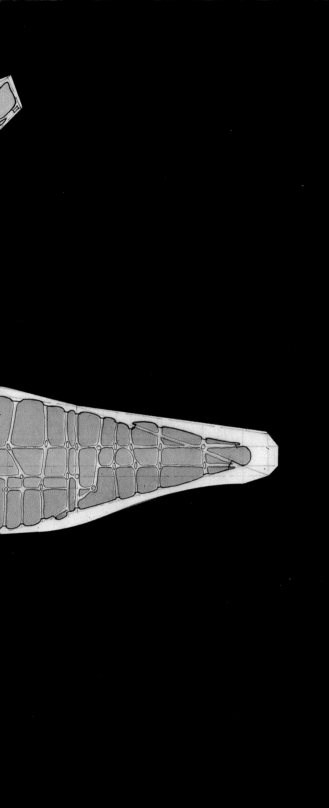

Several Haiku were written:

Tanaka rises
and adjusts the solar wall.
Morning rays strike feet.

Elevator stems,
destination lower sphere.
Diodes mark the way.

Taeg soaks in the pool,
alone in the midnight sky.
City lights glimmer.

Late for a meeting,
grabbing notes, running across
forty-fifth floor bridge.

Looking down the street,
green colored limb rising up.
Traffic is thwarted.

Aerial fish form,
habitations and theaters.
Many ways to get high.

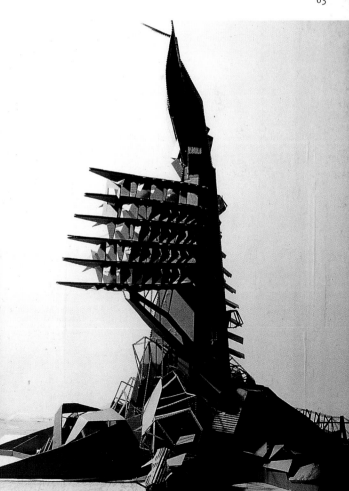

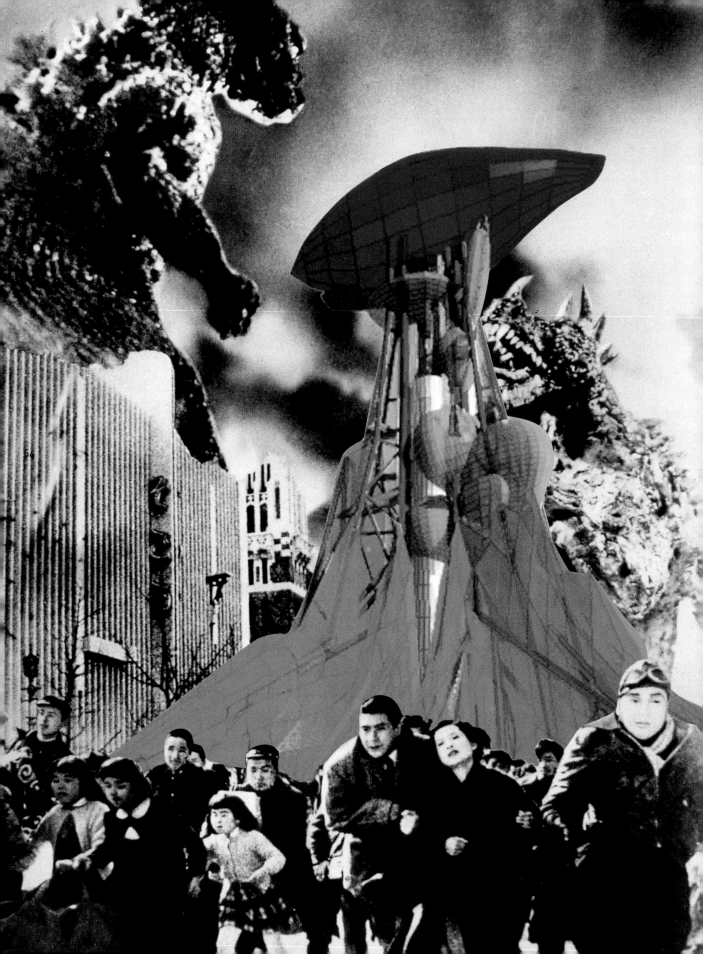

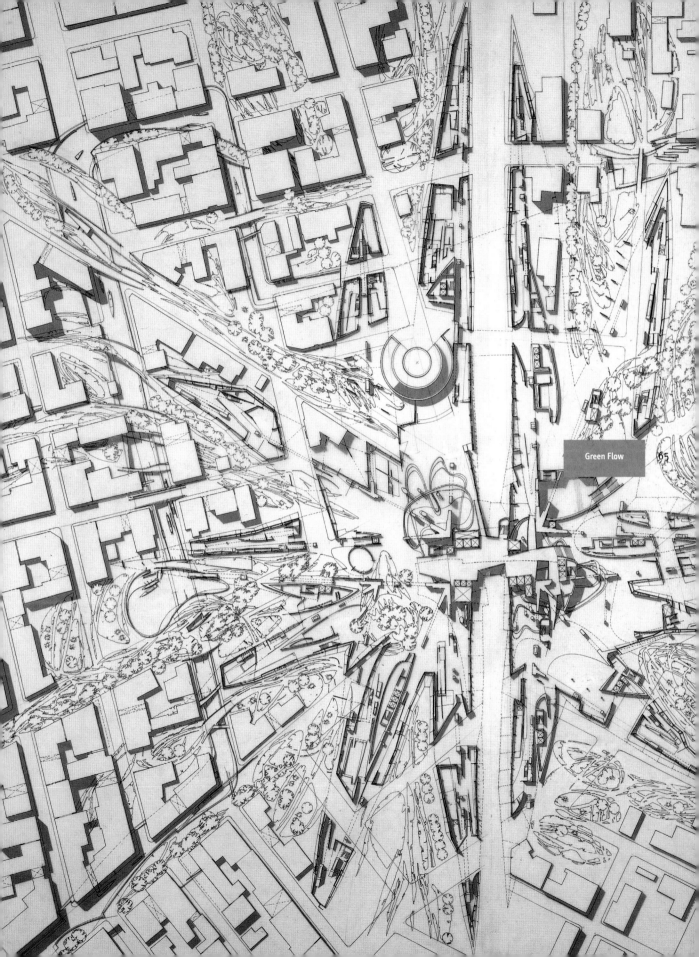

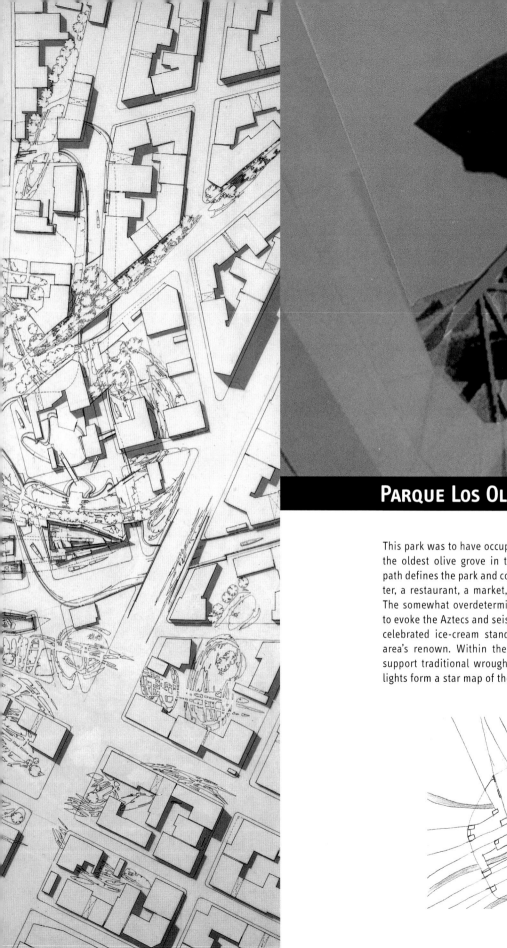

Parque Los Olivos MEXICO CITY, MEXICO

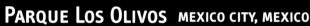

This park was to have occupied a site that holds remnants of the oldest olive grove in the Americas. A circular running path defines the park and connects its elements: a youth center, a restaurant, a market, a waterwork, and a monument. The somewhat overdetermined monumental piece is meant to evoke the Aztecs and seismic trauma, and to recall a much celebrated ice-cream stand that is the real source of the area's renown. Within the circle, precast concrete plinths support traditional wrought-iron benches and blue runway lights form a star map of the sky above.

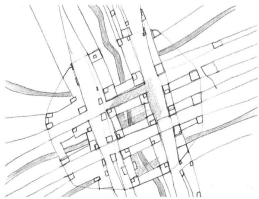

Urbanagram

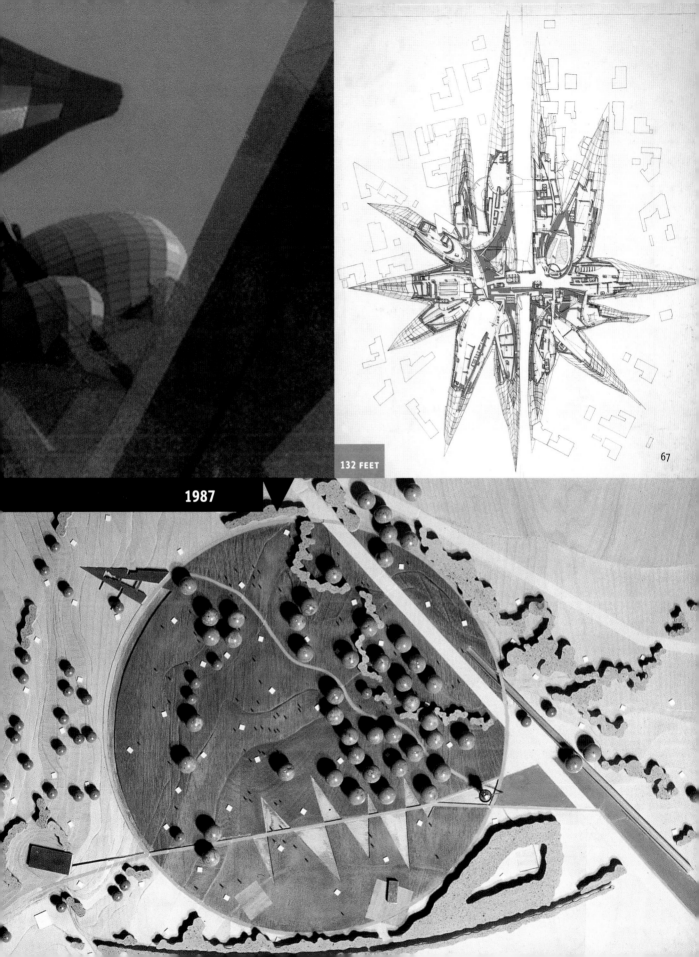

132 FEET

1987

67

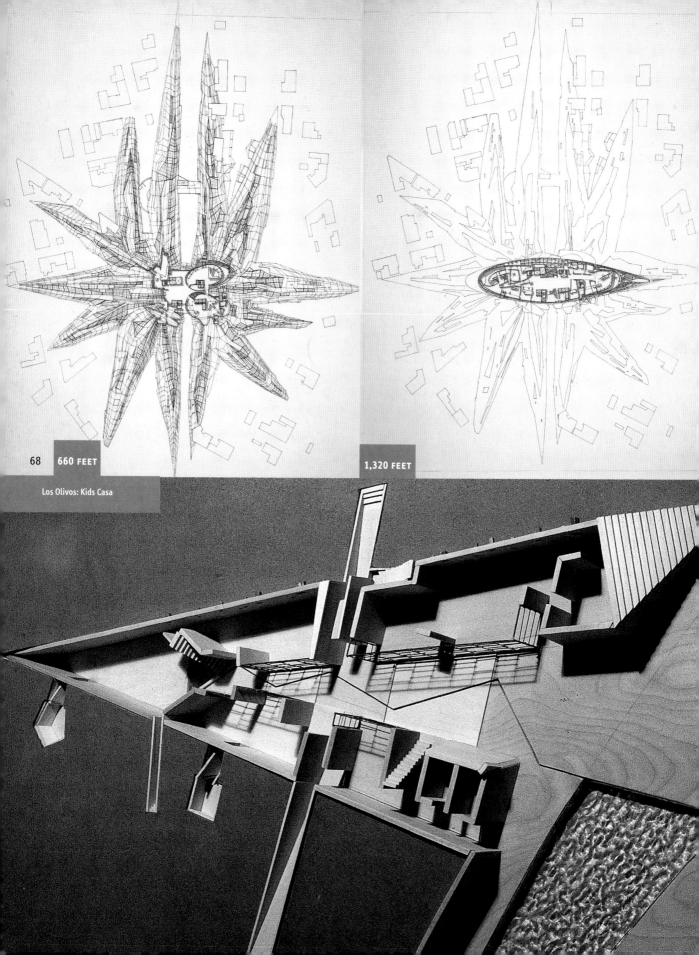

68　660 FEET

1,320 FEET

Los Olivos: Kids Casa

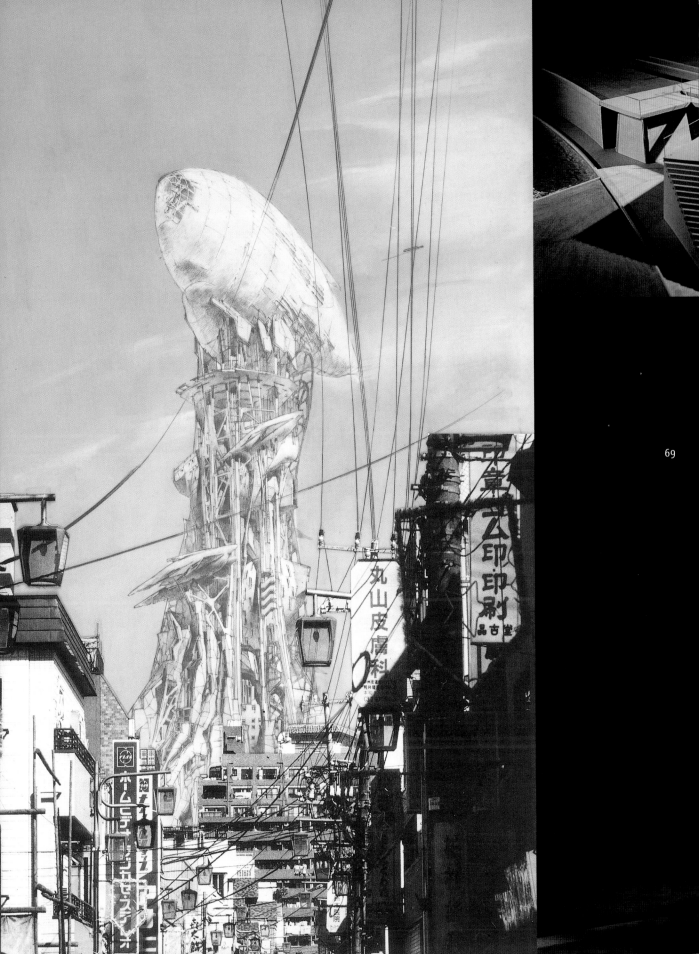

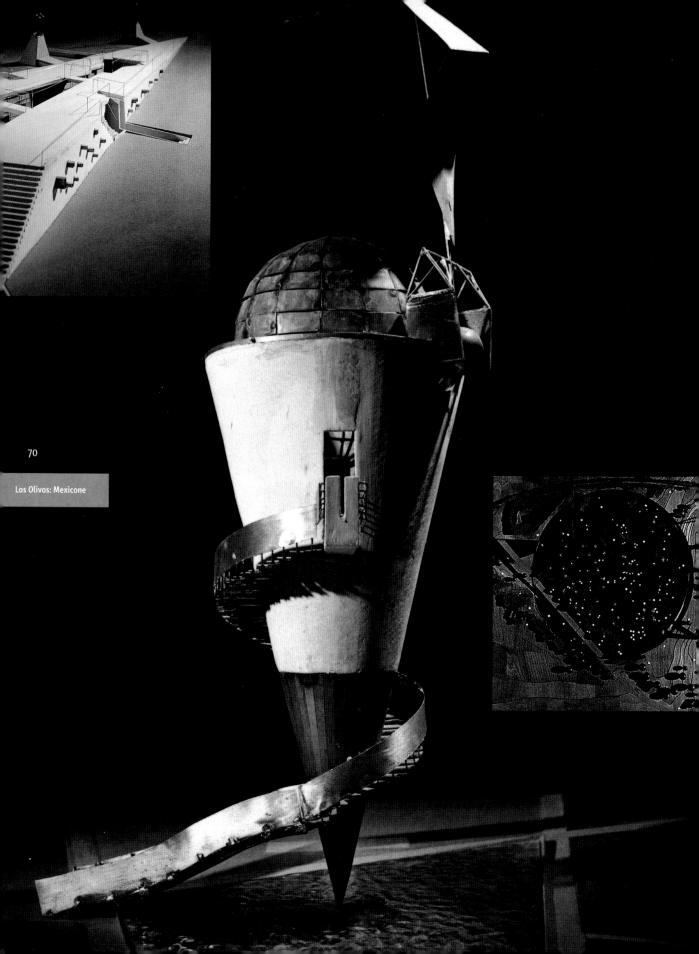

Los Olivos: Mexicone

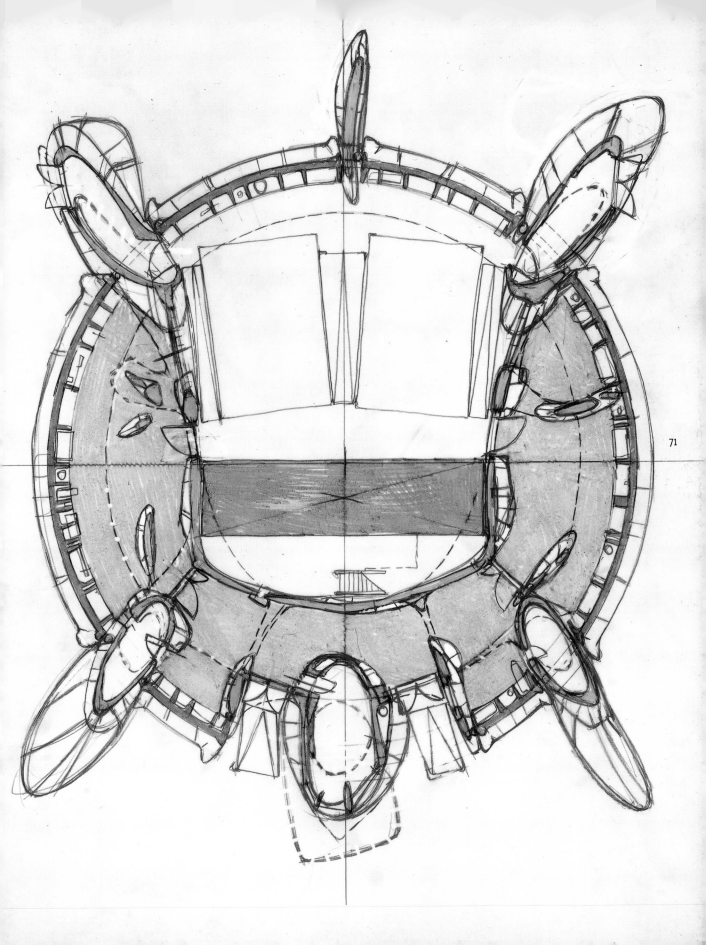

BEACHED HOUSES WHITEHOUSE, JAMAICA / ANIMAL HOUSES 1989–91

These little houses are all excursions in bilateralism, studies of symmetry and asymmetry. Fish are ideal research subjects because they are symmetrical but only until they wiggle. Our effort is to measure the space between the fish and the wiggle. This is the study of a lifetime.

Of course, the biomorphology is unmistakable and I happily own up to it: I have no qualms about mimesis; the only sources for form are imitation and accident and it seems a waste to deny either. The climate today, with its arbitrary, theatric rationalism privileges chance out of fear of social conviction and an anxiety that all representation is kitsch.

But modernity actually loved mimesis from the start. Its first copies were resolutely of things, of planes and trains and automobiles: physical technology. Later came the pared purity of the diagram, the transformation of the image from thing to "idea," yielding the minimalism that has so bored us. Recent production attempts to extend this scientistic mimesis another degree, to the realm of metaphysics. In the non-visual field, mimesis becomes procedure—a recipe— and today architecture adduces its authority tautologically, via an account of whatever steps produced its form (I took the Fibonacci series, the key of G, and the line joining my house with Brooke's and superimposed it on the ring that Heidegger's glass of Jagermeister left on the table down at Nazi headquarters, and so on).

At the end of the day, though, such appeals to authority accomplish nothing if you're not already in thrall—which is not to say that the forms can't be fascinating and serviceable, just that they're no more inherently persuasive than the snout of the family dog. Taste is always a matter of consent. I happen to think the entire visual field is ripe if it is useful. This does not mean that architecture relinquishes its capacity to read, that form and purpose are fully separable, that a history of cultural associations is meaningless. But there's a lot of slack, plenty of autonomy. Duke Ellington put it succinctly: "If it sounds good, it is good."

The Animal Houses were (like so much of our work) simply made up; the Beached Houses, the result of a somewhat flaky commission. On a piece of land next to his own house and a couple of blocks from the beach, a Manhattan art dealer proposed to build a little colony for sale at cost to his artists. We proposed three different species of loft houses, all caught in a net of palms.

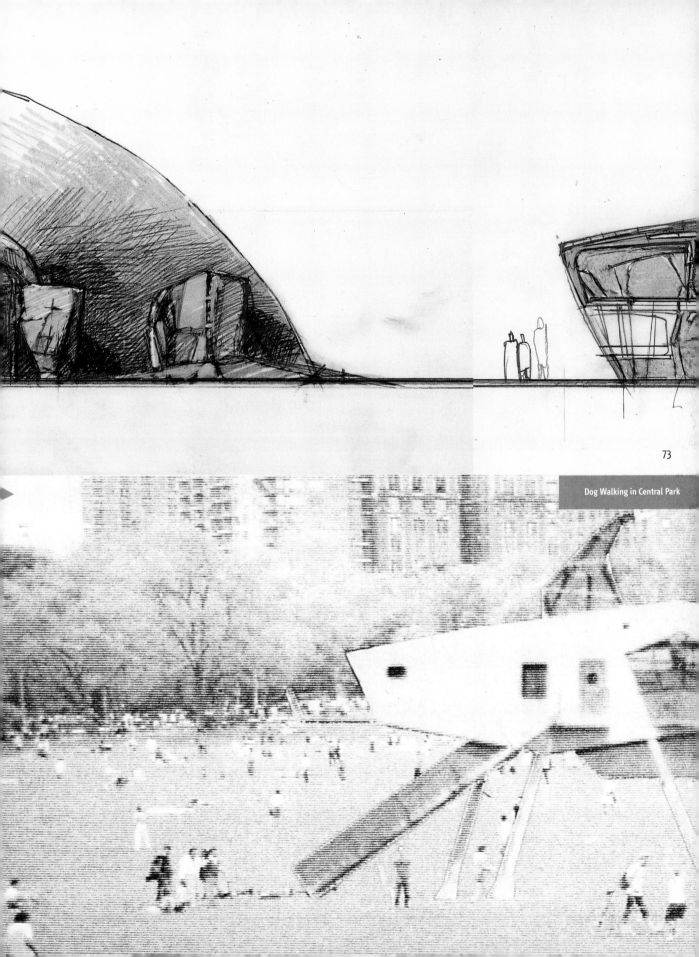

Dog Walking in Central Park

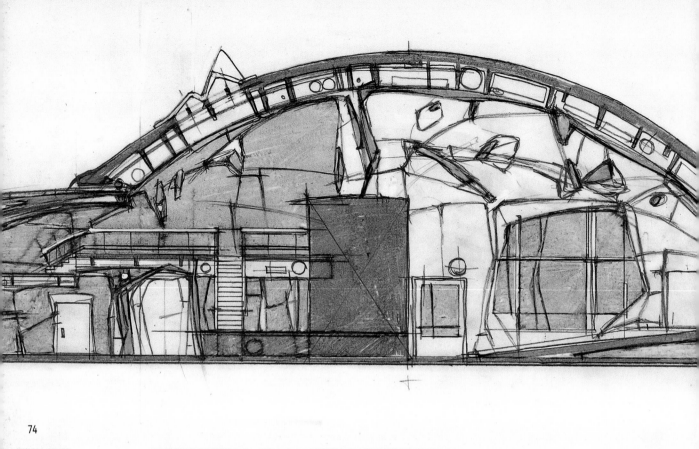

74

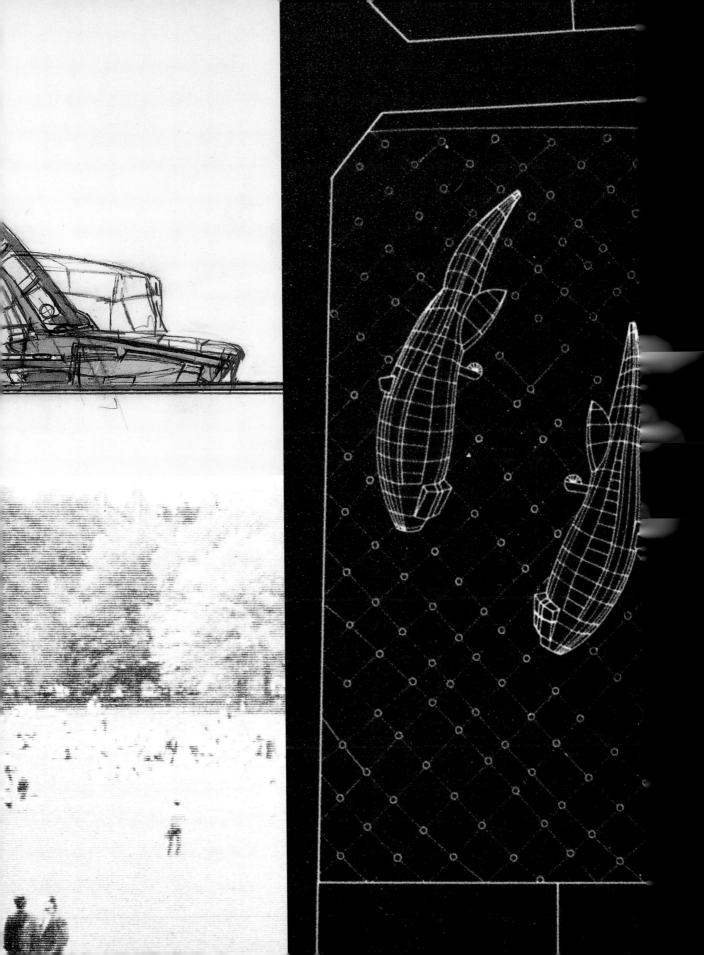

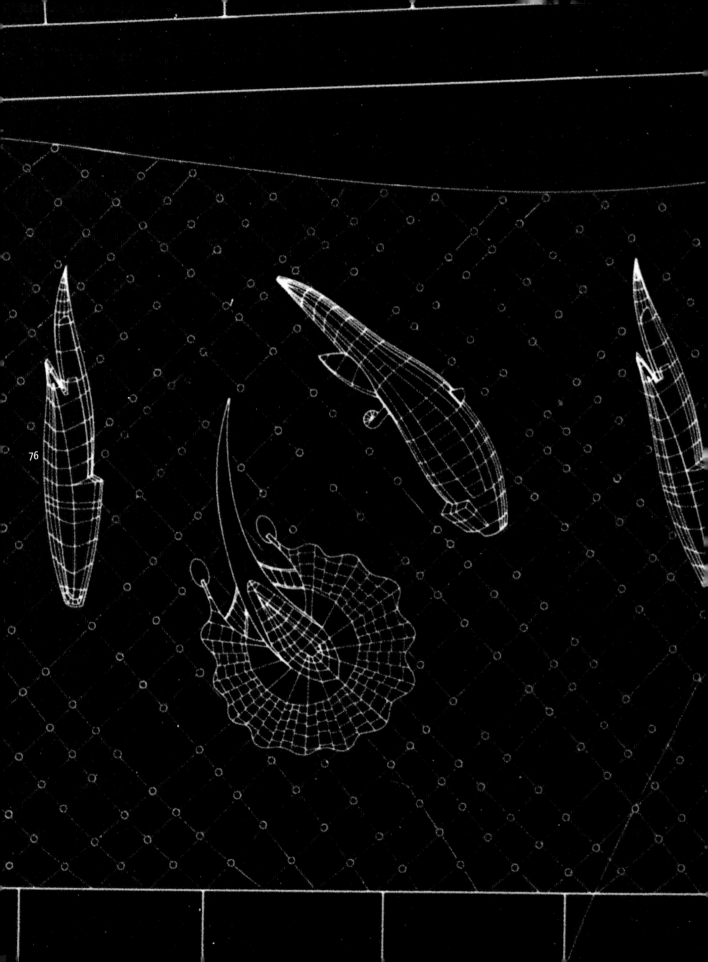

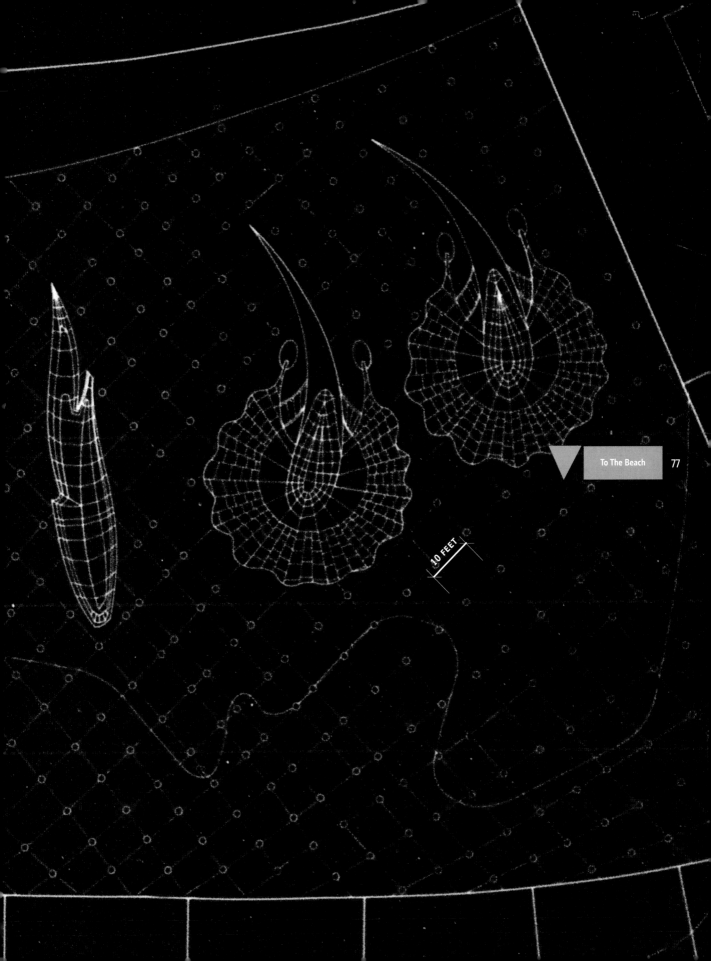

10 FEET

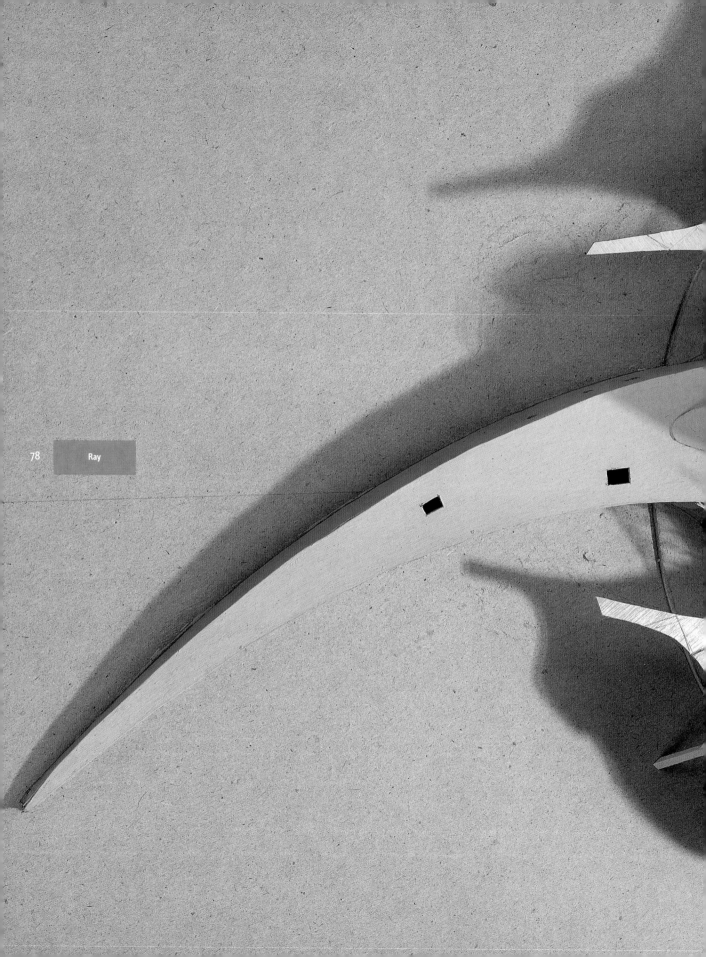

Ray

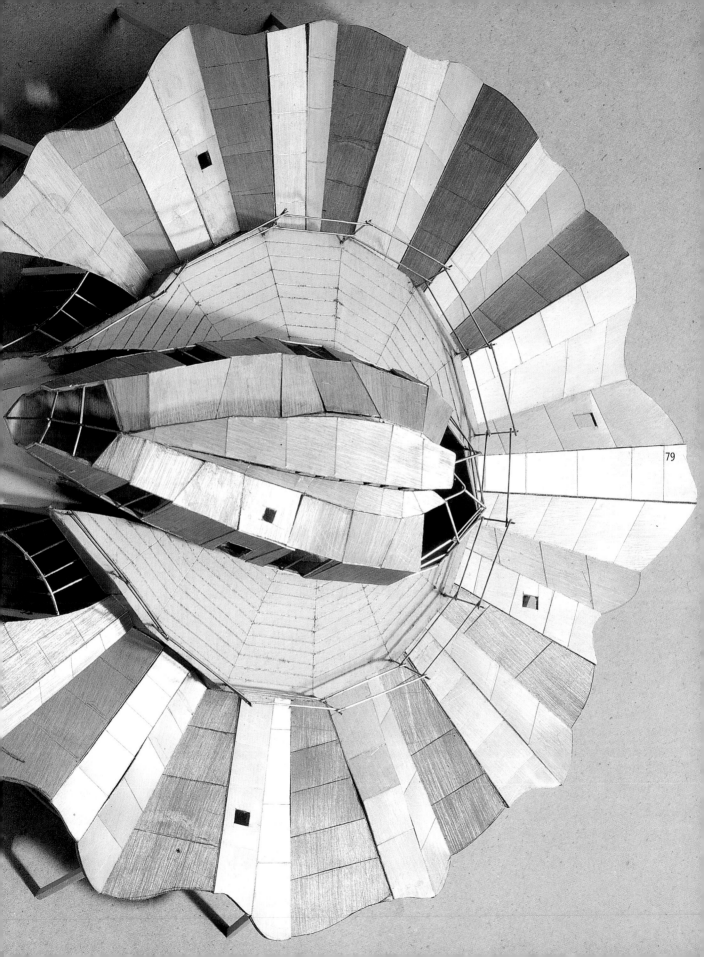

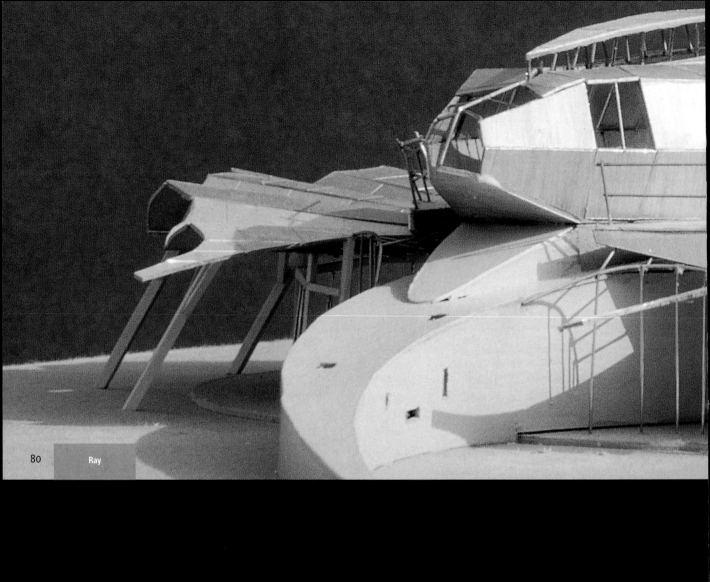

Ray

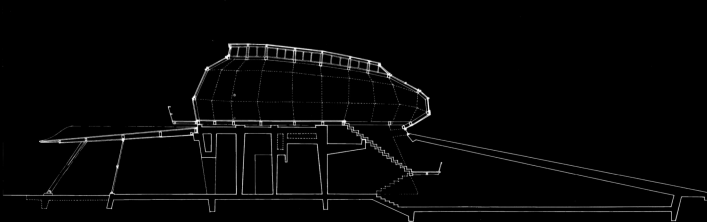

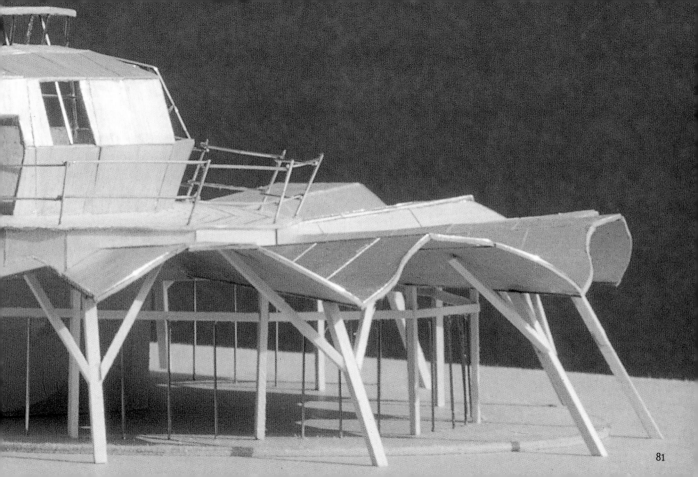

81

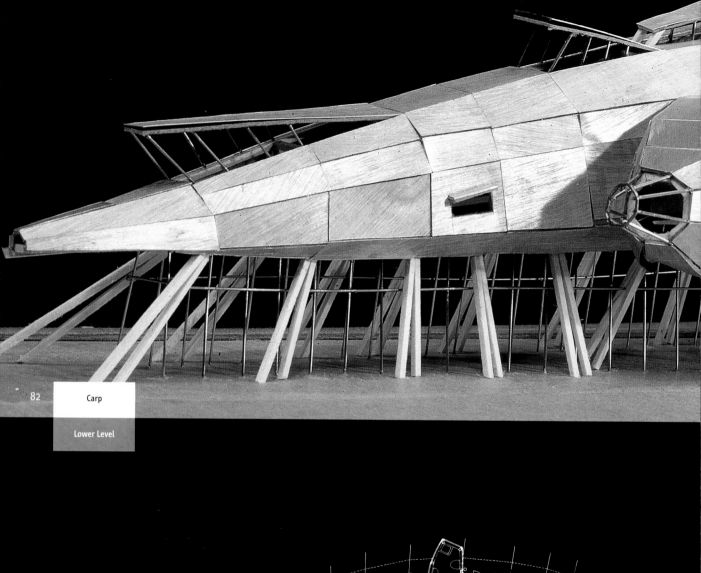

Carp

Lower Level

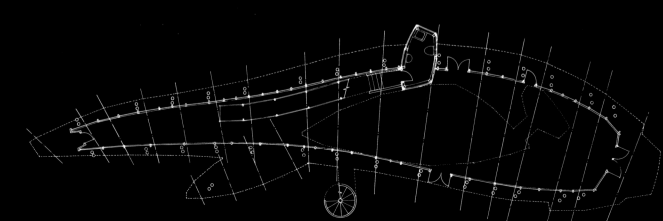

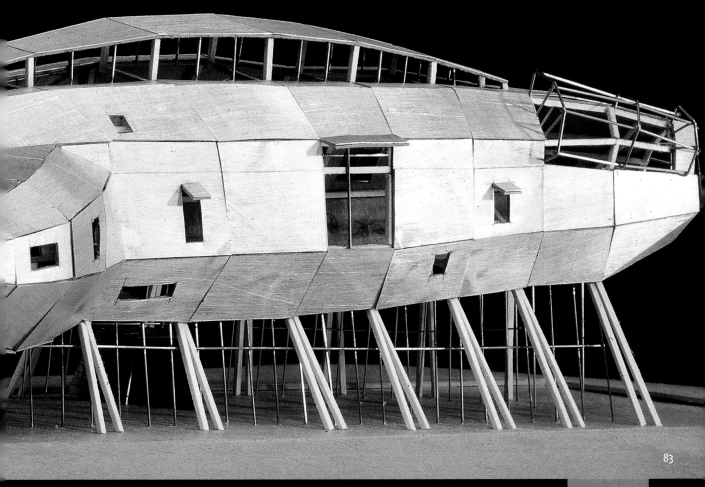

Upper Level

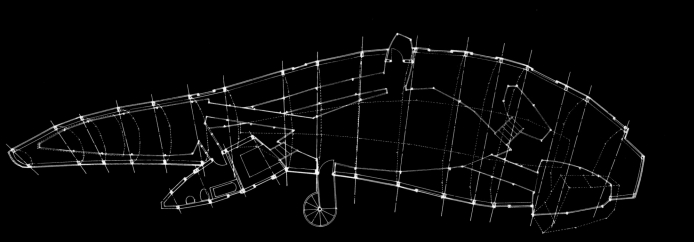

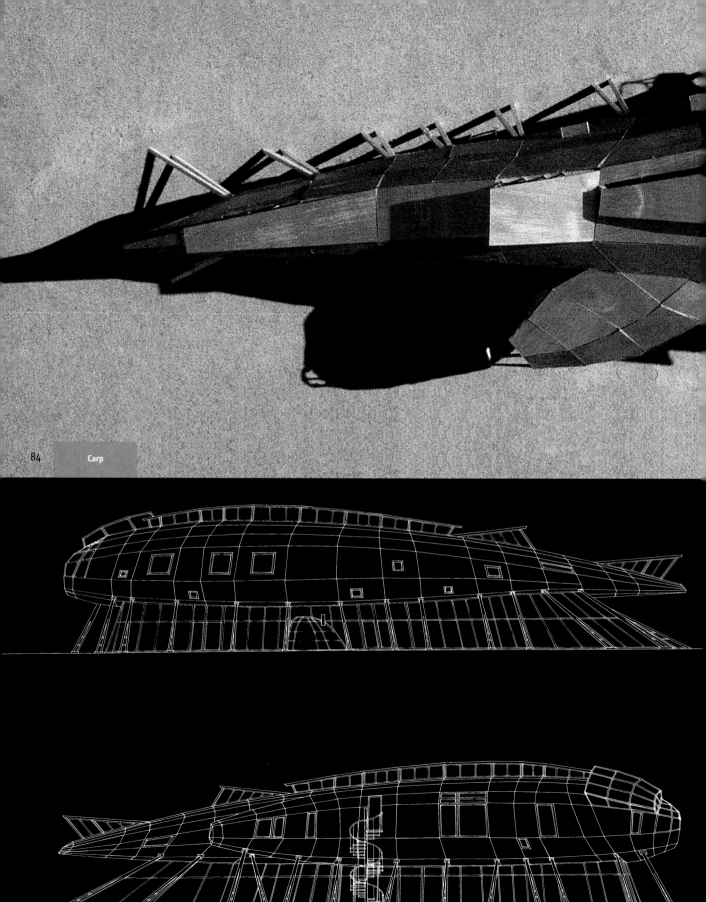

Carp

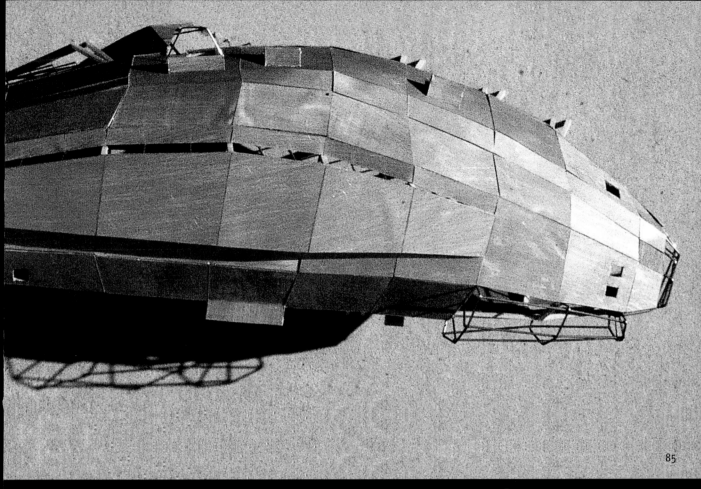

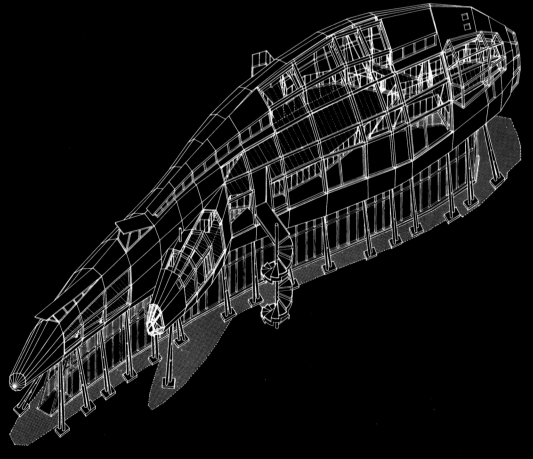

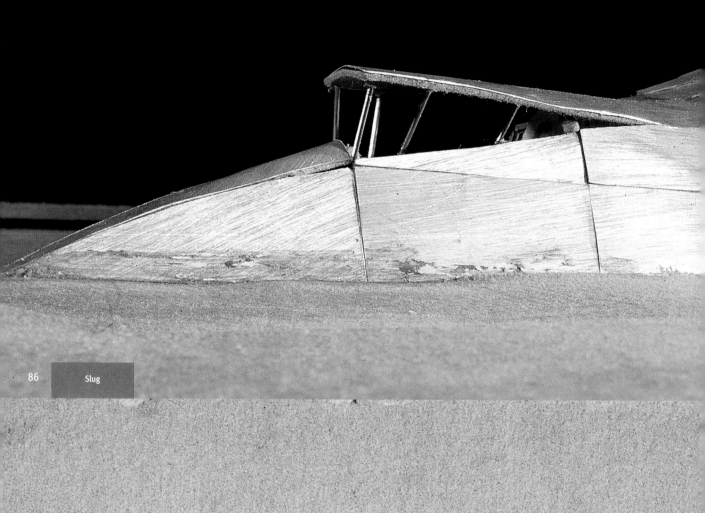

Slug

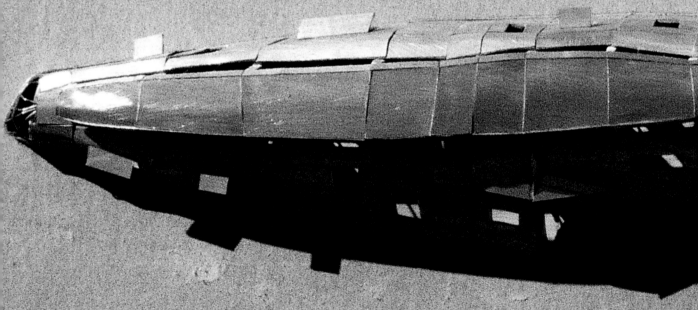

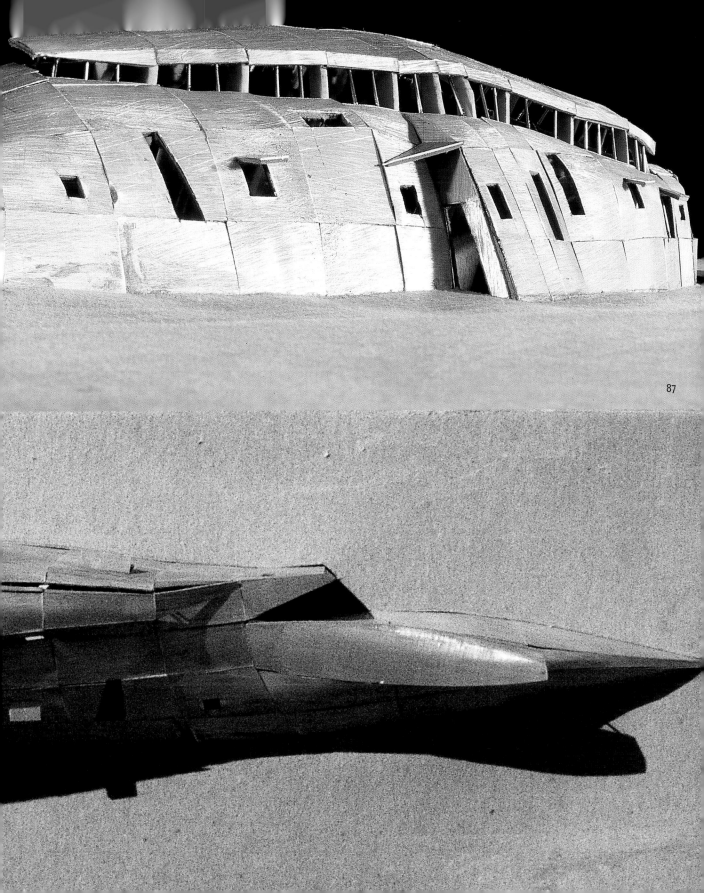

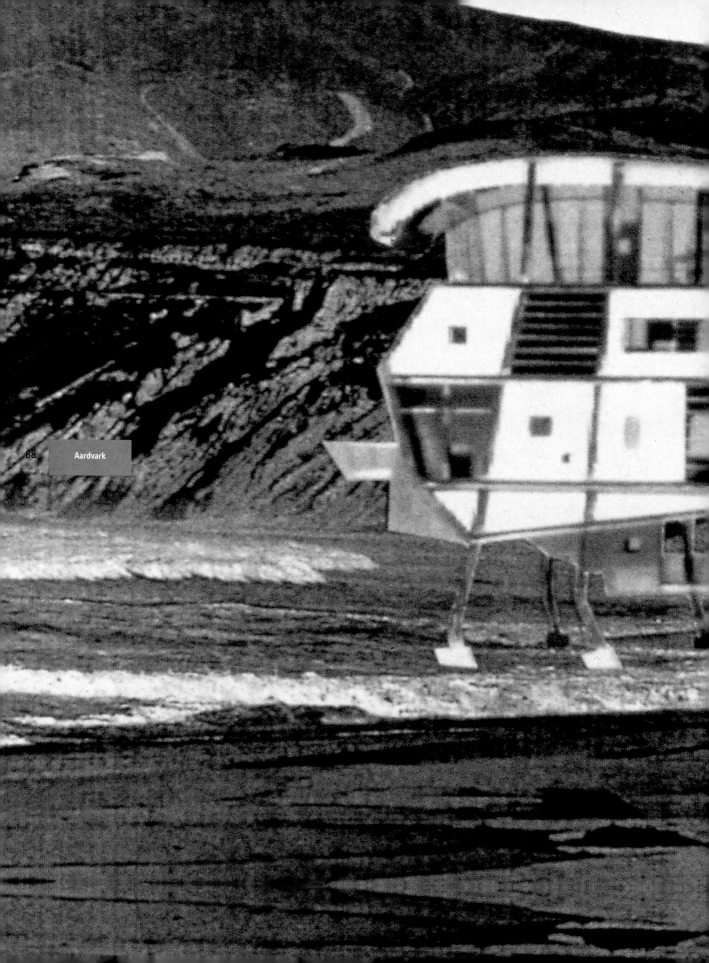

Aardvark

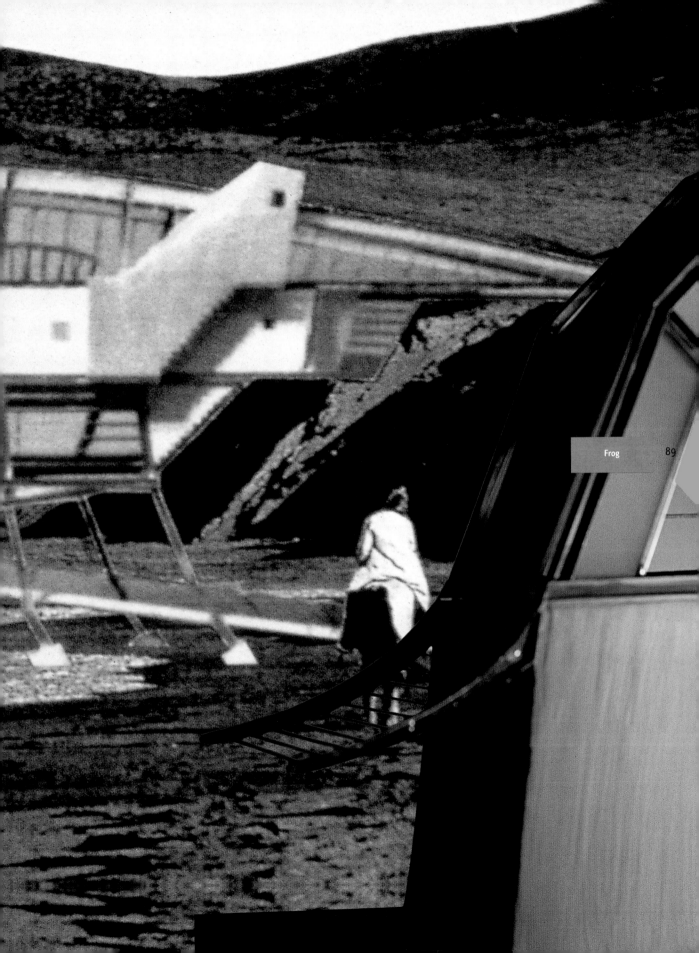

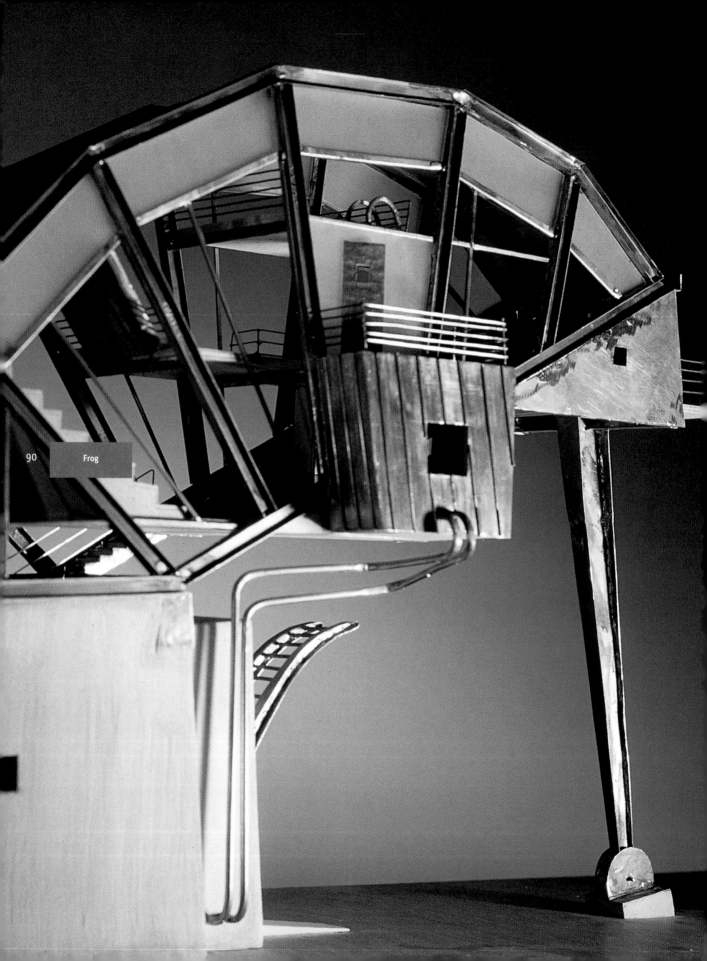

Frog

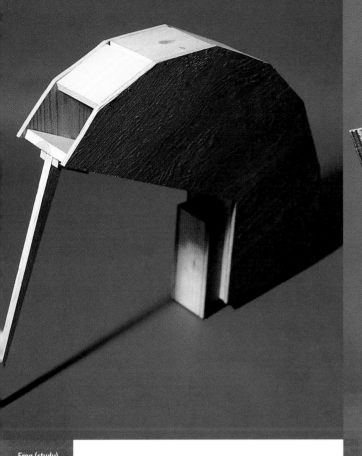

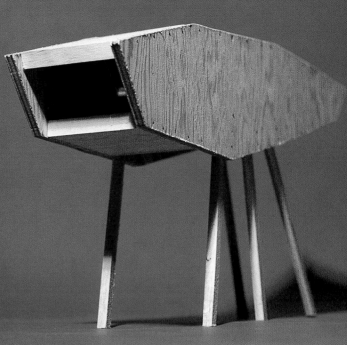

Frog (study)

Aardvark (study)

Dog (study)

Sheep (study)

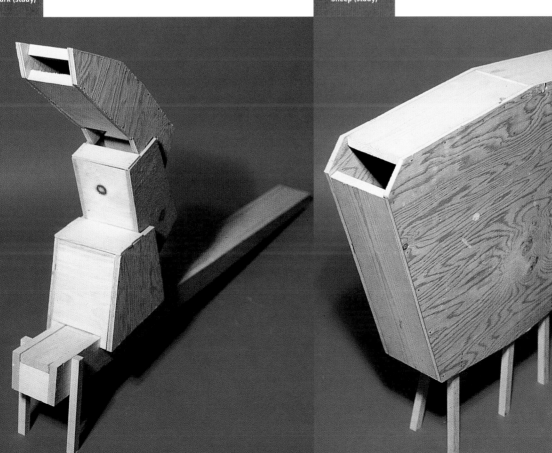

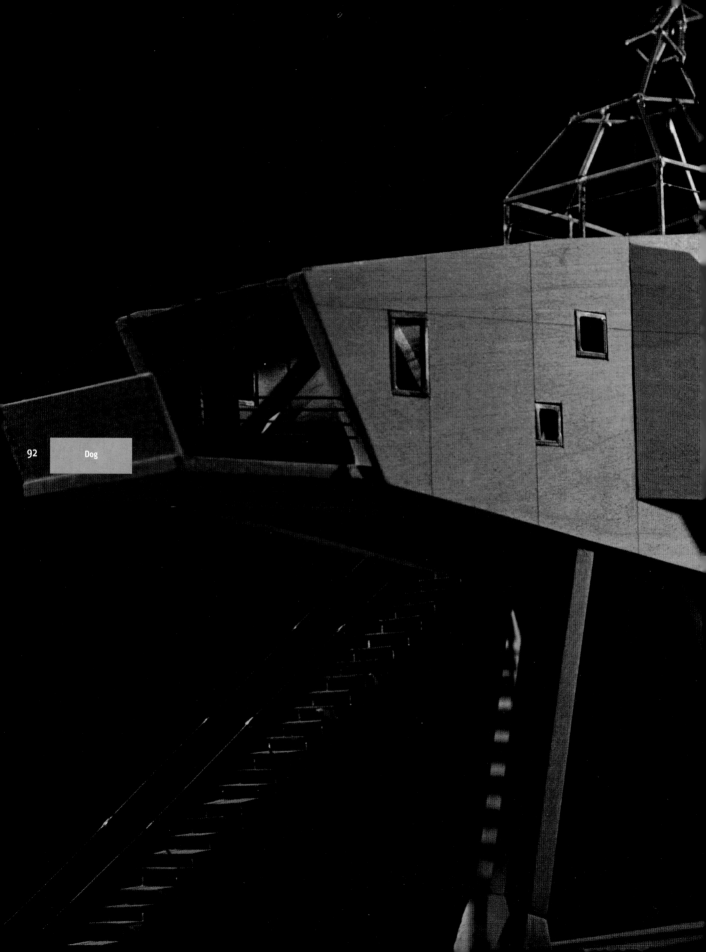

Dog

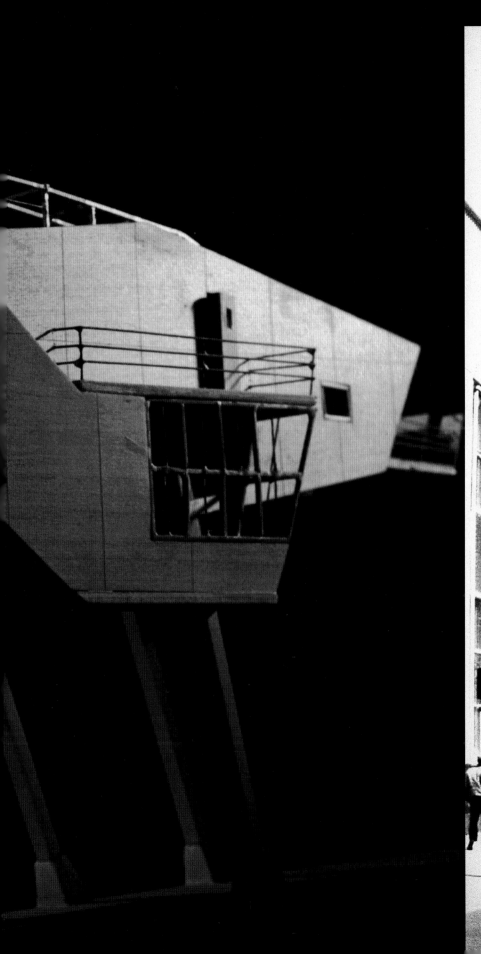

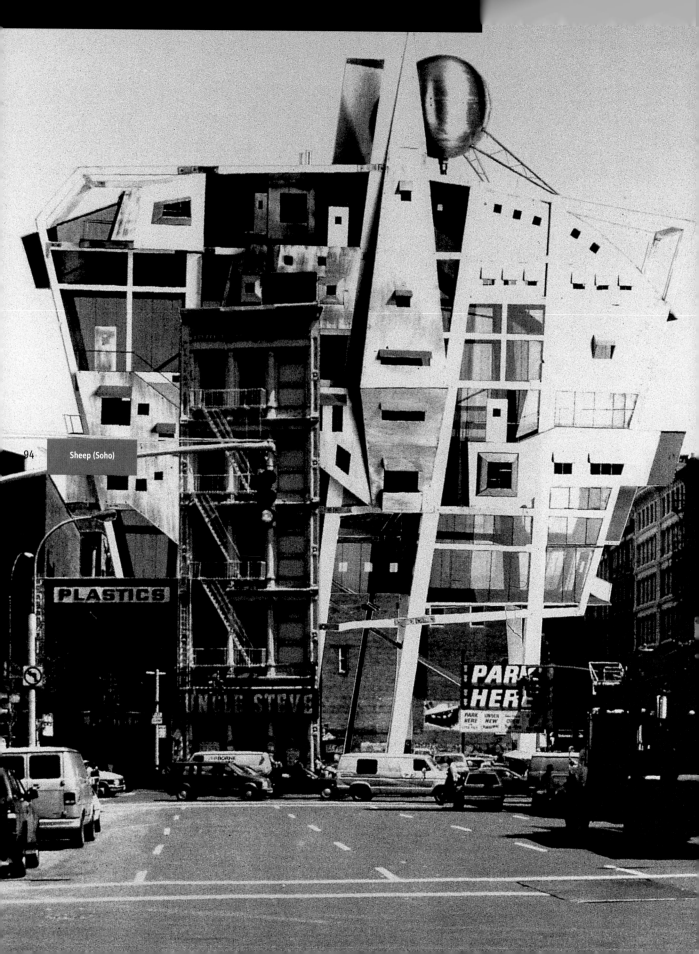

Sheep (Soho)

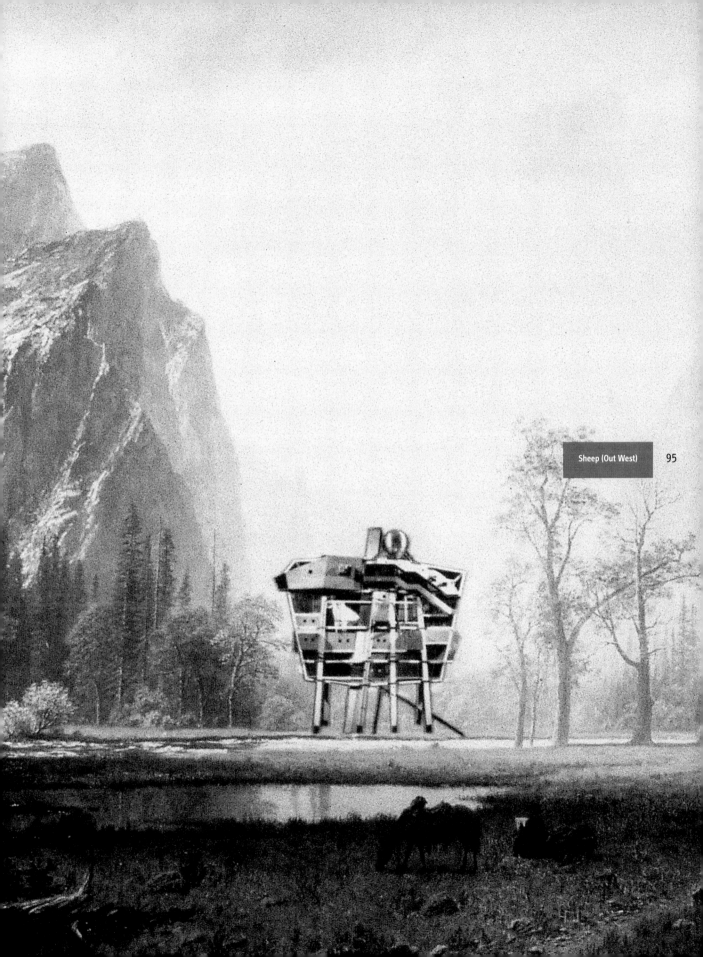

Soho and Tribeca are adjoining Manhattan neighborhoods comprised for the most part of loft buildings. Dating largely from the nineteenth century, these lofts were originally built as generic warehousing and manufacturing space. Later, as the result of economic shifts, they became redundant, having outlived their original uses. The rest of the story is familiar: discovered by artists, followed by galleries, Soho (and now Tribeca) became everybody's favorite examples of gentrification, an economic bonanza.

But the reinhabitation was problematic. While the vast high-ceilinged spaces of these lofts were great for studios, problems often arose as to their subdivisibility when the room plan ran up against the *raumplan.* Party-walled buildings usually admitting light only at front and back, they were ultimately inflexible. They did, however, have the aura of a particularly modernist fantasy of flexibility, the so-called equipotentiality of emptiness. Like Beaubourg, the dream was of infinite accommodation, of insertion rather than fit. Such perfect flexibility can run to money.

A certain shift is required. The new loft—like the old—should offer a certain amount of resistance, the kind of difficulty that is entailed by the reinhabitation of an old city by a new use, a new sensibility. The resistance I have in mind for lofts would lie in the particularity of the construction, in the idea of an architecture that formally exceeds a precise sense of its own requirements, including the requirement for flexibility. Instead of uniform open space, they would provide a wide variety of sizes and configurations, a resource susceptible to combination and recombination. These spaces would take careful cognizance of view, of solar access, of ventilation, and of neighbors' needs.

These two early specimens are located on opposite sides of Canal Street in Soho and Tribeca; both stand in spaces presently relegated to the car, a parking lot and a piece of street that might be easily removed from the automobile system.

Sheep: Plan at Grade

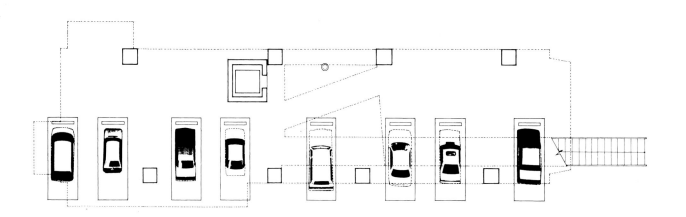

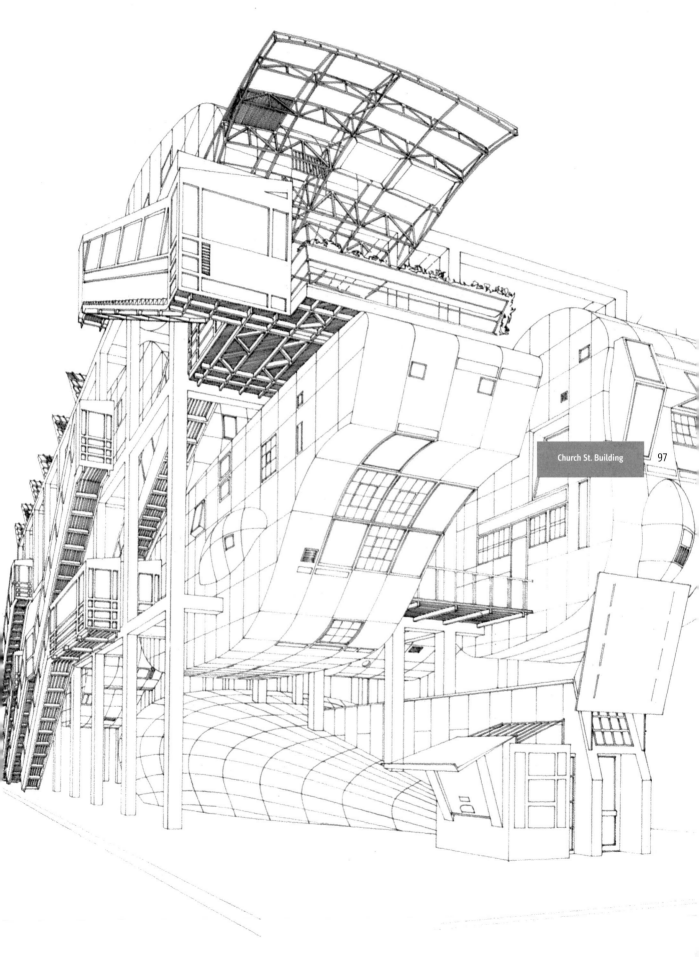

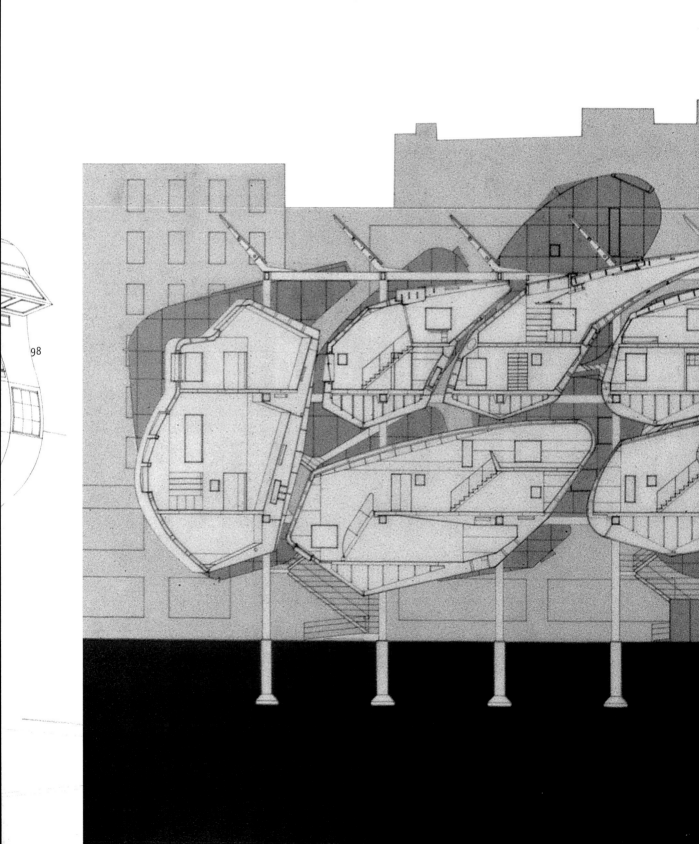

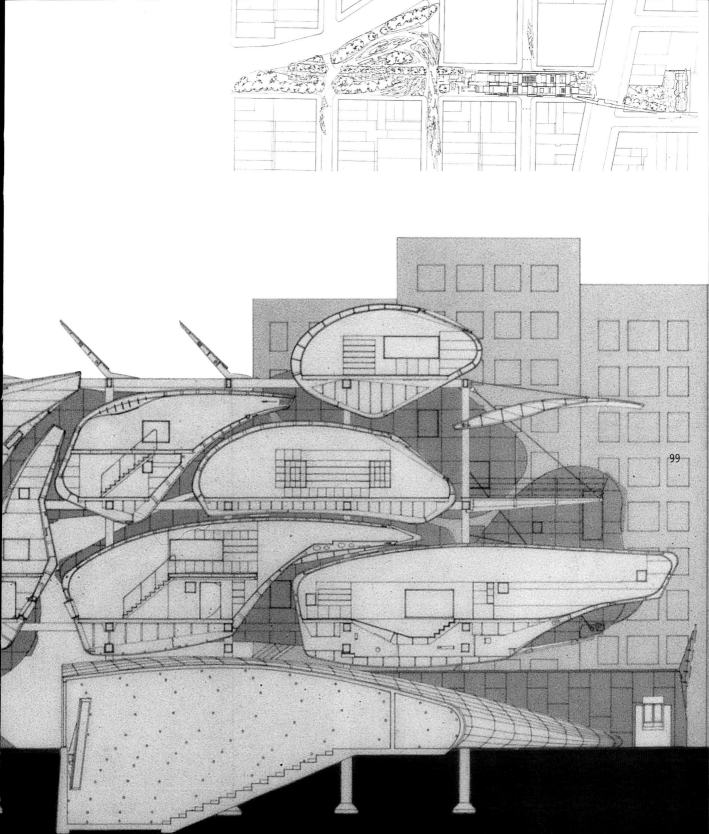

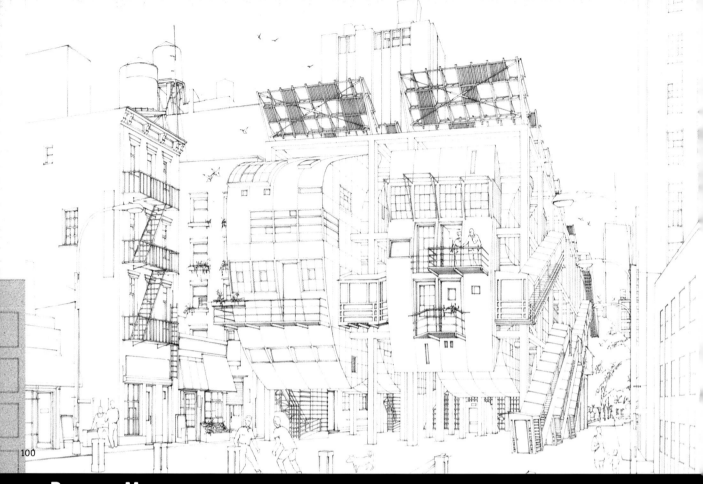

RANCHO MIRAGE NEAR PALM SPRINGS, CALIFORNIA 1988

Bracelet (1983)

Clearly a mixed metaphor. The site is in a desert town near Palm Springs and the building was to be located on Bob Hope Drive, which more or less says it all. Like most of our competition projects, this one sank without a trace.

The radial piece is for municipal offices; it is narrow-limbed to get each desk next to a window, to maximize natural ventilation, and to share shading. The anemones are skylights and windscoops and chimneys. The City Council chamber allows meetings and performances either indoors or out. The long piece is a giant drafting room for the City Engineer's Department, and the little flower at the end is a child-care center and classroom space.

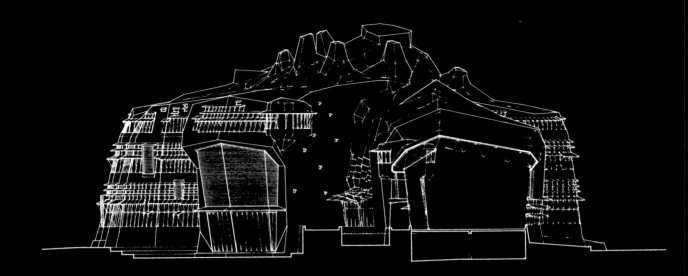

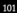

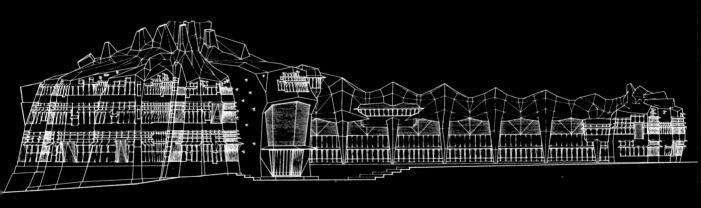

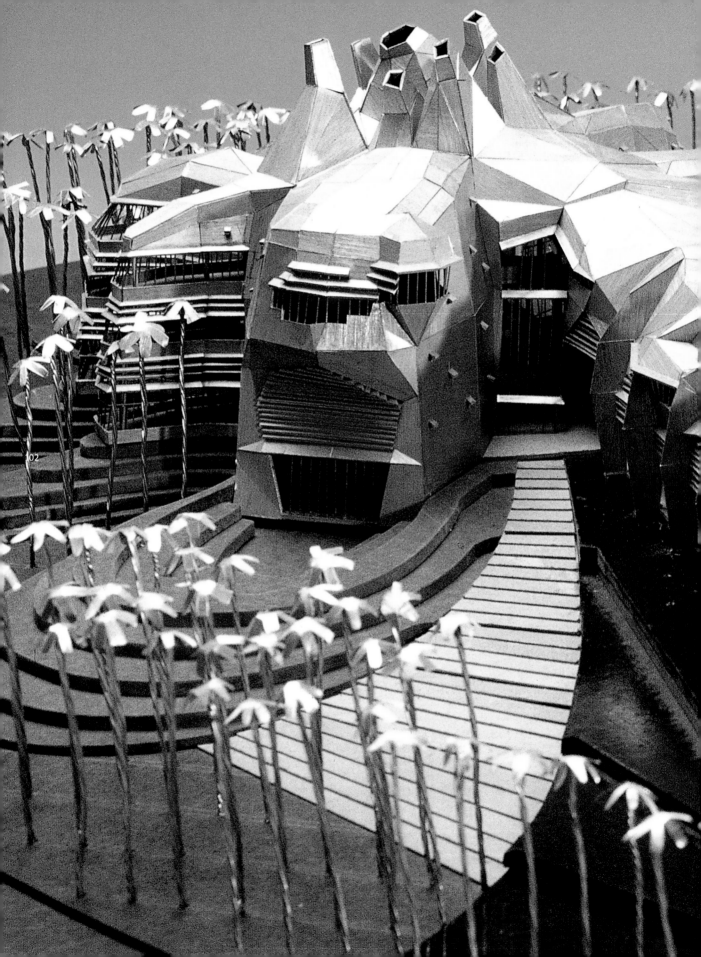

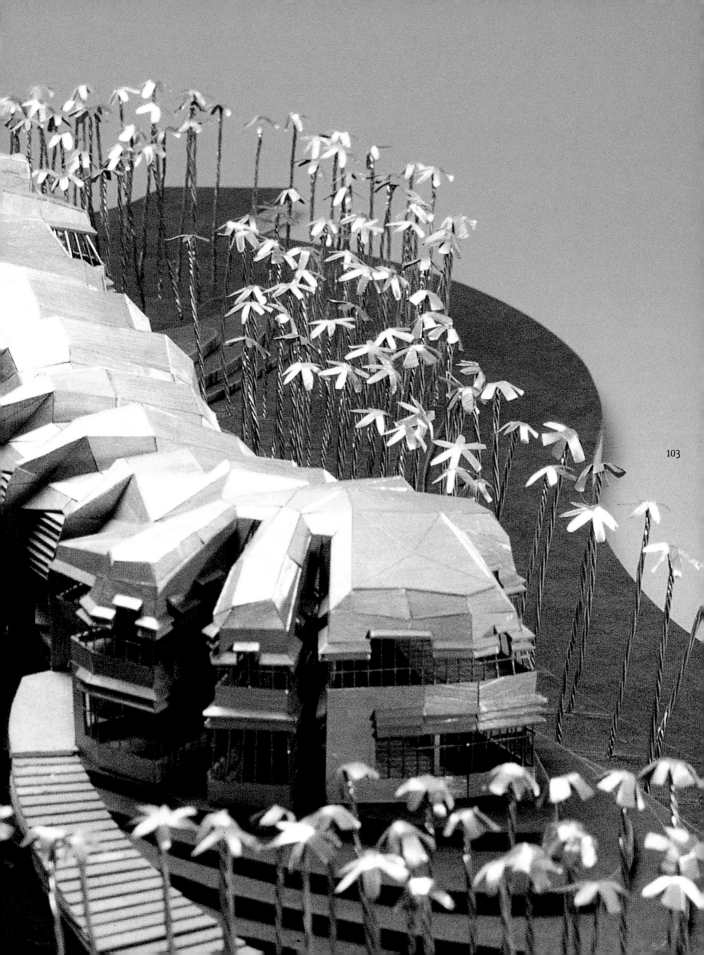

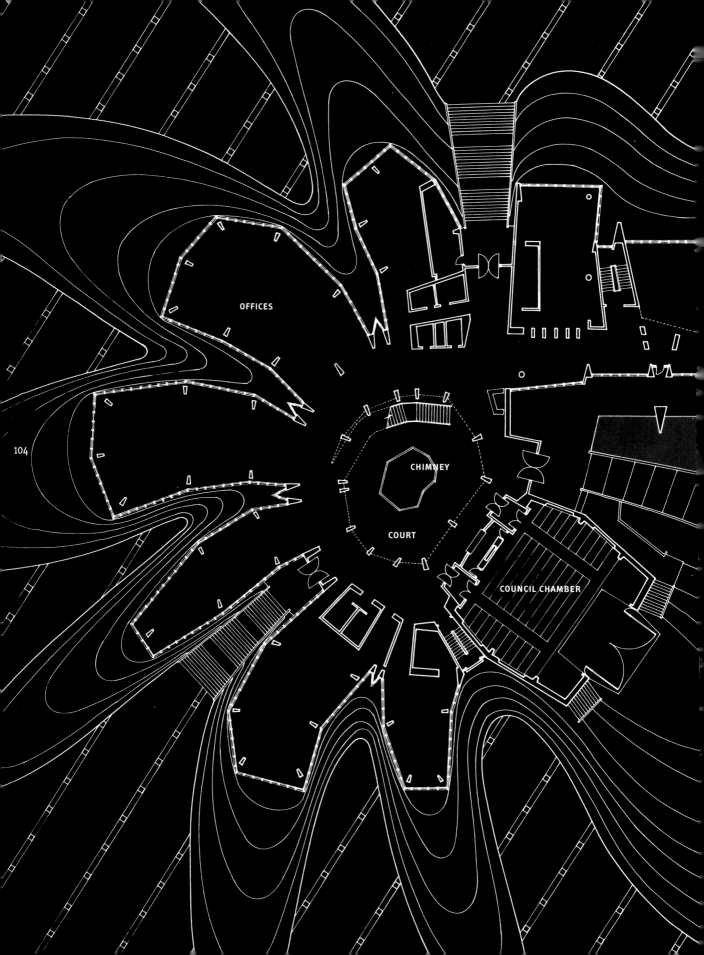

OFFICES

CHIMNEY

COURT

COUNCIL CHAMBER

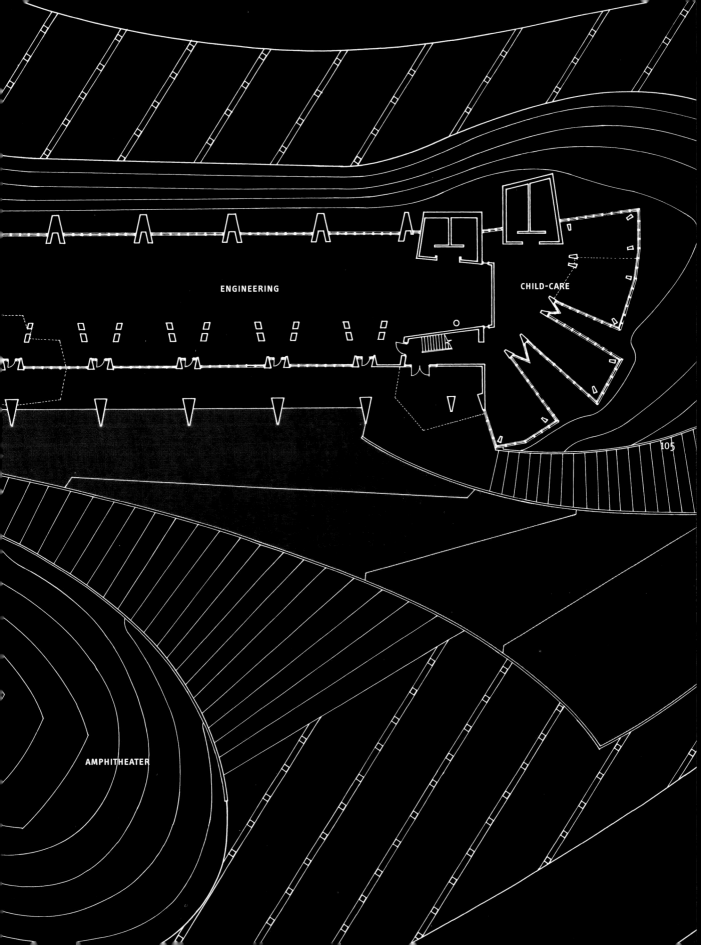

ENGINEERING

CHILD-CARE

105

AMPHITHEATER

The Spreebogen competition was for the design of a new governmental precinct near the restored Reichstag to house the return of parliament to the reunified capital. While architecture cannot guarantee democracy, it surely participates in supporting its institutions. The strategies here were to build at the scale and texture of a neighborhood rather than of a purely governmental zone, to provide an unprescribed surfeit of building in relatively compact increments, and to offer numerous gathering places of many scales and types. In particular, the small building strategy was meant to establish an intimate scale for the project and to suggest an attitude toward governance. Acknowledging that the basis for a pluralistic democracy is coalition and consensus, our proposal was that parliamentary groups find their offices via the aggregation of diverse buildings rather than through the subdivision of larger structures.

Public gathering spaces include a long arcade—the "corridor of power," which runs through the main range of parliamentary buildings—and a series of outdoor spaces that are meant frankly to evoke—though not ape—the moods of spaces we know. Here, then, a place with the big trees and paths of Lincoln's Inn Fields or Harvard Yard. Here,

the Washington Mall, a big, pretty symmetrical, fairly formal lawn. Here, surrounded by the Chancellery and Bundesrat, something dense and bosque-y. Here, a more Olmstedean park. Here, the bustle and cafés of an Italian piazza. Here, the busy station square. This collection of spaces is intended to support gatherings and demonstrations by crowds of many different sizes as well as to frustrate their ready surveillance and control.

The sense of plurality is vital to the idea of a multicultural metropolis. By this plurality, I do not mean a promiscuous, Disneyfied juxtaposition of predigested urbanisms totally wrested from their original contexts of meaning. Rather, I mean simply that the task of inventing the forms of the city is not yet dead, that the formal repertoire for city making need not simply be drawn from the inventory of the past, however much we may seek to nurture similar effects and sensations. Cities, after all, represent both compacts and inventions. The satisfying qualities of known places always form a point of departure for an urbanism of desirability.

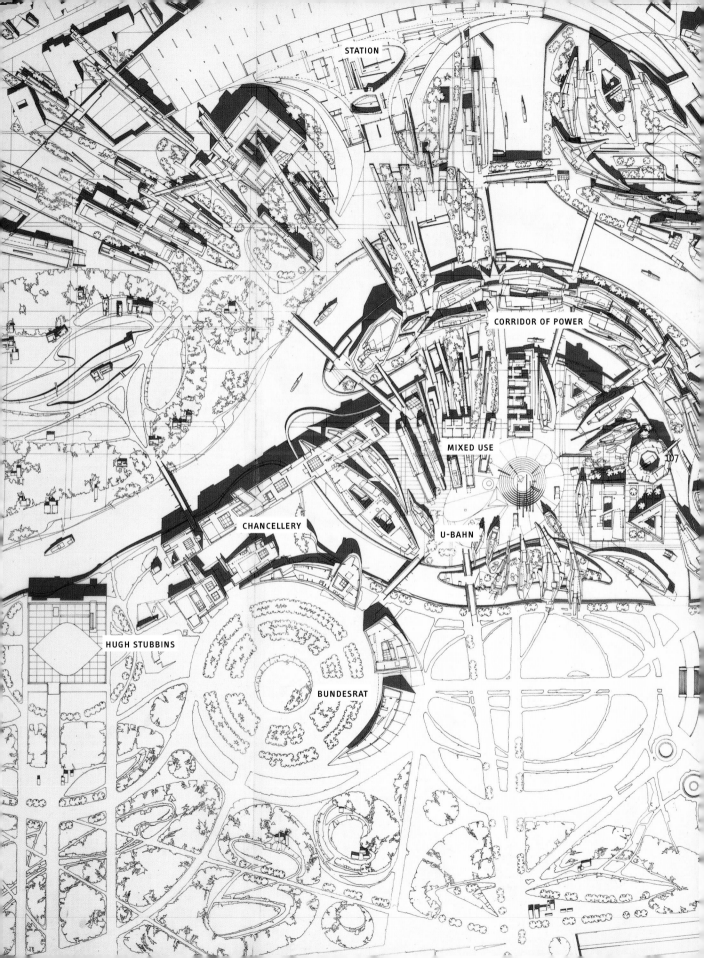

STATION

CORRIDOR OF POWER

MIXED USE

107

CHANCELLERY

U-BAHN

HUGH STUBBINS

BUNDESRAT

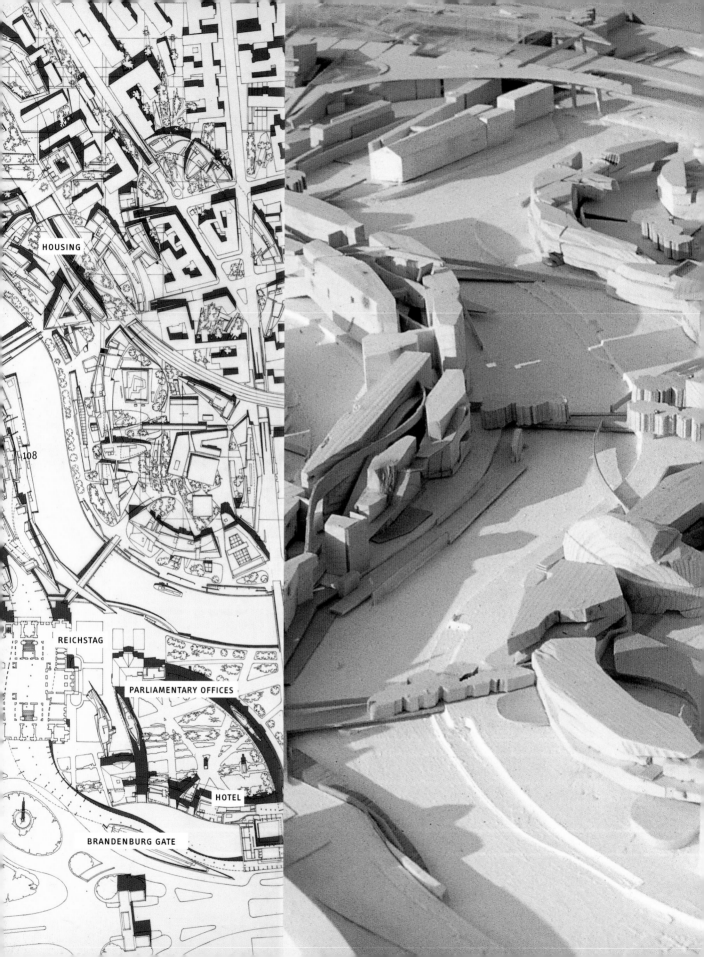

HOUSING

108

REICHSTAG

PARLIAMENTARY OFFICES

HOTEL

BRANDENBURG GATE

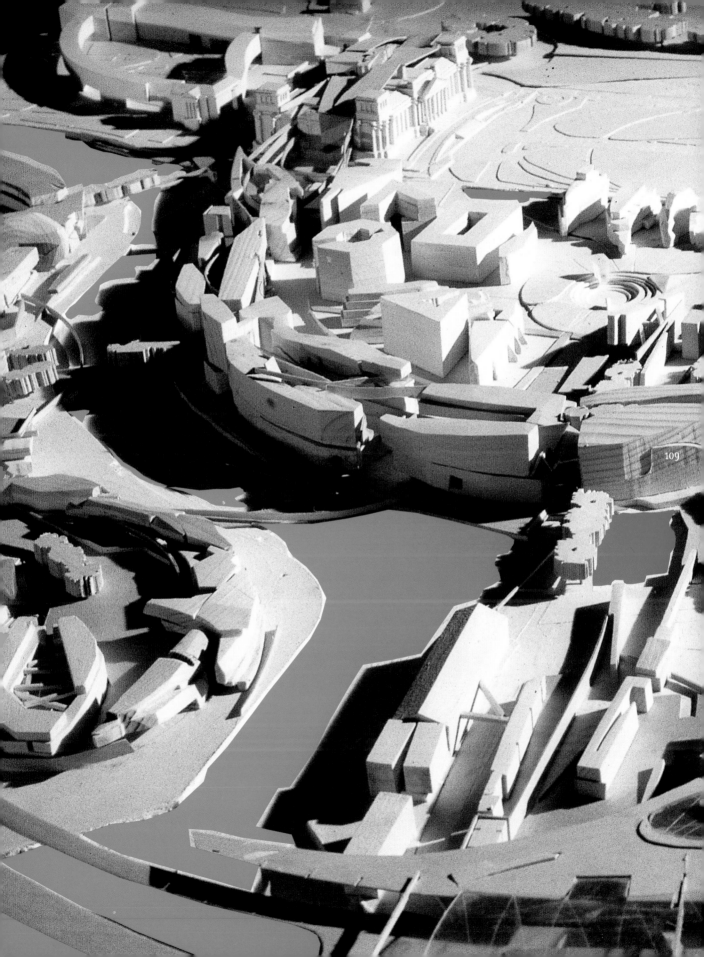

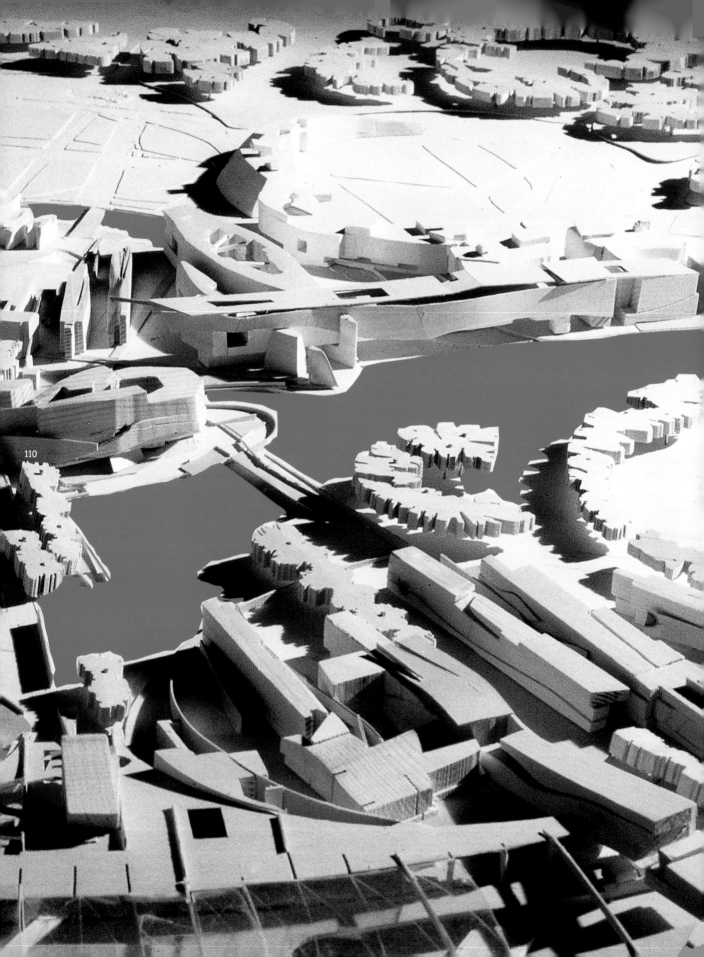

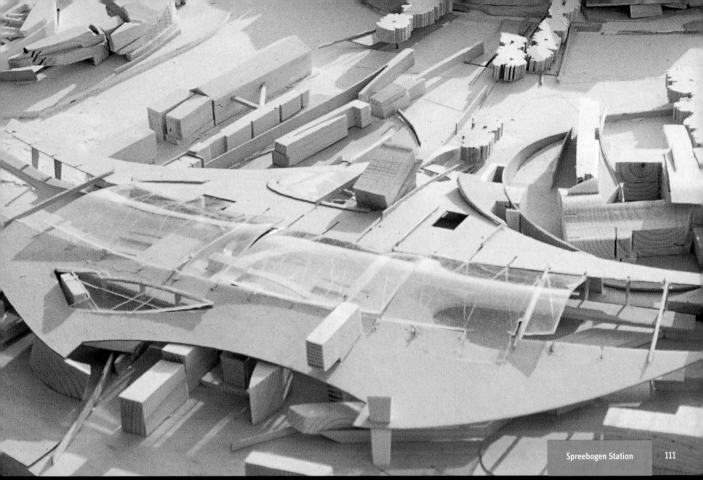

BERLIN SPREE INSEL COMPETITION 1993

This project seeks—like our Spreebogen submission—to make a mixed-use neighborhood from what might simply have been another single-use governmental precinct by adding housing and commercial activity to the program. We've made a big move—the circular figure that gloms the disparate buildings together and that was intended to accrete a range of variations. Cars are excluded from the interior of the site. And we've made the green vectors very important, tendrilizing up and down the river and organizing and pulling the vapid gardens of the Alexanderplatz westward across the site and shooting the greensward south to link up with other green spaces that it might inspire.

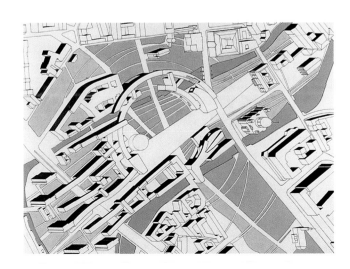

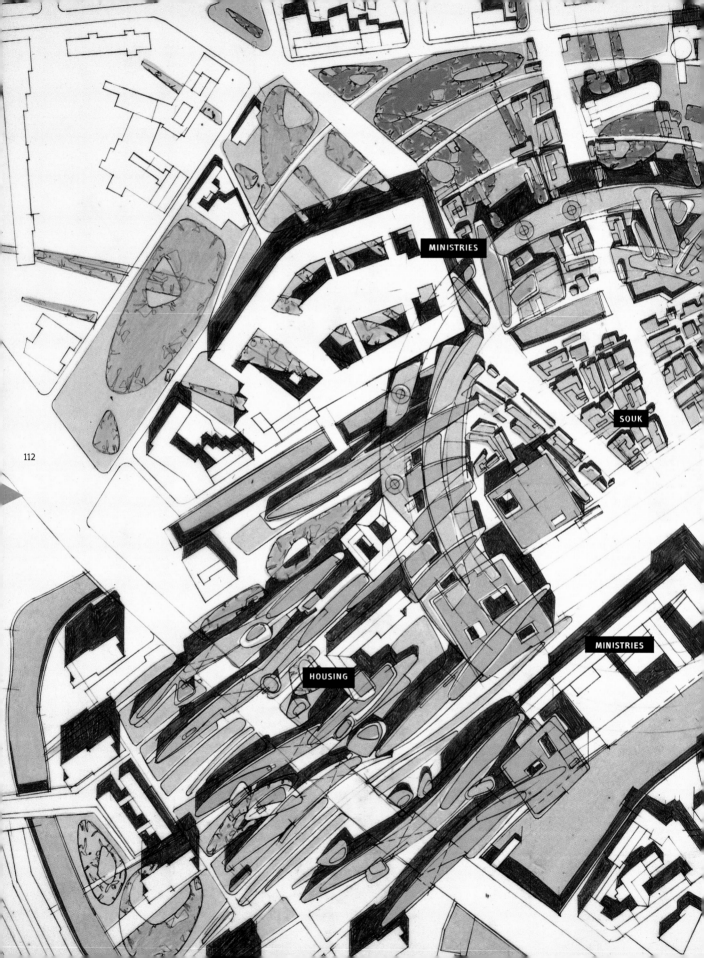

MINISTRIES

SOUK

MINISTRIES

HOUSING

112

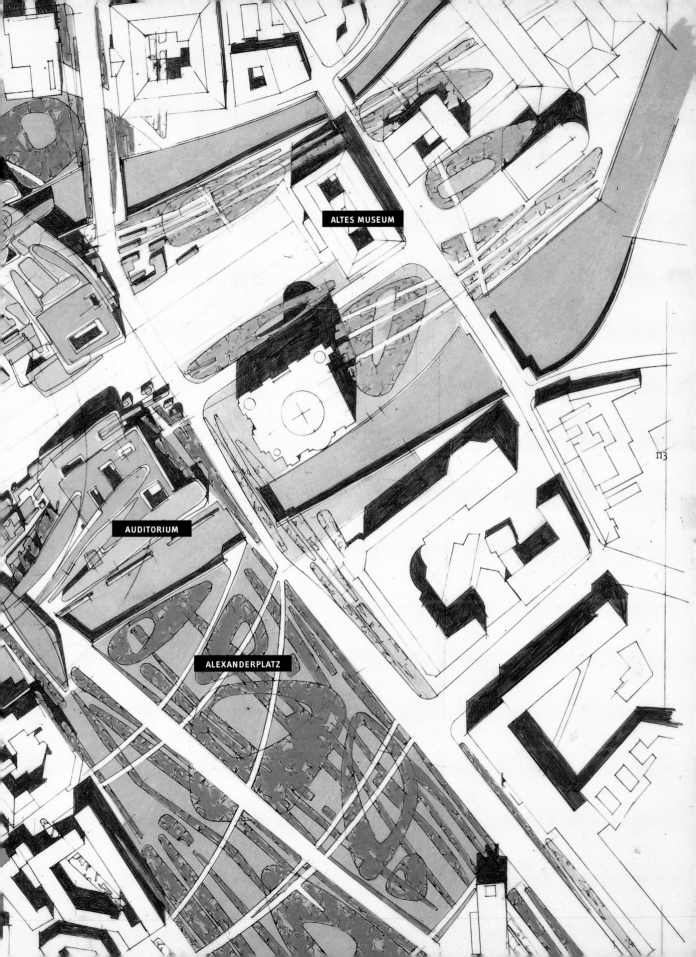

ALTES MUSEUM

AUDITORIUM

ALEXANDERPLATZ

113

An entry for a competition for rebuilding the historic central souks of Beirut, destroyed during the years of the civil war, this project sought to restore the atmosphere and commerce of the area without the literal re-creation of its vanished forms and to layer in new uses appropriate to a city on the verge of the twenty-first century. While eschewing literal historicism, the project does preserve all existing architecture on the site and formally accounts for the memory of the architecture that preceded it by acknowledging with some precision historical vectors of scale.

Although highly mixed in use, the scheme is zoned vertically. An ill-advised parking requirement is placed underground, as is a cinema complex. At grade, the proliferation of shops and souks spreads everywhere. At the second level is a mixture of offices, showrooms, and double height for some of the souks below. Above this, the project becomes residential.

Scattered around the site are a number of single-purpose buildings, including a department store, mosque, museum, hotel, and restaurant row (this area was formerly the center of Lebanese gastronomy). Flowing through the middle of the complex is a series of large, champignon-like structures that shade the main spine of the souks and cover a large produce market. The tops of these mushrooms are linked by bridges and serve as gardens for the surrounding apartments.

This green spine is meant to spread its branches throughout the city. Where once the so-called green line was the emblem and medium of the division of Beirut, the new, propagating, greenway is intended to help stitch the city back together, to extend the pedestrianized area of the souks throughout town, and to suggest a model of dense, mixed, and green development for the burgeoning reconstruction now underway.

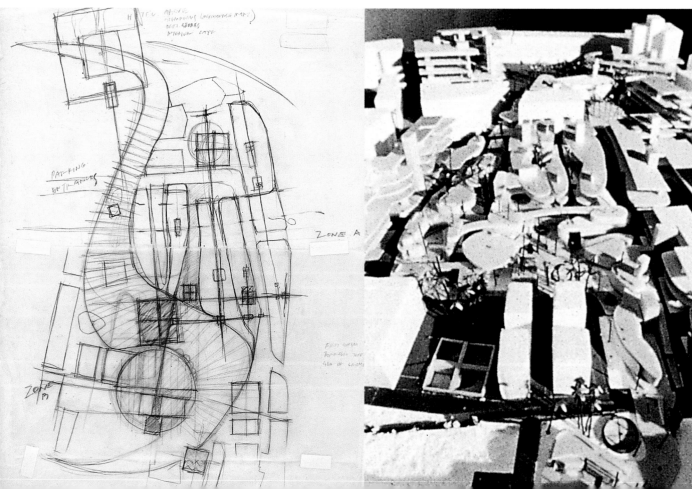

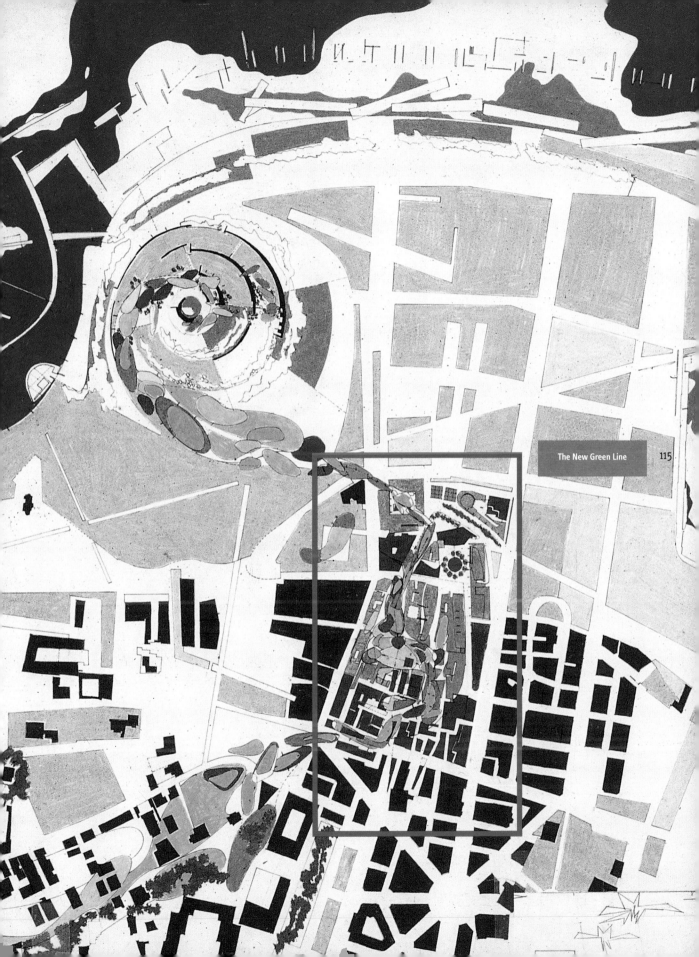

DEPARTMENT STORE

RESTAURANT COMPLEX

MAJIDEYA MOSQUE

PUBLIC FACILITY

MUSEUM

LIBRARY

EXHIBITION HALL

SHOPS

SHOPS

SHOPS

116 Level 0

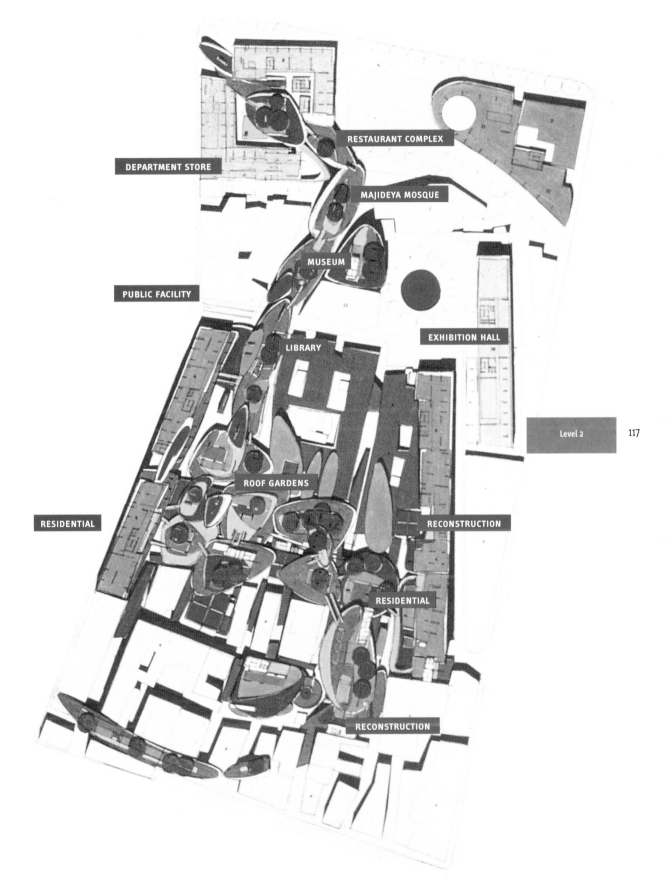

RESTAURANT COMPLEX

DEPARTMENT STORE

MAJIDEYA MOSQUE

MUSEUM

PUBLIC FACILITY

EXHIBITION HALL

LIBRARY

ROOF GARDENS

RESIDENTIAL

RECONSTRUCTION

RESIDENTIAL

RECONSTRUCTION

Level 2

117

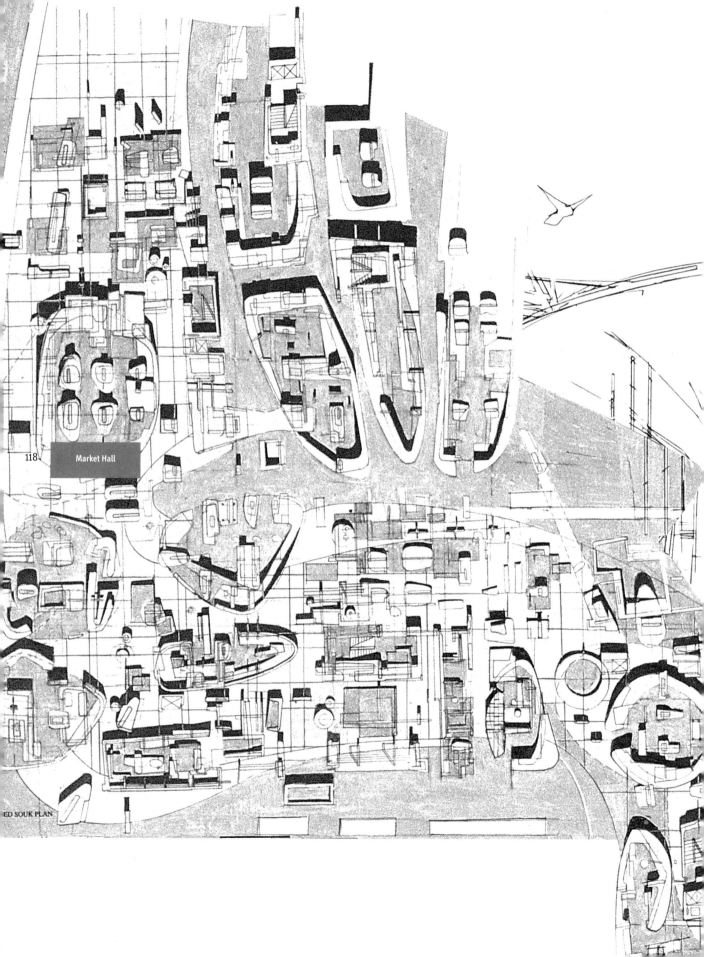

Market Hall

ED SOUK PLAN

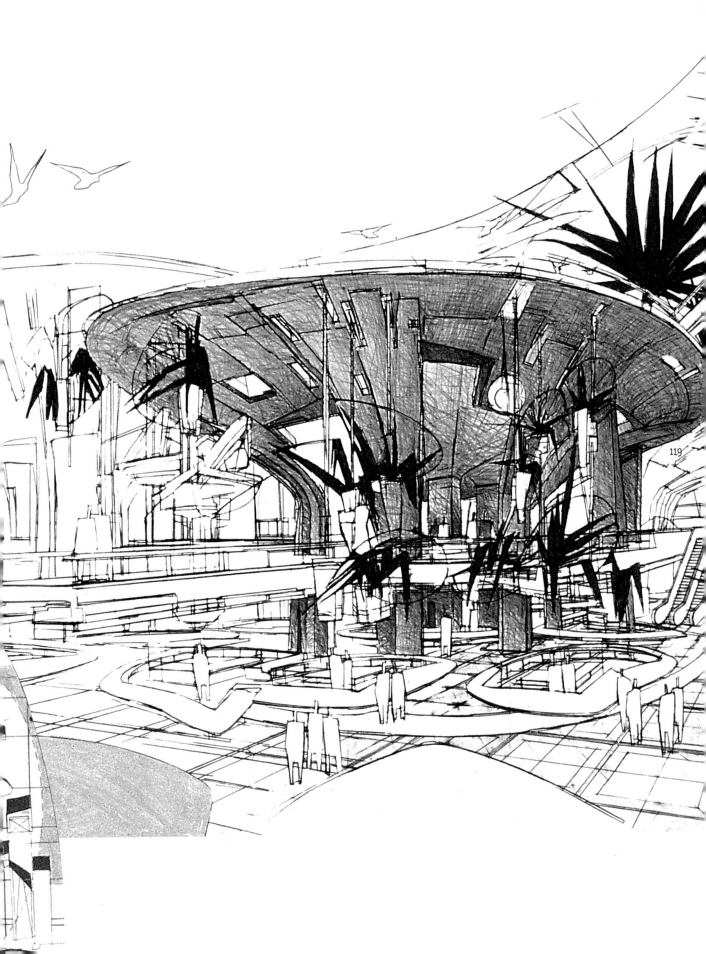

119

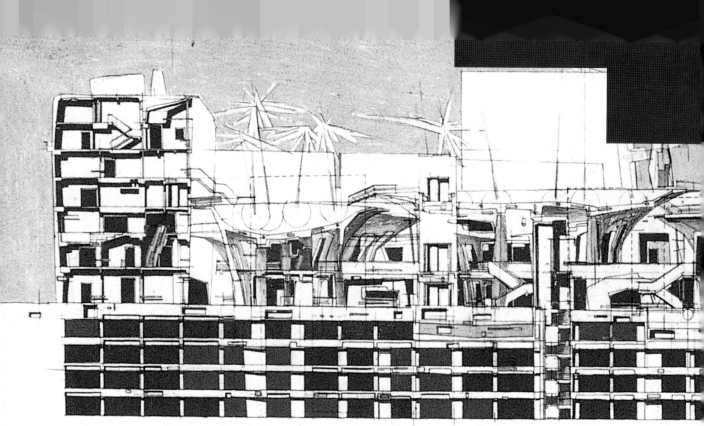

TRANSVERSE SECTION 1:500

SHROOMS EAST NEW YORK

The Shrooms are—if only formally—an obvious outgrowth of the souks of Beirut. Like the Beirut market pavilions, they're mushroom-shaped structures with strong roots and stems, sheltering a variety of smaller elements under a collective green roof. Shrooms advances the argument by adding pods of loft space and an interior "green room," a space reserved for collective use.

The genesis of Shrooms is in the idea of an "all-sided" loft building in a particular New York neighborhood—East New York—characterized by extensive abandonment and vacant land, much of it city-owned. Looking at the empty lots not as blight but as a community resource, we hoped that a growing garland of Shrooms might help in both greening and rebuilding the neighborhood. In addition, we thought of the loft type as crucial protopublic space—not a space with a fixed or predetermined set of uses but a kind of resource out of which innumerable private possibilities might be drawn. This is important: we too much think of public and private as an absolute division rather than as a mutually reinforcing gradient. Rejecting the modernist notion of public space as disembodied and universal, Shrooms is an investigation of the reciprocities of public and private rather than an essay in their disjunction.

As an urban proposition, Shrooms seeks to establish a new pattern of movement through the neighborhood, a greenway that operates not as a replacement for the street grid but as a supplement to it. Flowing through the middle of the large blocks, it occupies the spaces of abandonment as they are found. These public greenways lead to the green rooms at the core of each structure, form blossoms that act as distributors for the loft spaces that surround them and that provide appropriable areas for various collective and semi-private uses. The system of green and publicly aggrandizable spaces emerges on the roofs of the Shrooms as a linked system of gardens, a vertical displacement of the ground plane, a return to collective use.

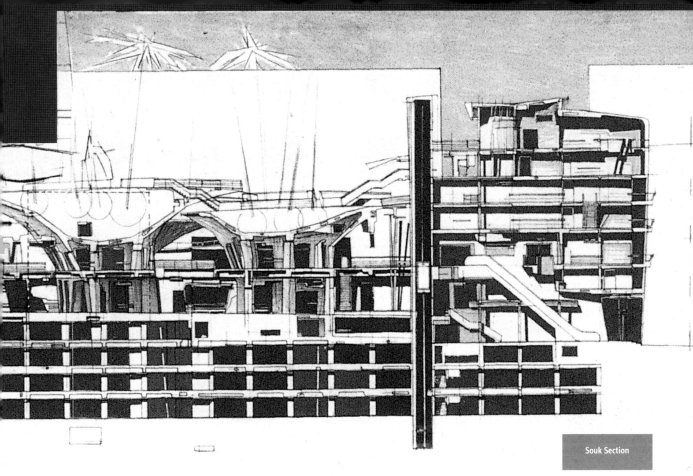

Souk Section

MICHAEL SORKIN STUDIO
145 HUDSON STREET
NEW YORK CITY 10013
212 431 9120 FAX 343 0561

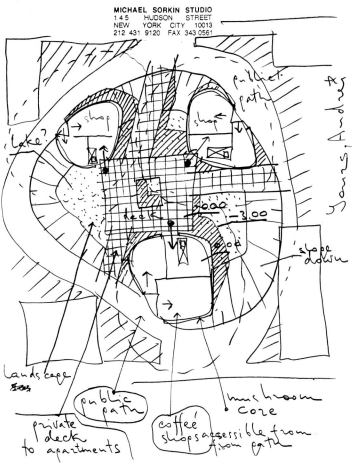

lake?

shop

shop

public path

deck

-3.00

shop down

yours, Andrew

landscape

public path

private deck to apartments

coffee shops accessible from from path

mushroom core

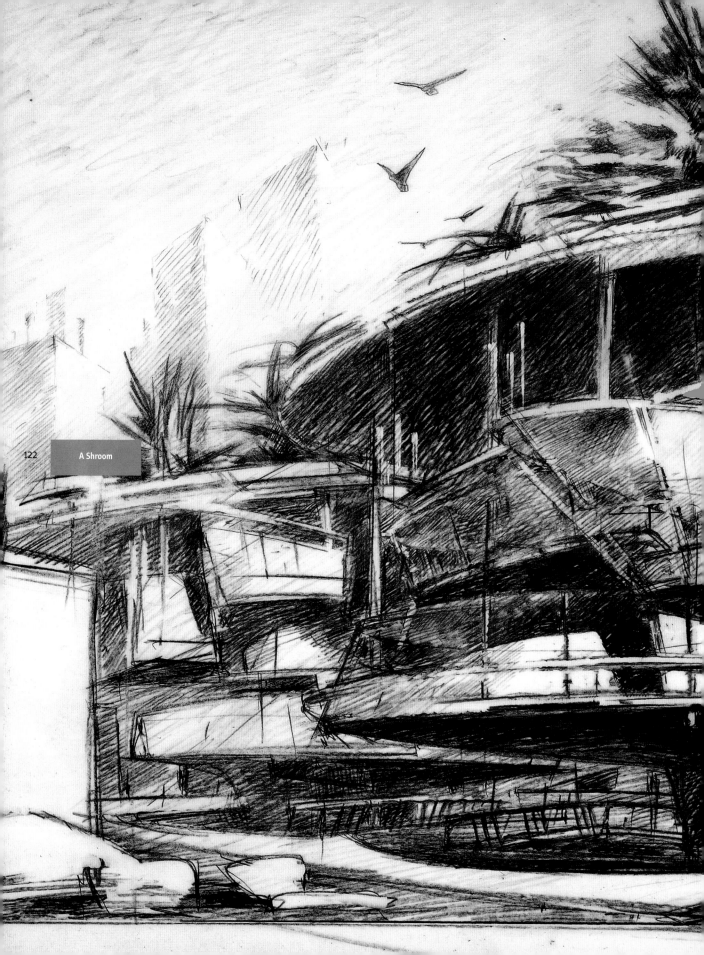

A Shroom

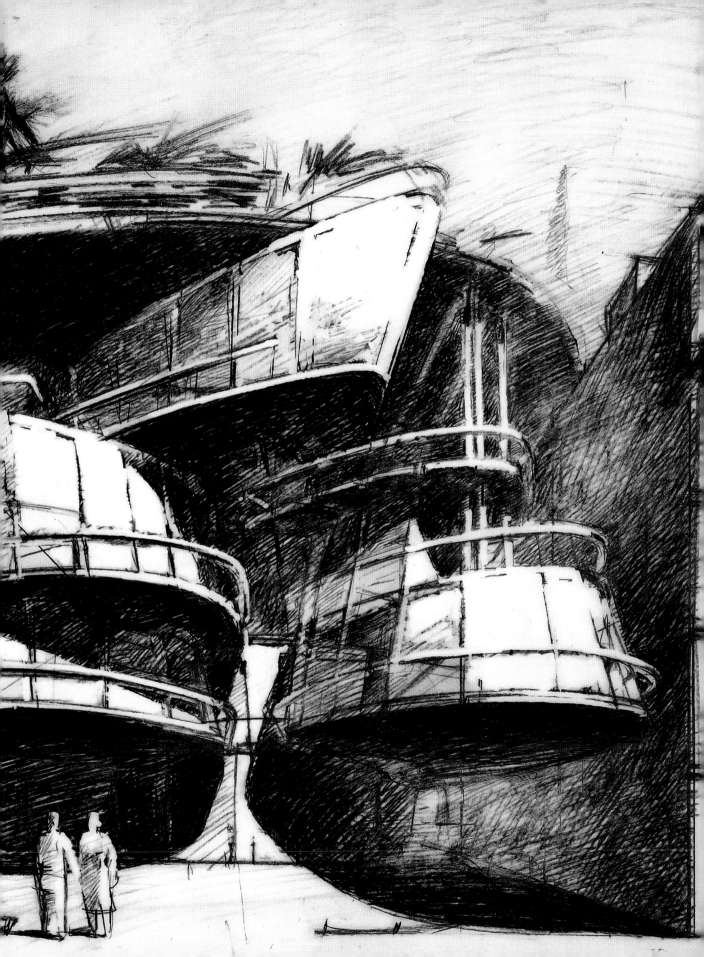

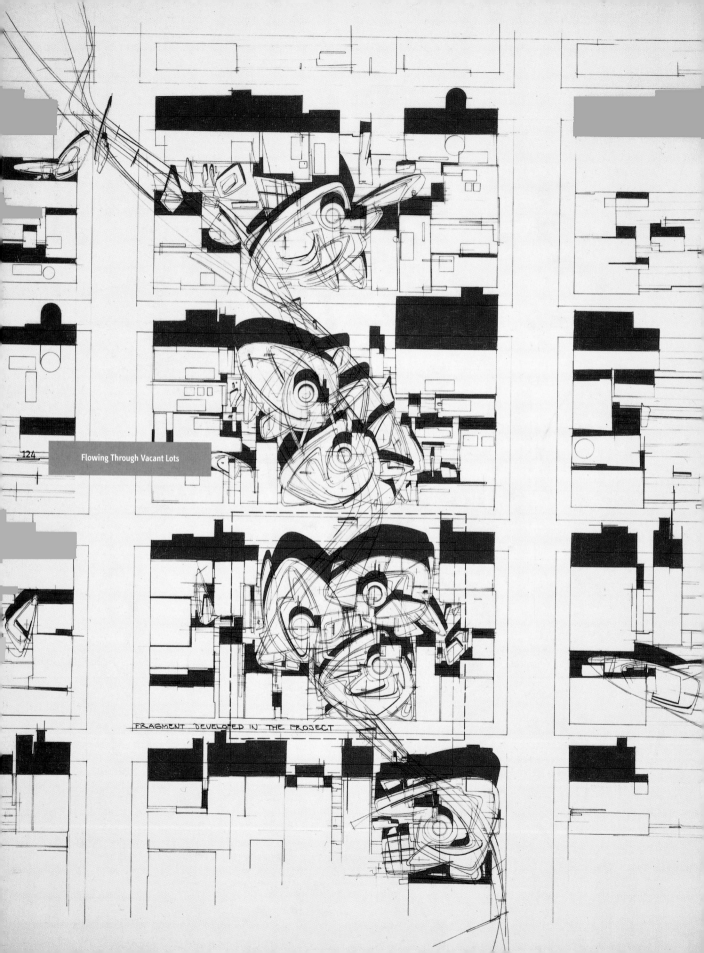

Flowing Through Vacant Lots

FRAGMENT DEVELOPED IN THE PROJECT

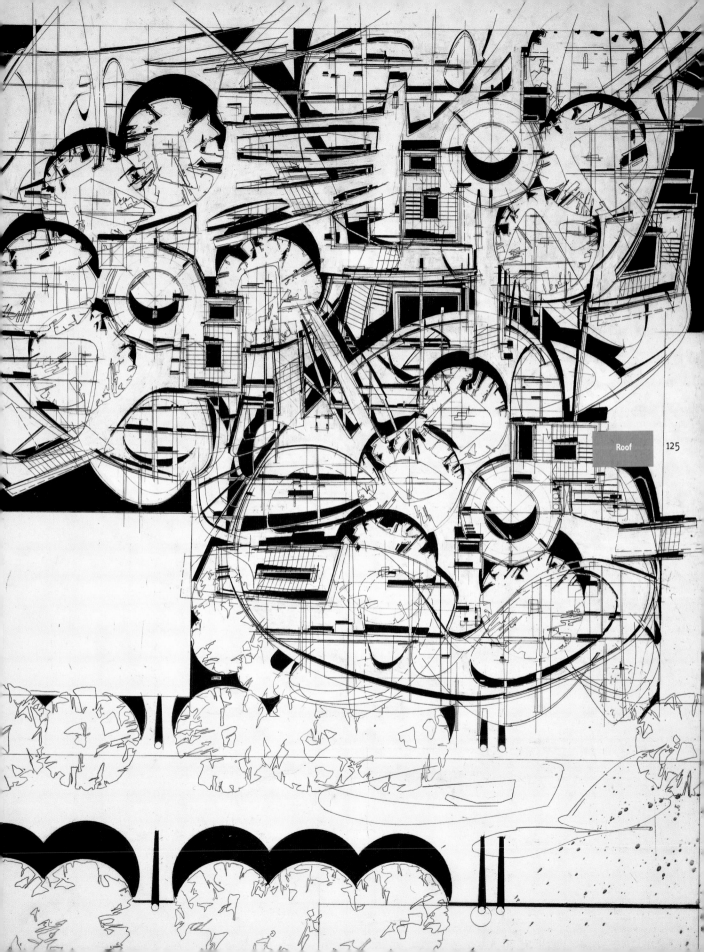

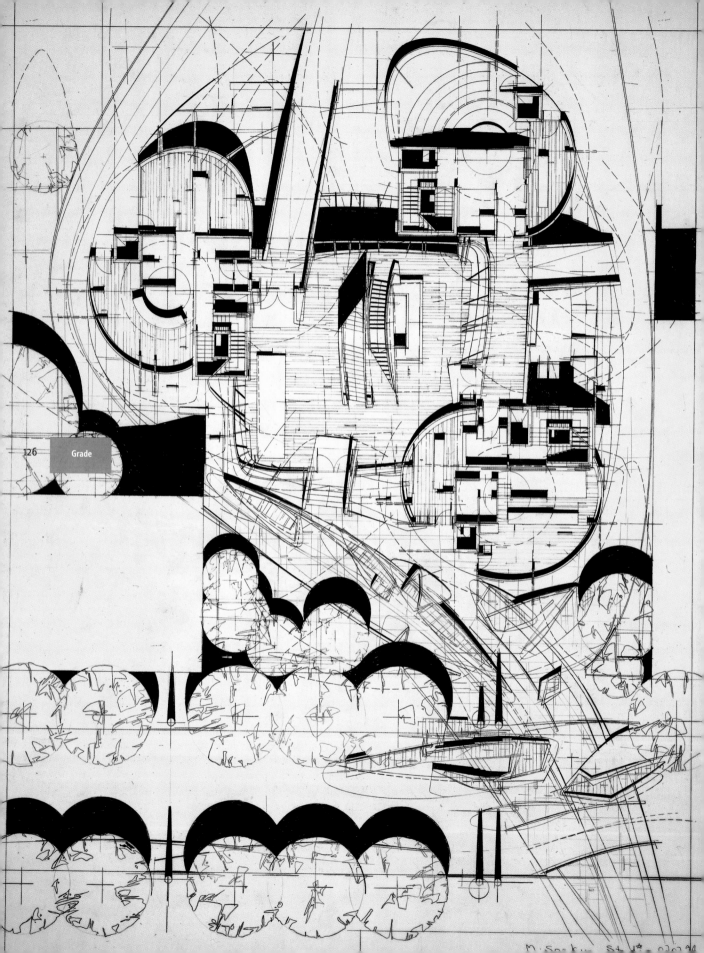

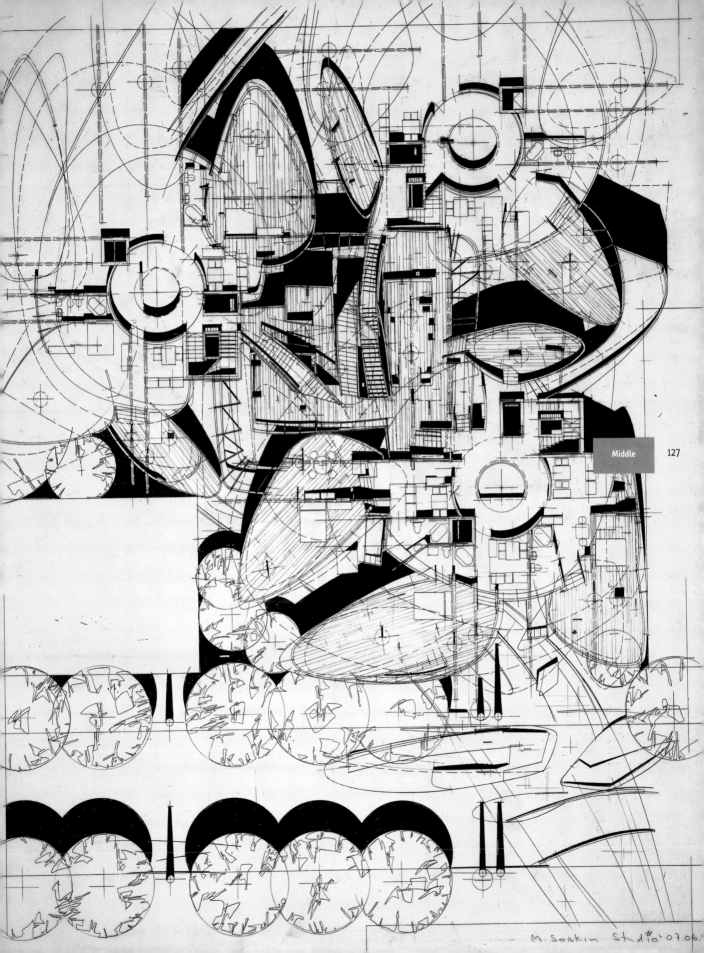

M. Sorkin Studio '07.06.

For a public housing project—a kind of Fukuoka West—eight designers were invited to collaborate: eight big egos, one small site, as one wag gagged. No one, of course, was willing to trust anyone else with the site plan, so we decided on an Exquisite Corpse. This strategy was nothing if not simple. We salamied the site into slices of equal area with frontage on the main street for everyone and departed to draw in ignorance, hoping for an accidental miracle. I was inwardly delighted, since I had done exactly this parallel-slice problem some years before with students and I wondered how "grown-up" collaborators would alter the results. I also knew that success would combine luck and intensive collaboration. I figured we would have to luck out.

In fact, the first results weren't bad. The mix of scales and uses was fairly good, the pattern was strong and dense, and the variety was within reason. But it needed work. Cross-site connections were weak and there were many underdeveloped juxtapositions. And the charms of the aleatory can be overstated: not every accident is a happy one.

First Project

The projects presented here represent three iterations of the game, the first done in ignorance, the second and third after having seen our neighbors' proposals. Our first scheme was built continuously from the front to the back of the site and soon struck us as too much of a barrier to the lateral movement of both bodies and space. Our next two projects tried to address the artificial autonomies of the initial division into property-like strips and to capitalize on the opportunities opened by the work of our collaborators. The second scheme fragmented the project into a space-managing colony of seven buildings of uniform plate and varying heights. Their small-scale plan form was generated from a sense of motility and orientation and by a desire to have floor-through apartments, each exposed to an open southerly view and to a series of intimate internal visual connections with nearby buildings. In this version, each building held two apartments to the floor in a longish New York layout. We also sought to use the buildings to encourage lateral movement on the site and to make small, streetlike walking links with active sec-

tions. Something on the order of 70 percent of the equivalent total surface area of the site was available for common use, either at grade or displaced upward to roof gardens.

On reflection, though, there seemed to be too many buildings, if only for economic reasons, and the regular shapes struck us as a little stiff. Iteration three reduces the total to three buildings and gives them a more robust wiggle. The green terracing becomes private garden space, although it is likely (when we get to version four) to be at least partially enclosed in glass to produce winter energy. The apartments themselves are more "efficiently" laid out but do retain at least two exposures each. Collective uses—a café, a shop, professional offices, and a children's center—are located in the ground floors of the buildings. As the project progresses and as the surrounding conditions unfold and reconfigure themselves, the three creatures can be expected to flex and wiggle into positions that optimize views, solar exposure, neighborliness, circulation, and a more general sense of urban ensemble.

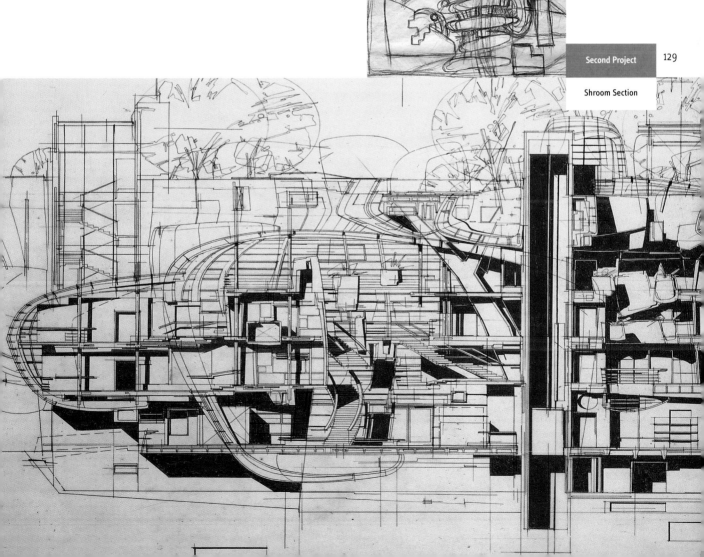

Second Project 129

Shroom Section

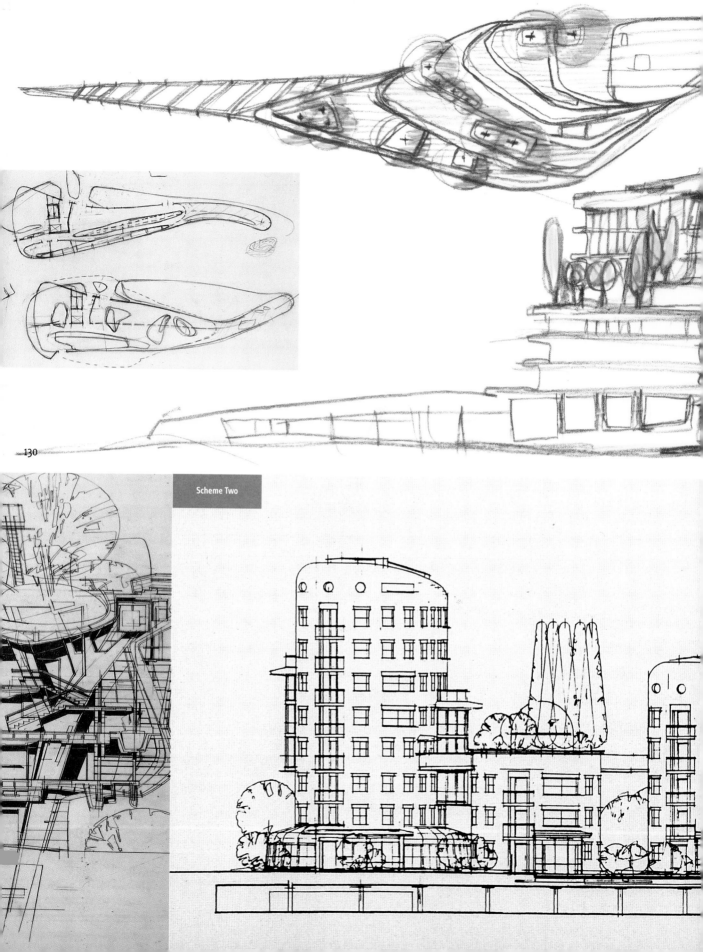

Scheme Two

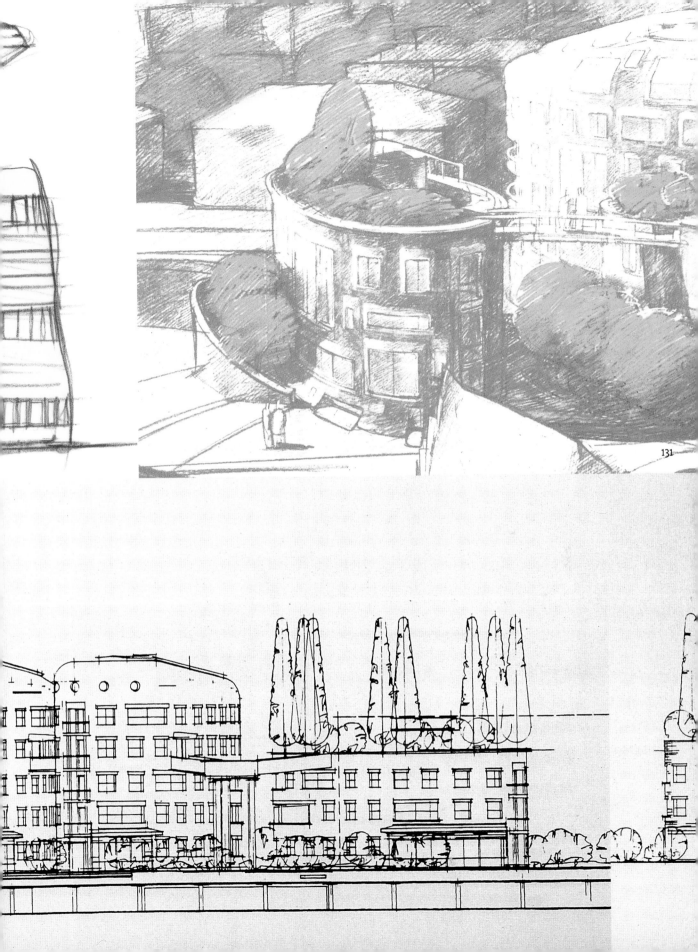

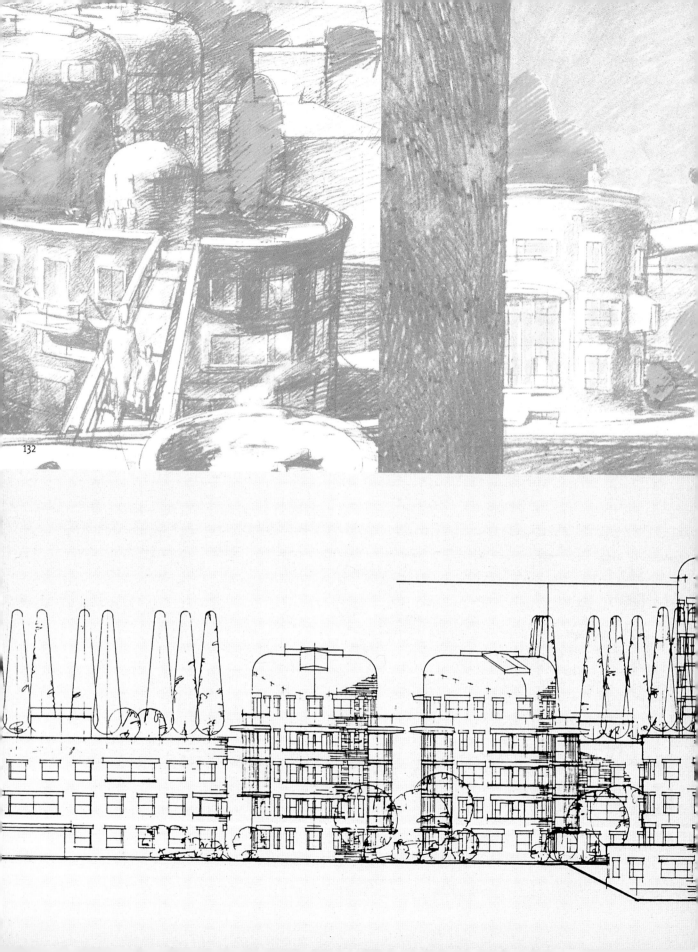

132

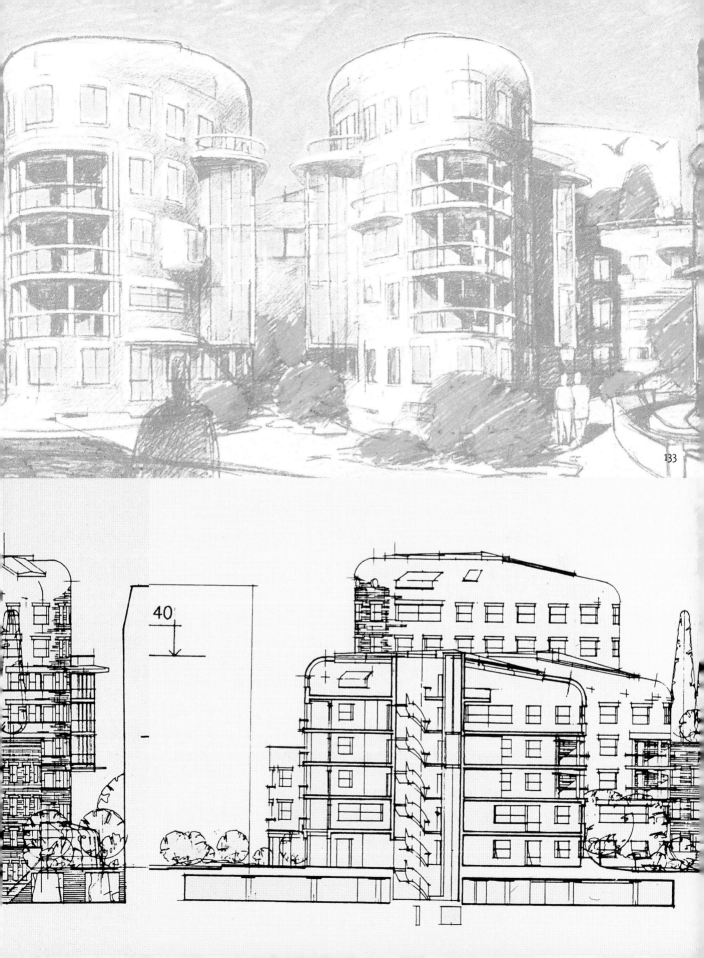

133

40

134

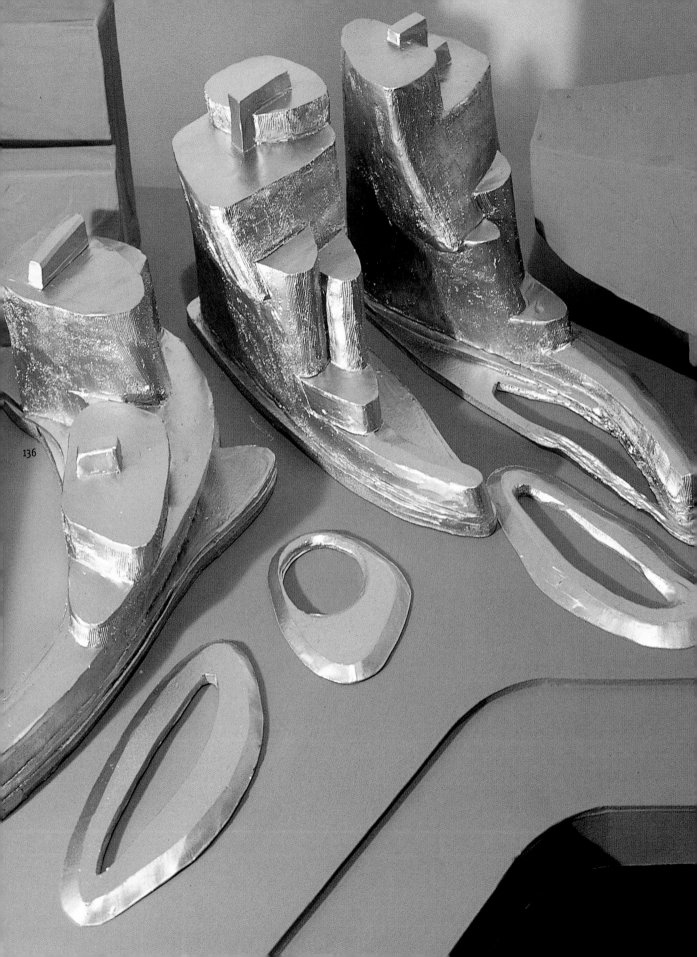

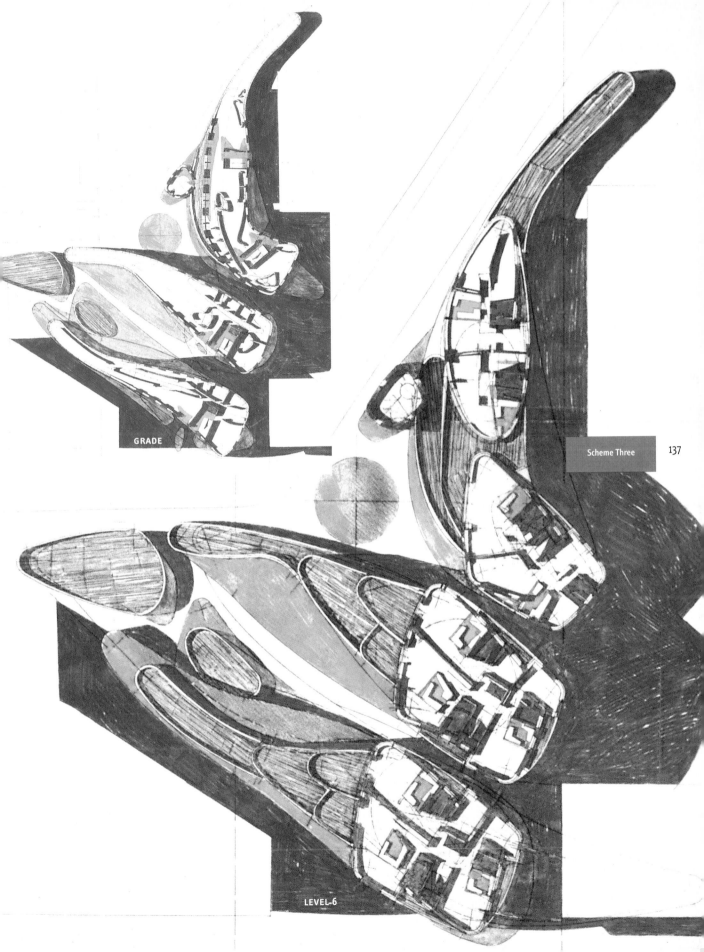

GRADE

LEVEL-6

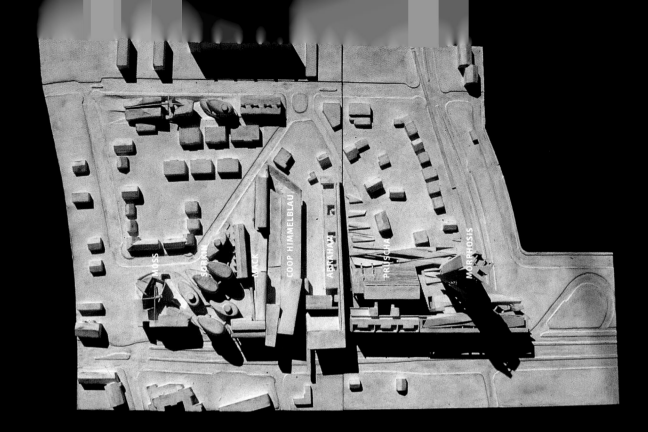

First Site Plan

Second Site Plan

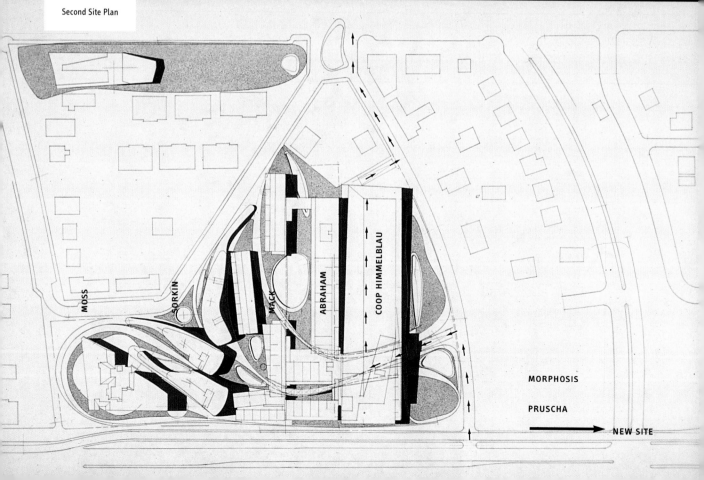

MOSS

SORKIN

MACK

ABRAHAM

COOP HIMMELBLAU

MORPHOSIS

PRUSCHA

NEW SITE

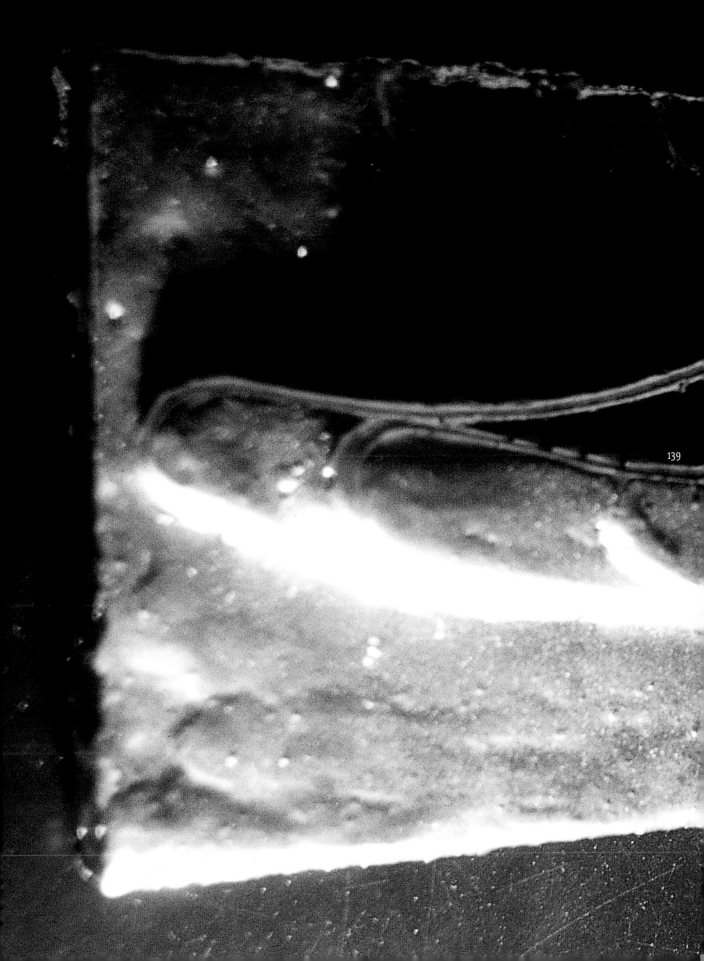

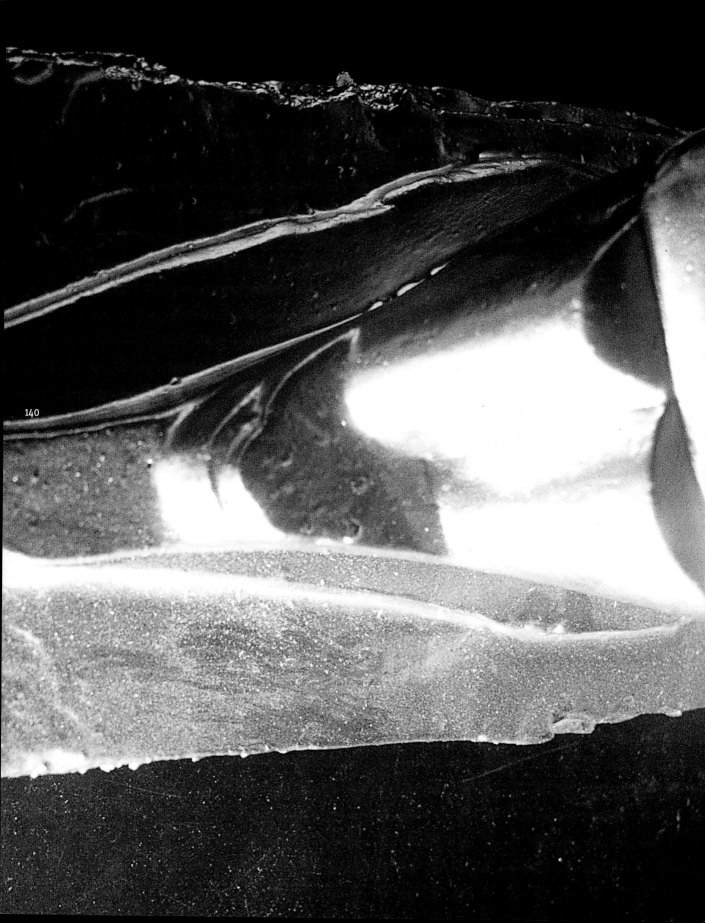

140

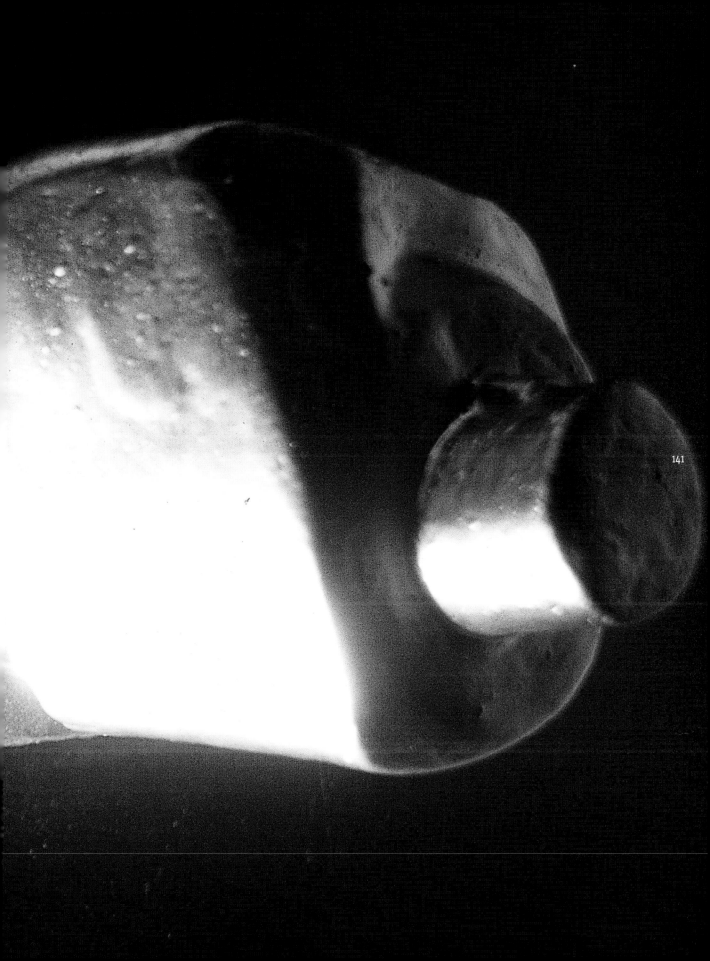

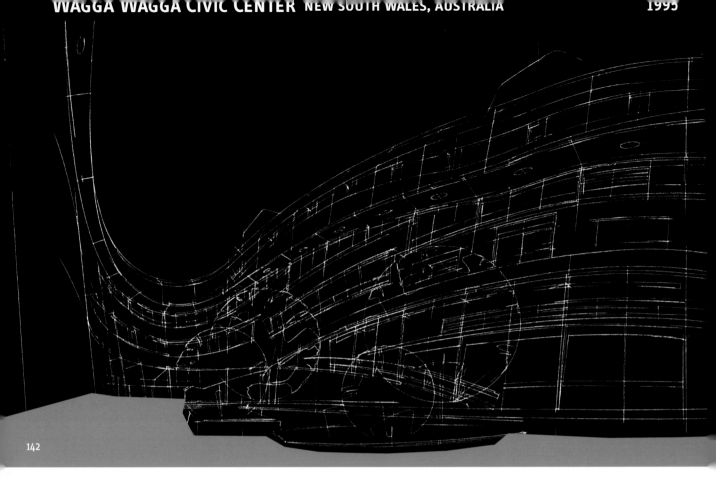

Yet another competition, this time for a town hall in Australia. The jury felt the building looked too much like a snake. We used the addition of the new building complex to leverage a plan for the elaboration of the surrounding downtown.

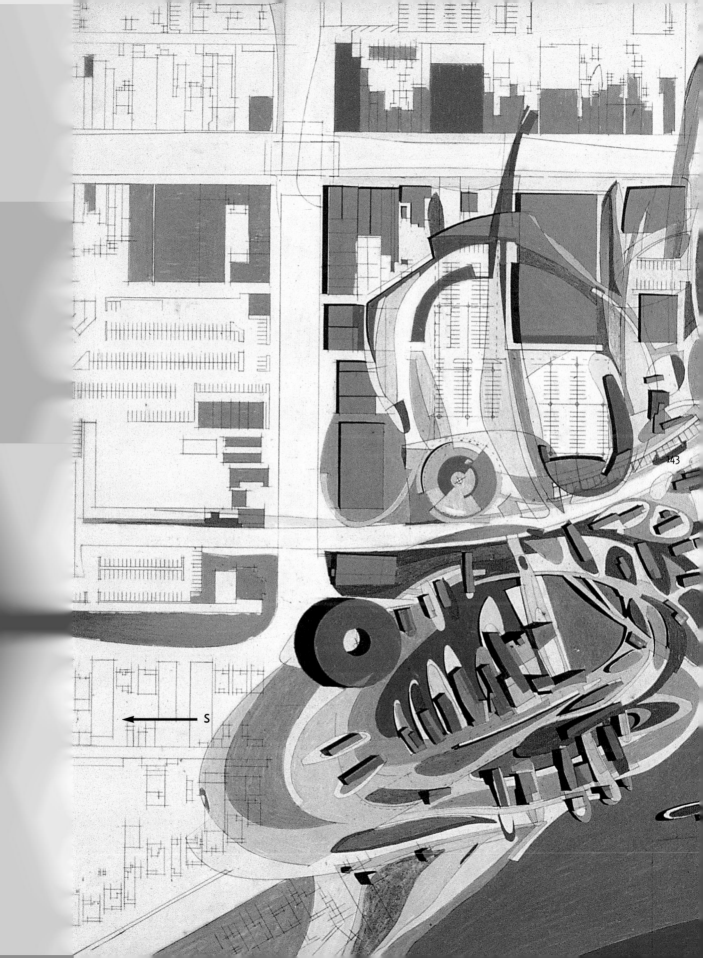

S

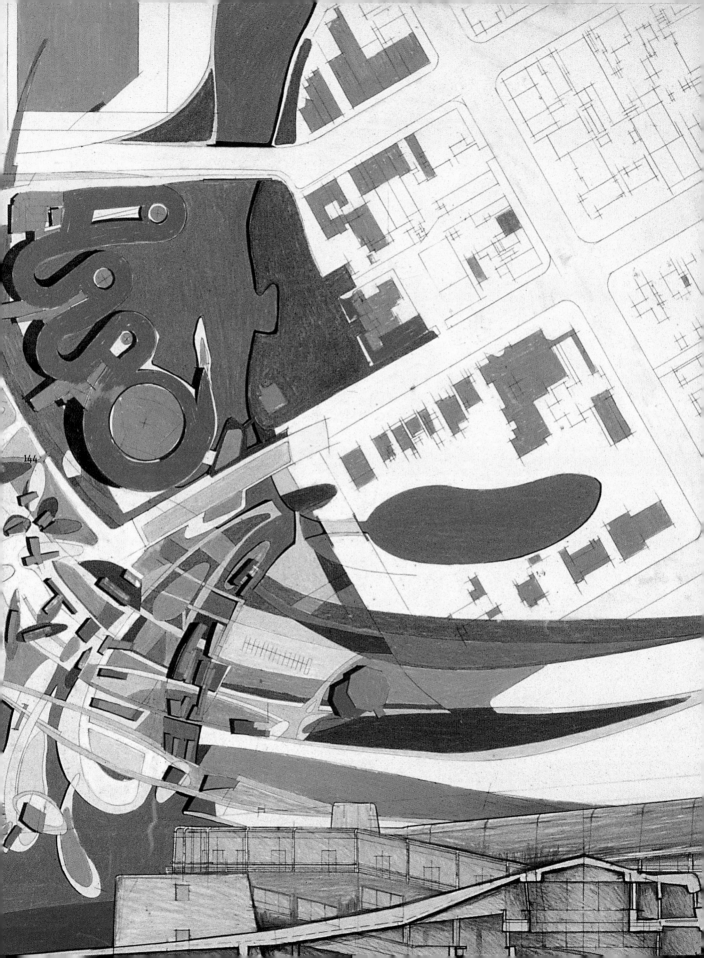

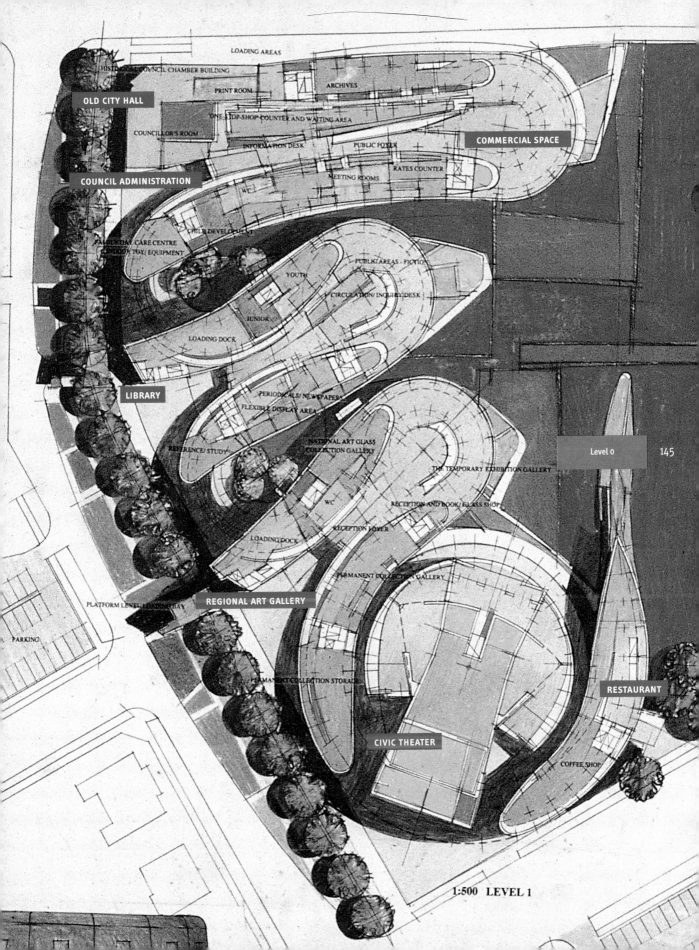

LOADING AREAS

HISTORIC COUNCIL CHAMBER BUILDING

OLD CITY HALL

PRINT ROOM

ARCHIVES

COUNCILLOR'S ROOM

ONE-STOP-SHOP COUNTER AND WAITING AREA

COUNCIL ADMINISTRATION

INFORMATION DESK

PUBLIC FOYER

COMMERCIAL SPACE

RATES COUNTER

MEETING ROOMS

WC

CHILD DEVELOPMENT

FAMILY DAY CARE CENTRE
OUTDOOR TOY/ EQUIPMENT

PUBLIC AREAS - FICTION

YOUTH

CIRCULATION/ INQUIRY DESK

JUNIOR

LOADING DOCK

LIBRARY

PERIODICALS/ NEWSPAPERS

FLEXIBLE DISPLAY AREA

REFERENCE/ STUDY

NATIONAL ART GLASS
COLLECTION GALLERY

THE TEMPORARY EXHIBITION GALLERY

RECEPTION AND BOOK/ GLASS SHOP

WC

RECEPTION FOYER

LOADING DOCK

Level 0 145

REGIONAL ART GALLERY

PERMANENT COLLECTION GALLERY

PLATFORM LEVEL LOADING QUAY

PARKING

PERMANENT COLLECTION STORAGE

RESTAURANT

CIVIC THEATER

COFFEE SHOP

1:500 LEVEL 1

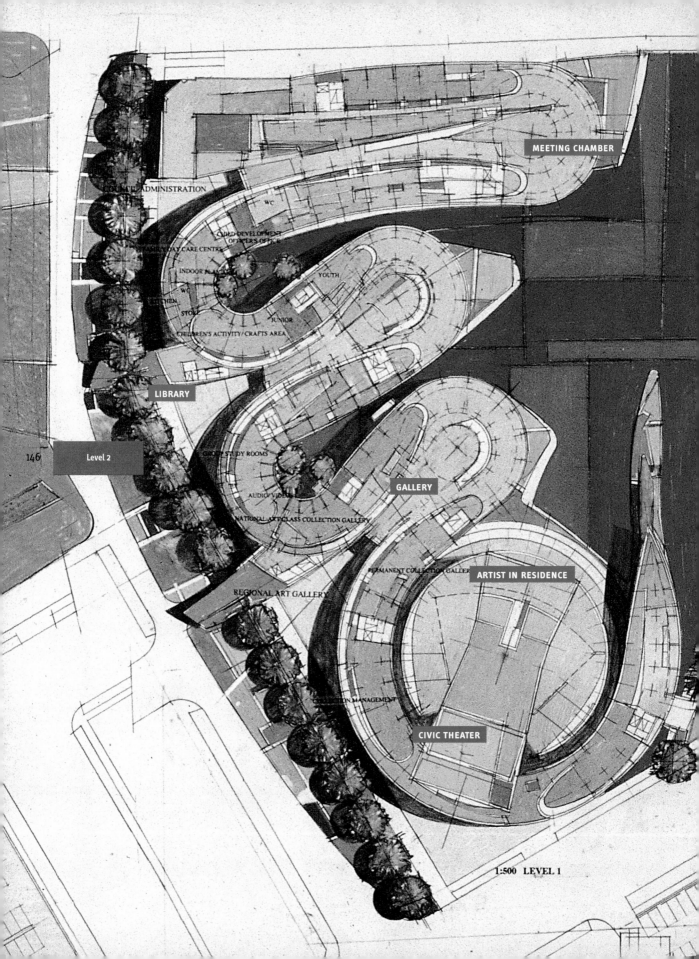

MEETING CHAMBER

COUNCIL ADMINISTRATION

WC

CHILD DEVELOPMENT
OFFICER'S OFFICE

TEMPORARY DAY CARE CENTRE

INDOOR PLAY

WC

KITCHEN

STORE

JUNIOR

YOUTH

CHILDREN'S ACTIVITY/CRAFTS AREA

LIBRARY

146 Level 2

GROUP STUDY ROOMS

AUDIO VIDEO

NATIONAL ART GLASS COLLECTION GALLERY

GALLERY

PERMANENT COLLECTION GALLERY

ARTIST IN RESIDENCE

REGIONAL ART GALLERY

COLLECTION MANAGEMENT

CIVIC THEATER

1:500 LEVEL 1

Seven hundred condos on Biscayne Bay: a classic problem of the relationship of density, automobiles, and view, most typically solved with a double-loaded slab oriented perpendicular to the shore. This site had the further complication of a high water table, which made underground parking (to house an insane volume of cars—more than enough to cover the entire site) prohibitive. Our wish was to try to keep as much of the ground plane as possible available for use, both as recreational space for tenants and to tie the big project to its neighborhood by providing an amenity that could be shared.

Fortunately, the site—although deep—was also pretty wide. Our solution gives each apartment a good view (as well as cross-ventilation) and—by putting parking on upper levels—frees virtually the entire ground plane for use. As with many of our other proposals, we hope that the green core of this project can grow into its surroundings, perhaps anchoring a pedestrian connection into downtown Miami.

This bleed of green—along with the inclusion of a variety of public and commercial facilities—is also intended to defeat the fortresslike, enclaved character evoked by so many similarly scaled condominiums.

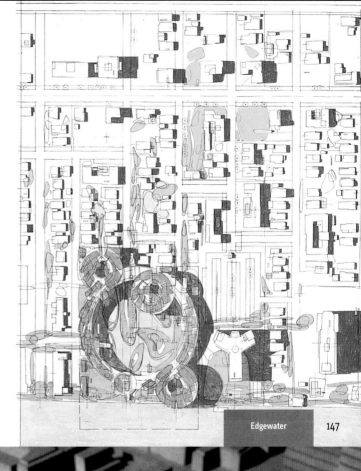

Edgewater 147

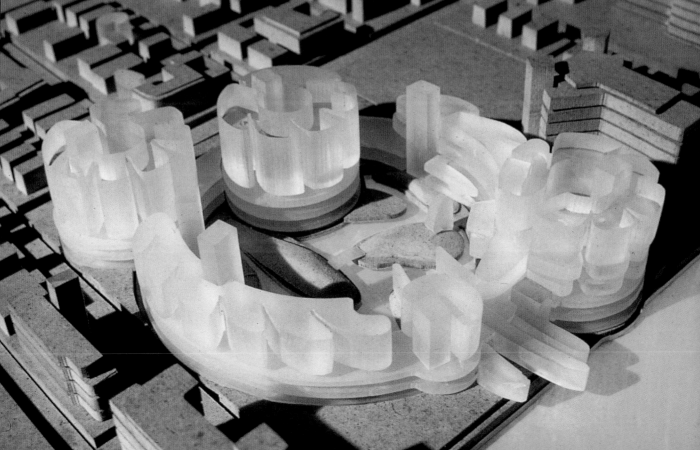

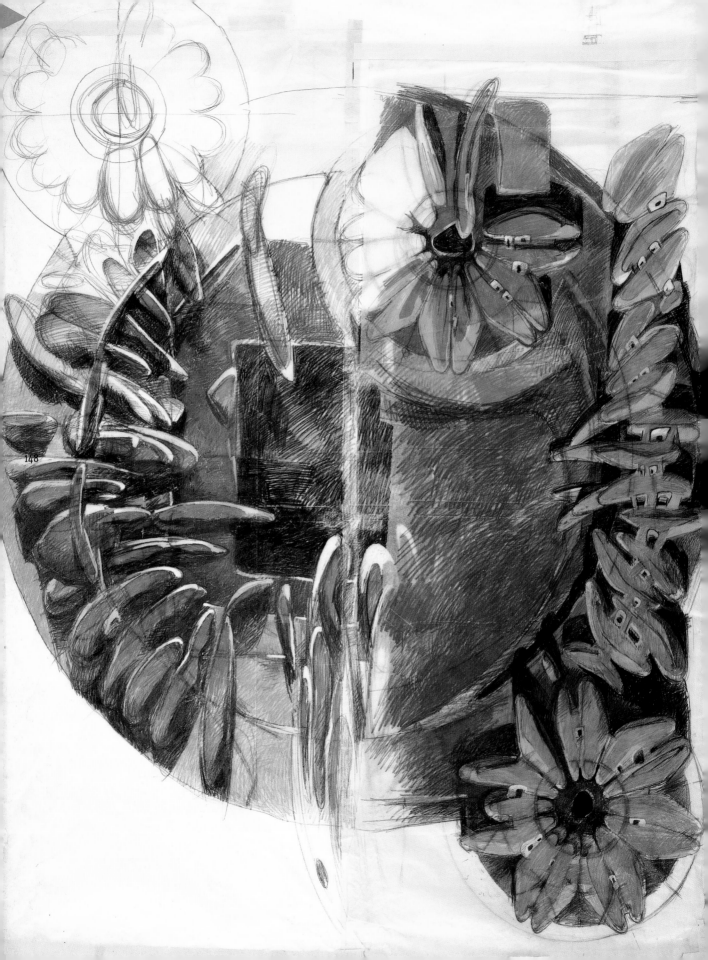

148

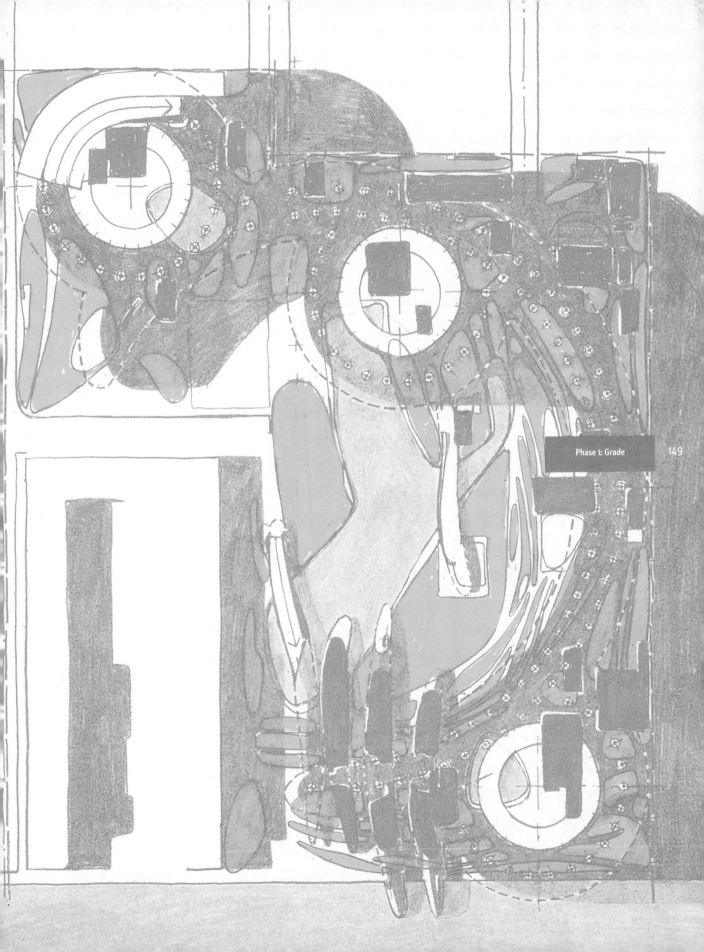

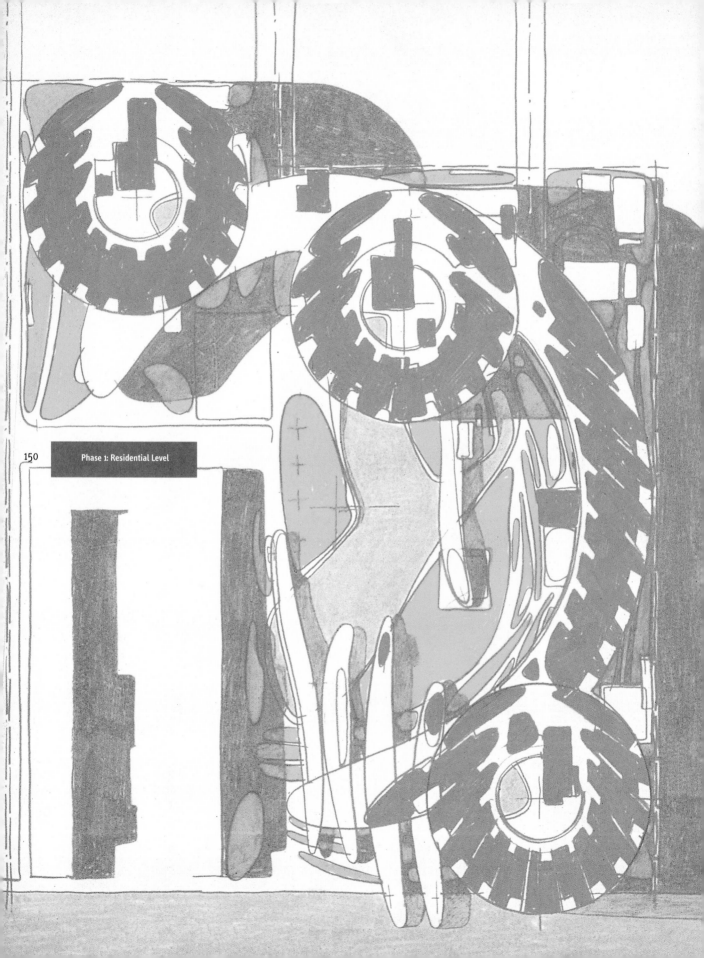

Phase 1: Residential Level

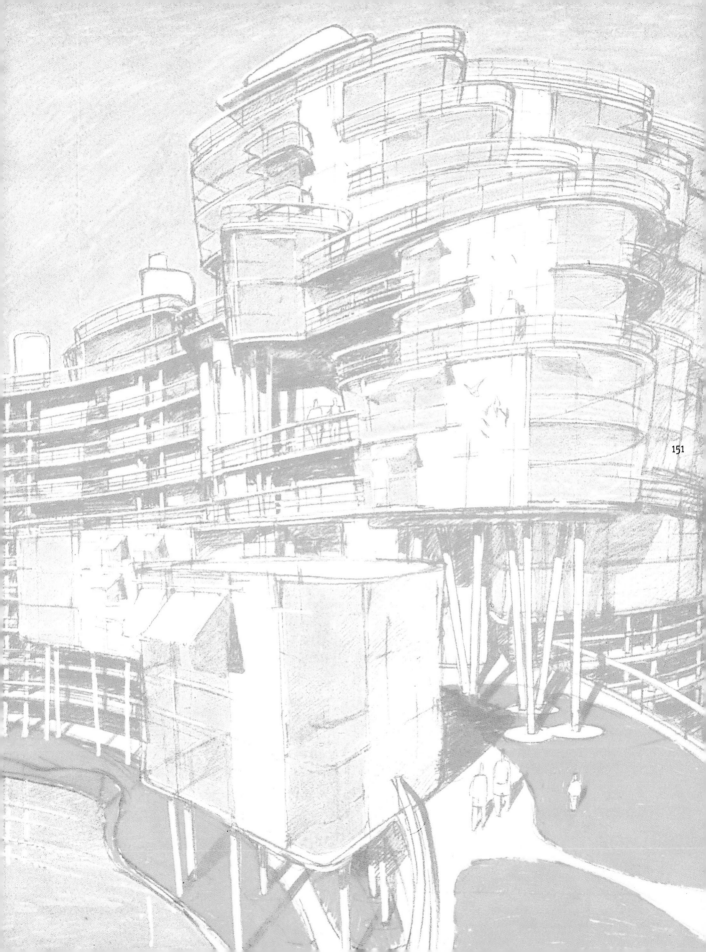

151

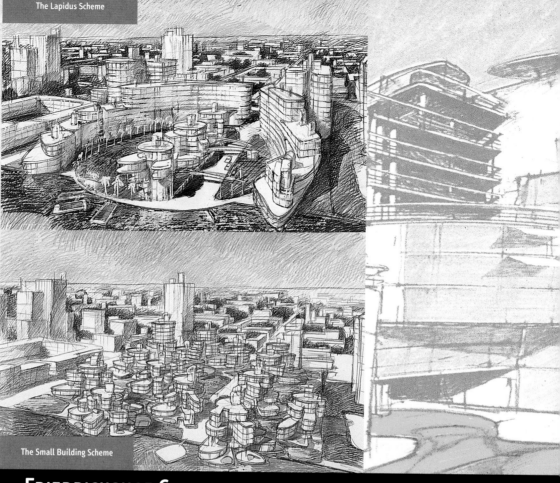

The Small Building Scheme

FRIEDRICHSHOF COMMUNE BURGENLAND, AUSTRIA

A former commune with a large piece of property an hour from Vienna has decided to expand, eventually doubling its present population to around three hundred. Although communal living is a thing of the past, the fifty or so communards who remain on site wish to preserve the artistic and cooperative vibe of the place.

Recognizing the potential mix of full-time and week-end residents, of horse-boarders, daily commuters, artists, artisans, farmers, telecommuters, kids, those locally employed, and short-term visitors, our plan adds two new building types to the apartment buildings in which most residents now live: cottages and lofts. This variety is intended to round out the limited residential choices currently available and to newly emphasize the roles of individuals and small groups in the life of the community.

We've also proposed improvements to the commune's infrastructure, including a new system of parking and internal circulation, an artificial lake linked to an existing pond, and the extension of a small hill (constructed from material excavated for earlier buildings) to serve both as a landscape element and as a barrier to winter winds.

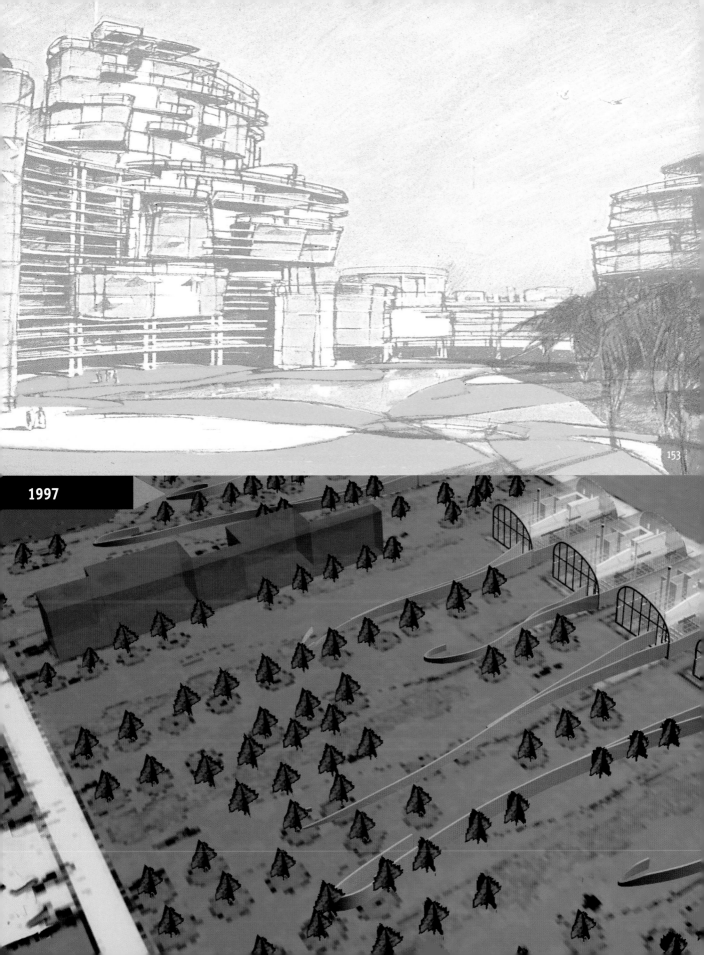

1997

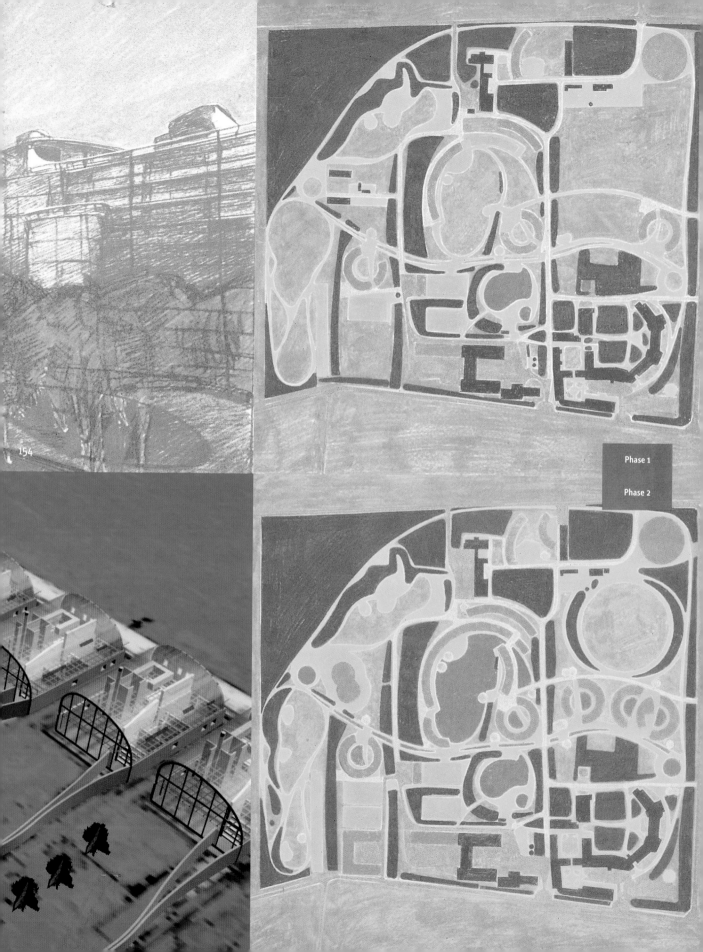

Phase 1

Phase 2

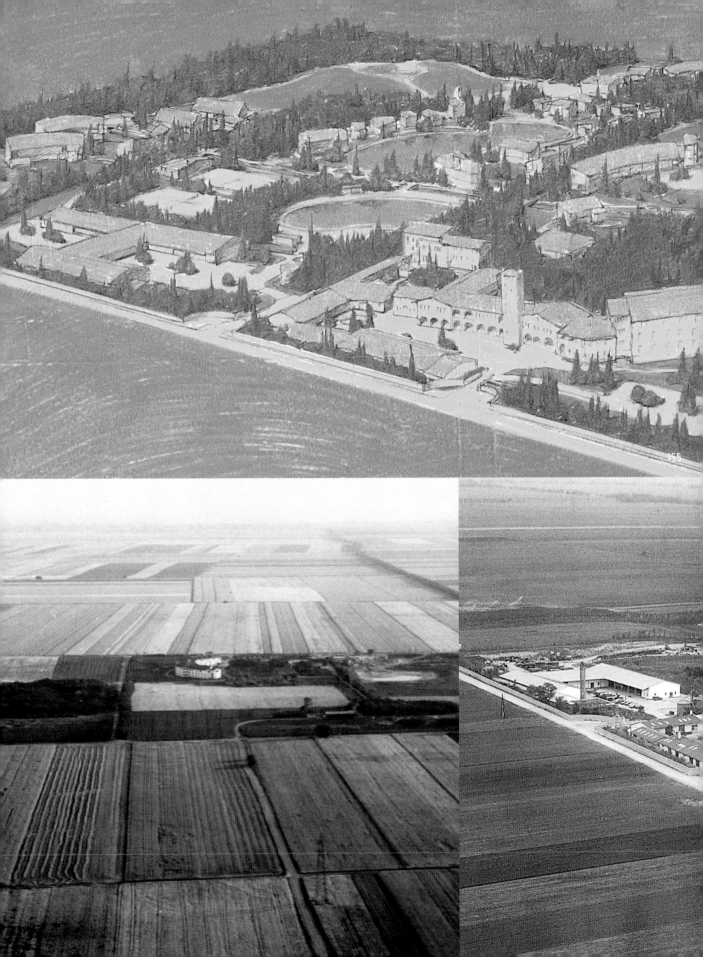

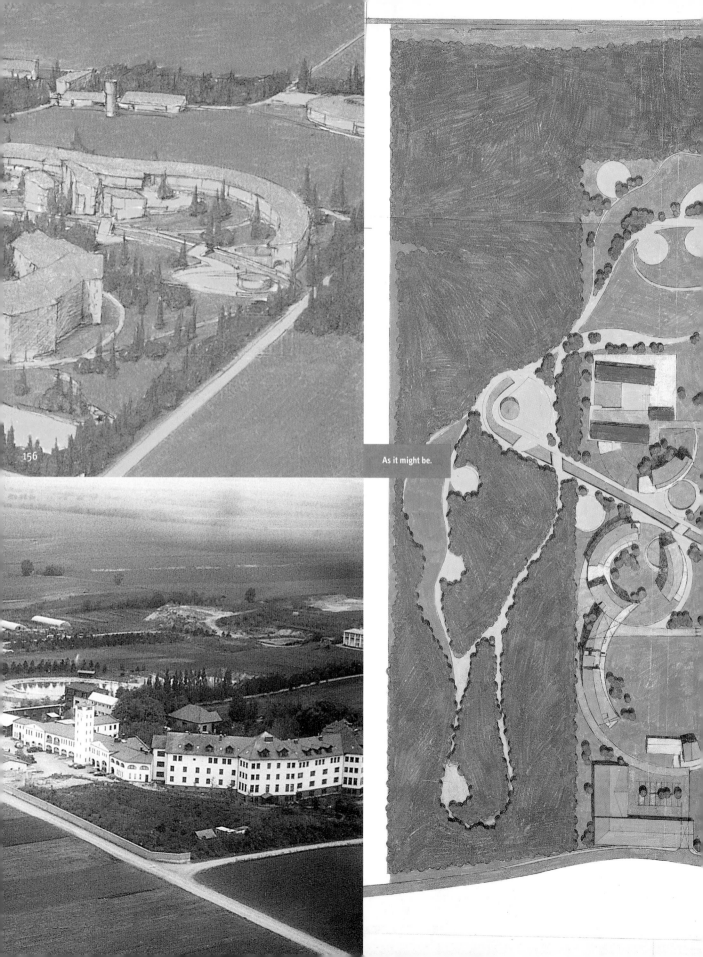

As it might be.

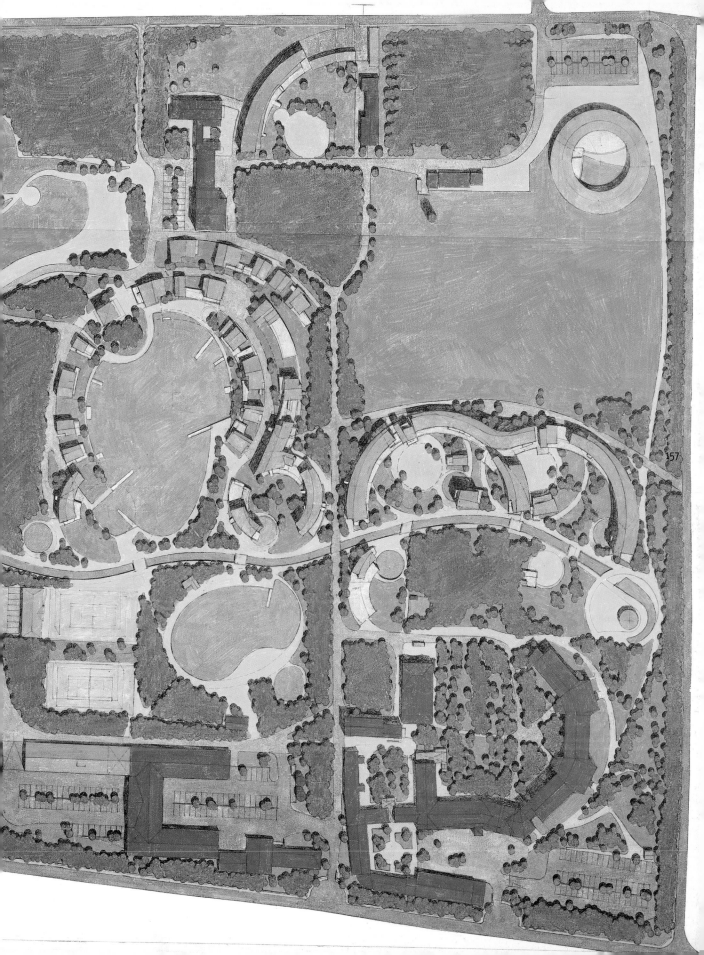

157

A reply to Trump's proposal to turn the abandoned West Side Rail Yards into an enormous condo colony. Ghosts of the railroad moving continuously provide housing for the homeless colony that lives in the enormous railway tunnel that runs under Riverside Park and disgorges into the yards.

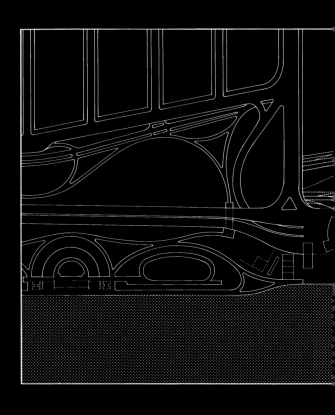

Urbanagram

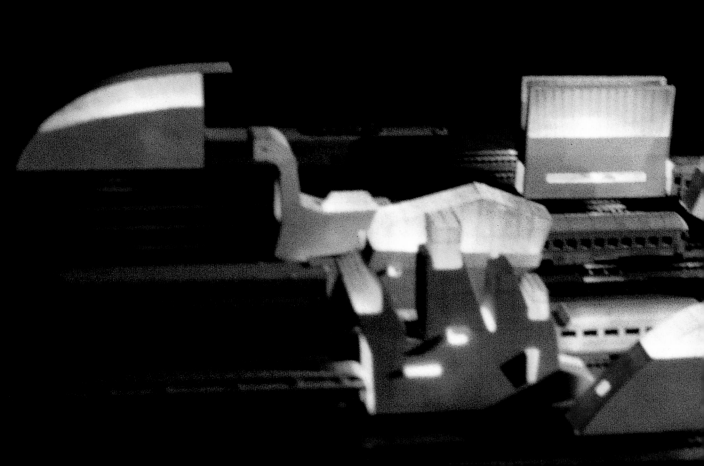

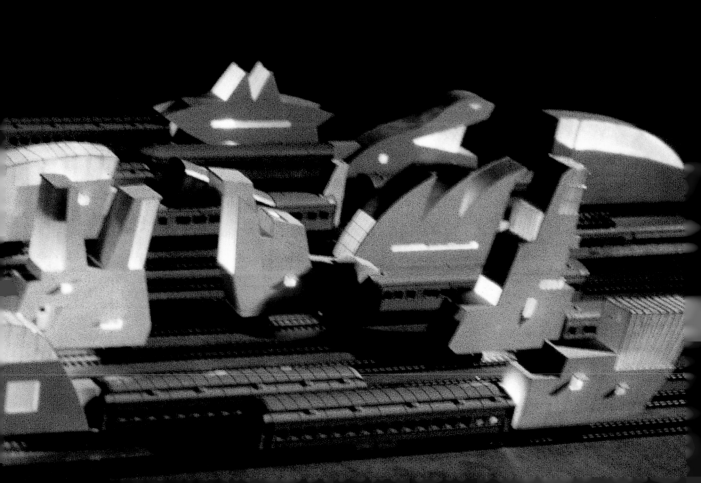

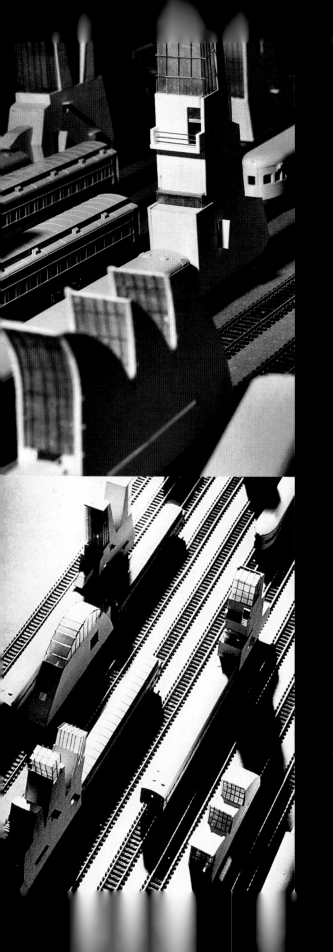

04.25.91. 07:31

07.04.91. 11:27

Invited by the *Los Angeles Times* to speculate on the future of Chavez Ravine and Dodger Stadium, we suggested creating a large new park. To leverage the conversion of a vast acreage of parking lots into green space, we have proposed developing a one-hundred-yard-deep band around the stadium where all parking would be consolidated and a series of towers would rise.

Juke Ball Exhibition Proposal, 1993

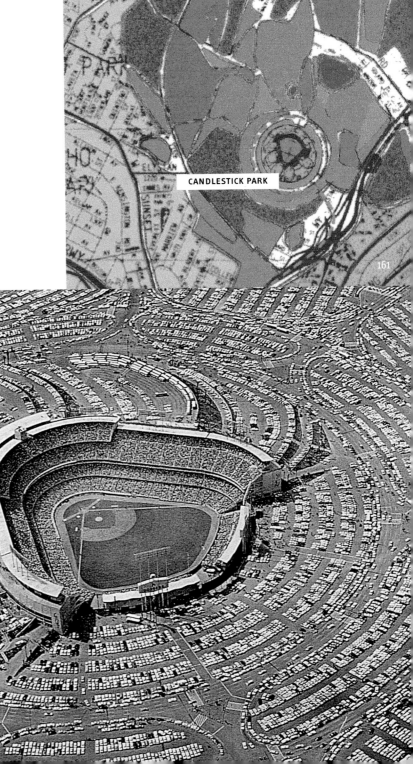

CANDLESTICK PARK

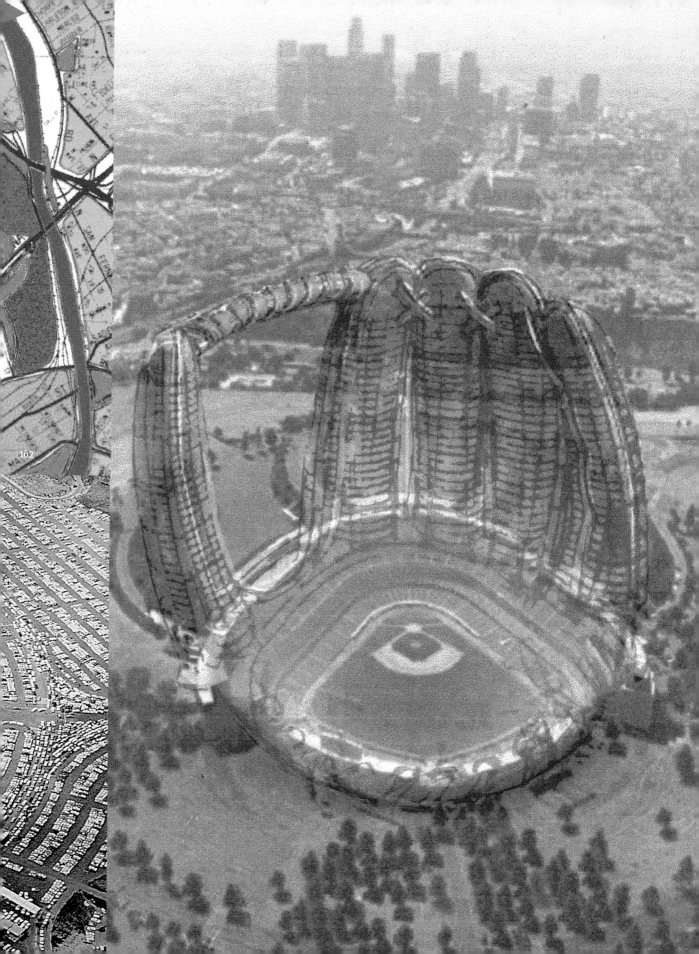

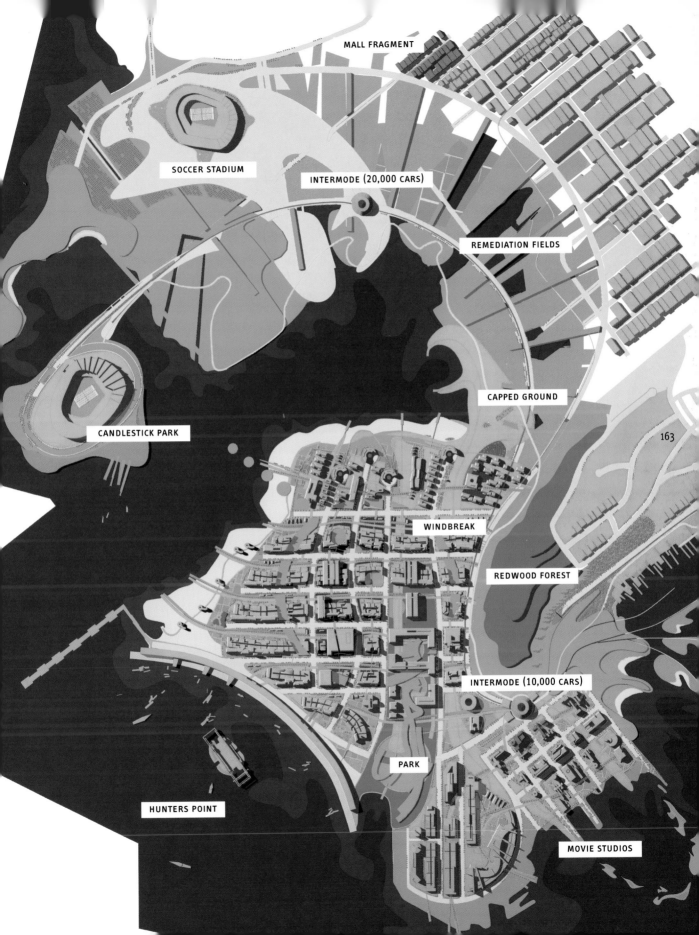

MALL FRAGMENT

SOCCER STADIUM

INTERMODE (20,000 CARS)

REMEDIATION FIELDS

CAPPED GROUND

CANDLESTICK PARK

163

WINDBREAK

REDWOOD FOREST

INTERMODE (10,000 CARS)

PARK

HUNTERS POINT

MOVIE STUDIOS

An unsolicited master plan for a portion of the San Francisco waterfront.

MIXED USE

This plan supposes the minimum of zoning by use in order to promote the maximum of both mix and flexibility. As cities move beyond class- and race-based planning and as urban industry—particularly in places like San Francisco—becomes increasingly focused on "clean" services and technologies, planning by use becomes increasingly unnecessary. Urban design will increasingly devolve instead on compatibilities of size, on the reinforcement and elaboration of public space, and on tactics of sustainability. Indeed, in the growth of the area south of Market, in the legal establishment of "live-work" building, and in the initial reuse of areas like Hunters Point, the city has pioneered a new and vital style of urbanity.

This new mix should appear at both the urban and architectural scales. Our plan assumes that the generic building type (at least conceptually) is a loft: a daylit, walk-up structure that might become housing, laboratories, offices, commercial space, or any of a variety of mixtures of all of these.

Scales would vary with context, but the likes of the Bradbury Building in Los Angeles or the reused industrial buildings of Soho in Manhattan are suggestive types. Such malleable architecture—adapted to modern standards and carefully reworked environmentally—would be very suitable to the largely industrial contexts of both Mission Bay and Hunters Point. Lofts would, as well, help to avoid a problem that has plagued every plan for Mission Bay to date: complete collapse with the disappearance of their momentary market rationales. A more adaptable process of both planning and building would assure potential viability indefinitely.

164

MALL FRAGMENT

MALL FRAGMENT

INDUSTRIAL RESERVE

FRAGMENTS OF A MALL

Suppose that instead of building a single, enormous shopping mall on the isolated territory next to Candlestick Park, its shops were concentrated in a series of smaller centers dispersed along the new trolley line. This might capture a richer synergy, offering jobs and services directly to the neighborhoods along the waterfront.

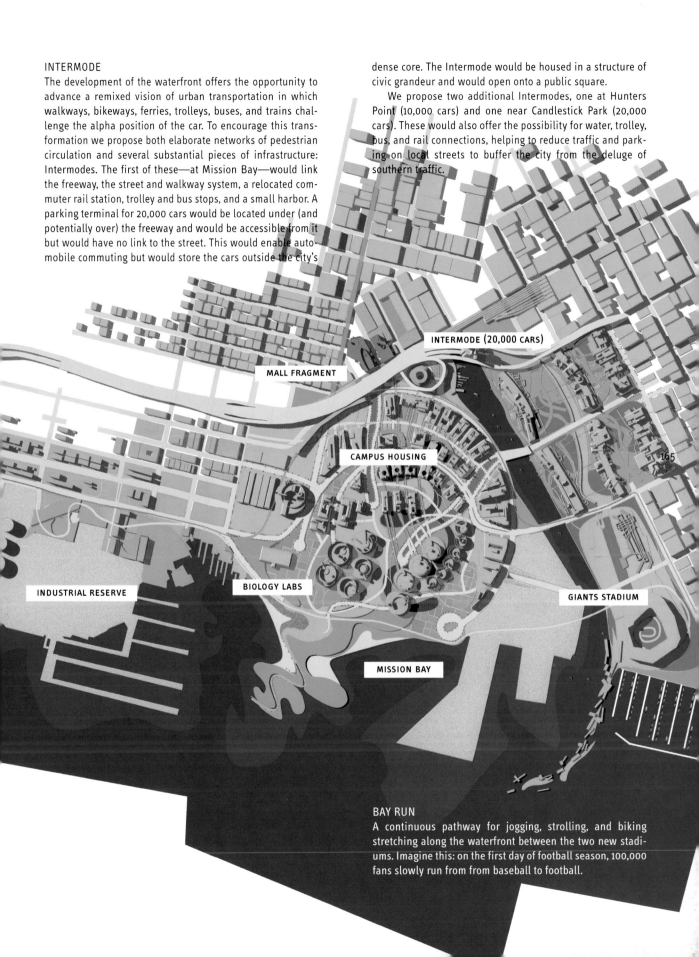

INTERMODE

The development of the waterfront offers the opportunity to advance a remixed vision of urban transportation in which walkways, bikeways, ferries, trolleys, buses, and trains challenge the alpha position of the car. To encourage this transformation we propose both elaborate networks of pedestrian circulation and several substantial pieces of infrastructure: Intermodes. The first of these—at Mission Bay—would link the freeway, the street and walkway system, a relocated commuter rail station, trolley and bus stops, and a small harbor. A parking terminal for 20,000 cars would be located under (and potentially over) the freeway and would be accessible from it but would have no link to the street. This would enable automobile commuting but would store the cars outside the city's dense core. The Intermode would be housed in a structure of civic grandeur and would open onto a public square.

We propose two additional Intermodes, one at Hunters Point (10,000 cars) and one near Candlestick Park (20,000 cars). These would also offer the possibility for water, trolley, bus, and rail connections, helping to reduce traffic and parking on local streets to buffer the city from the deluge of southern traffic.

INTERMODE (20,000 CARS)

MALL FRAGMENT

CAMPUS HOUSING

165

INDUSTRIAL RESERVE

BIOLOGY LABS

GIANTS STADIUM

MISSION BAY

BAY RUN

A continuous pathway for jogging, strolling, and biking stretching along the waterfront between the two new stadiums. Imagine this: on the first day of football season, 100,000 fans slowly run from from baseball to football.

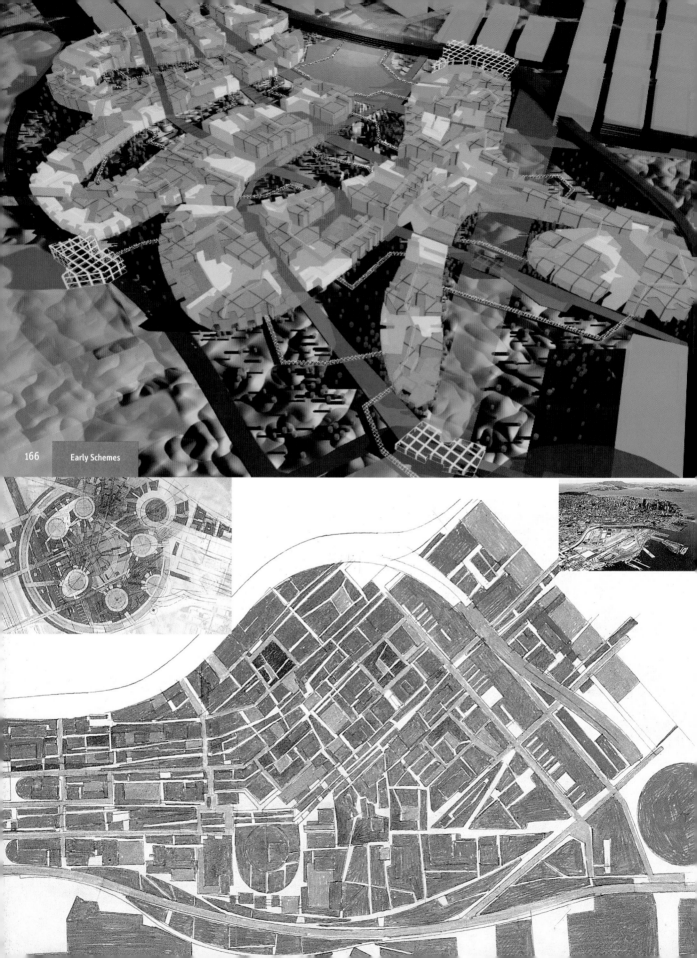

Early Schemes

Model City was the first of an ongoing series of Urbanagrams and took the form of an Analogue Relief Plan (ARP). Meant to be an elastic representation of urban ideas, the model shows relations of near and far, solid and dense, built and unbuilt, green and blue, as well as suggesting other potential particularities of form, scale, and place.

Urbanagram

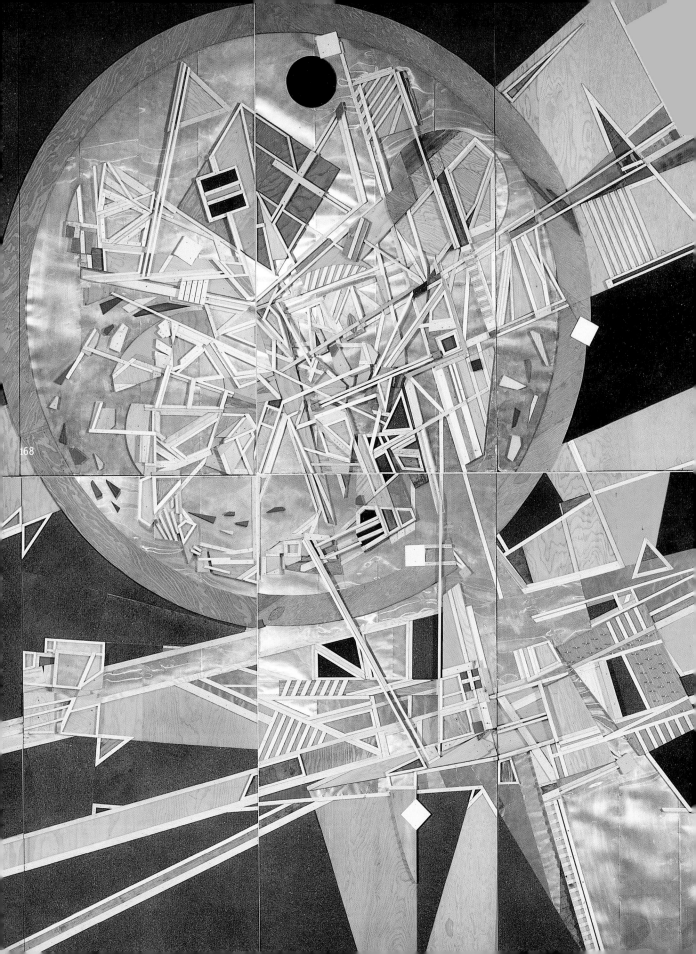

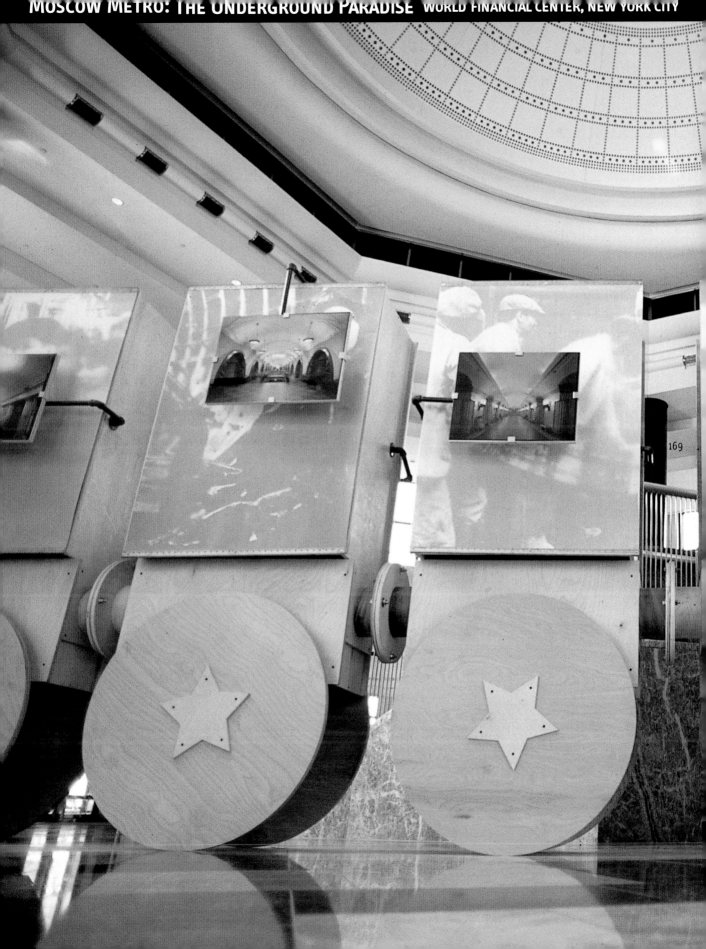

169

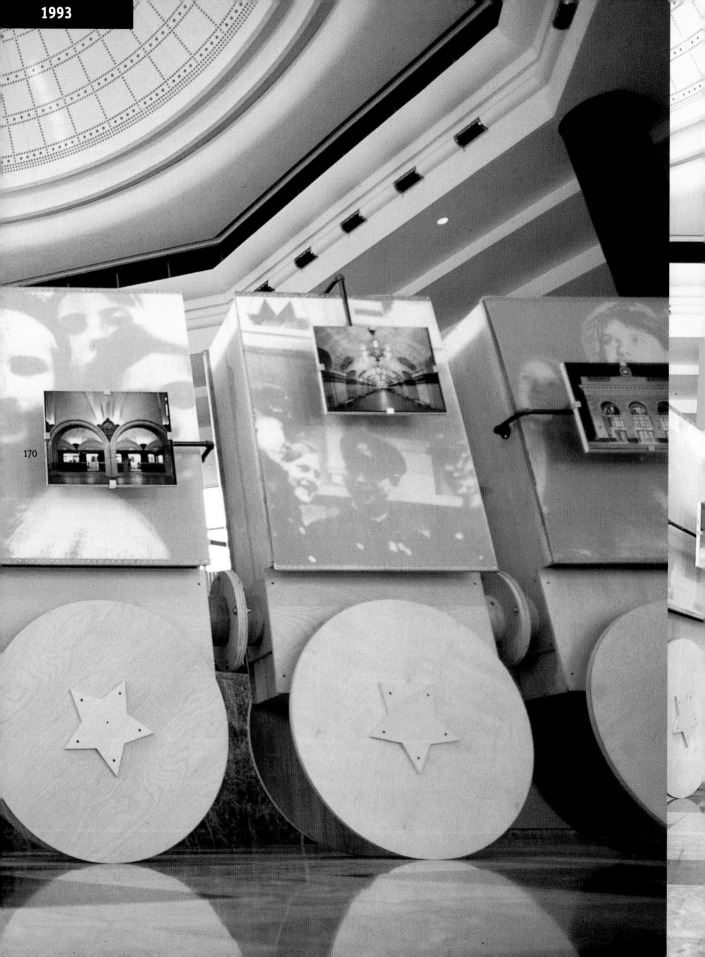

170

More exhibition vehicles. We tried—in form and materials—to capture something of extravagant purposiveness of wartime constructions. Although there are reminders of the real price of war, in retrospect the show seems too attractive, too reminiscent of boyish fascinations with planes and ships, and the elegant functionalisms of death.

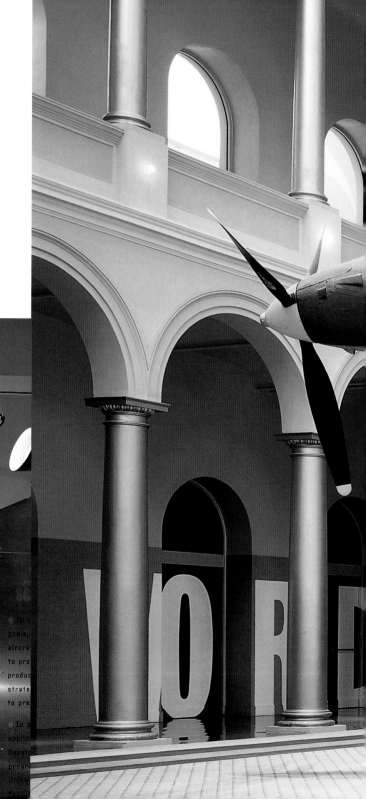

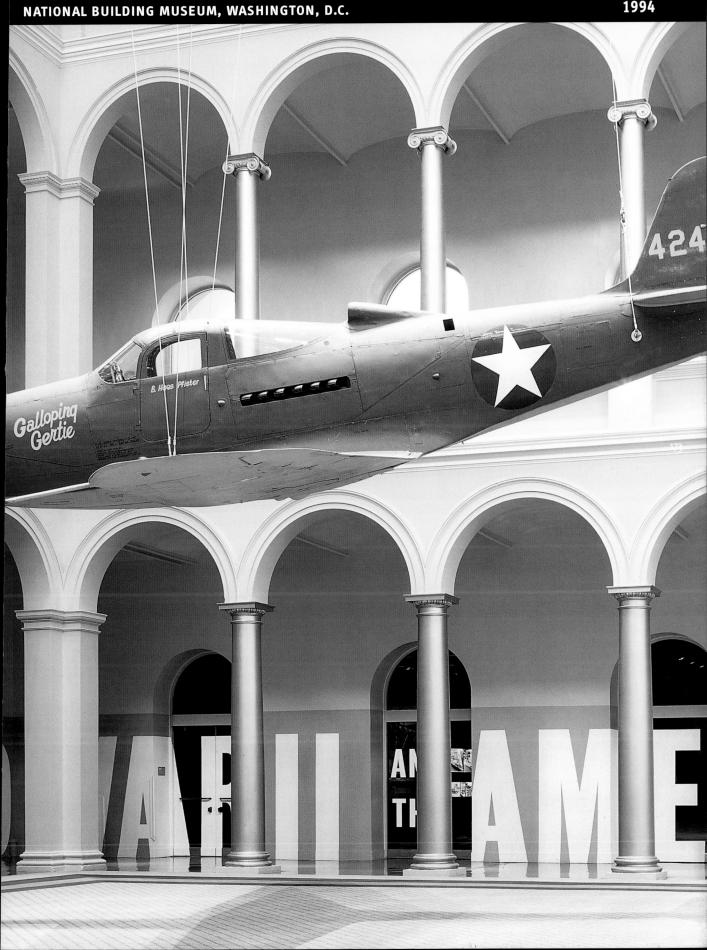

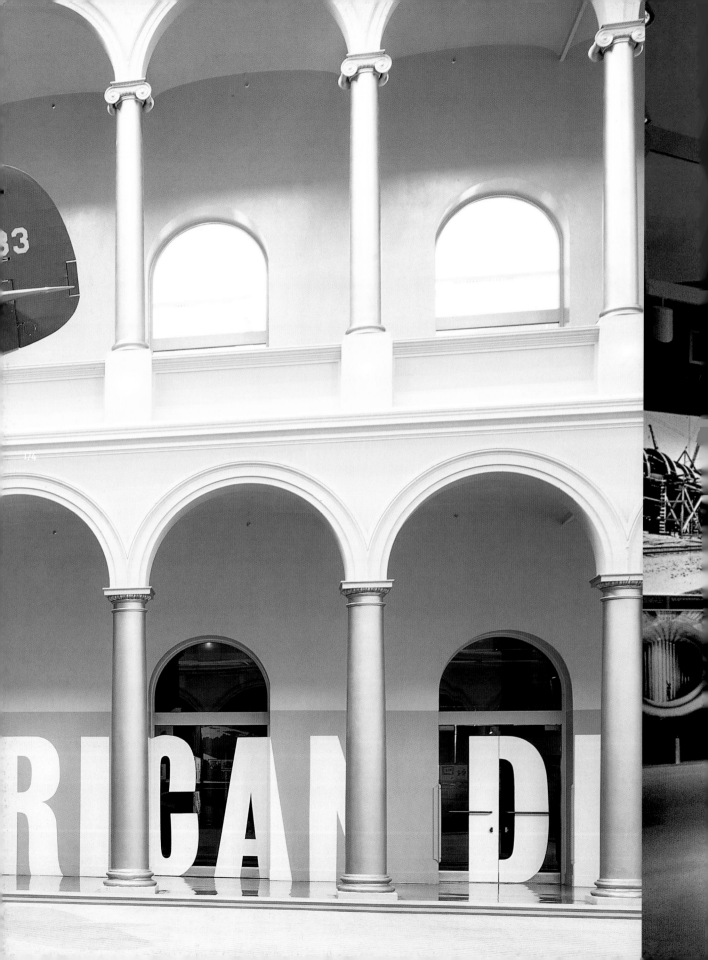

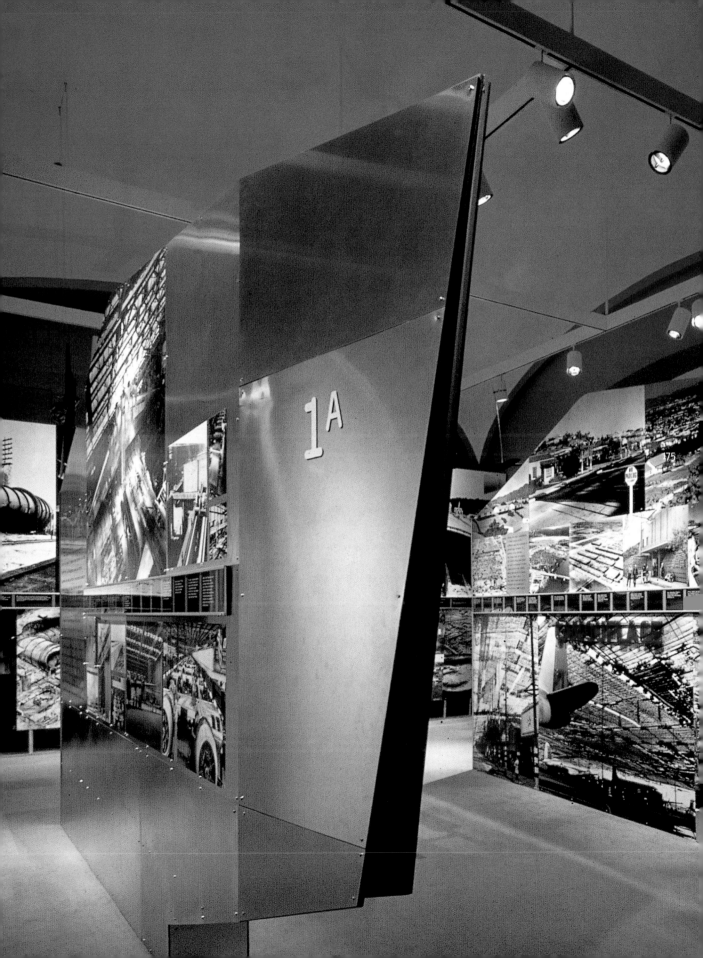

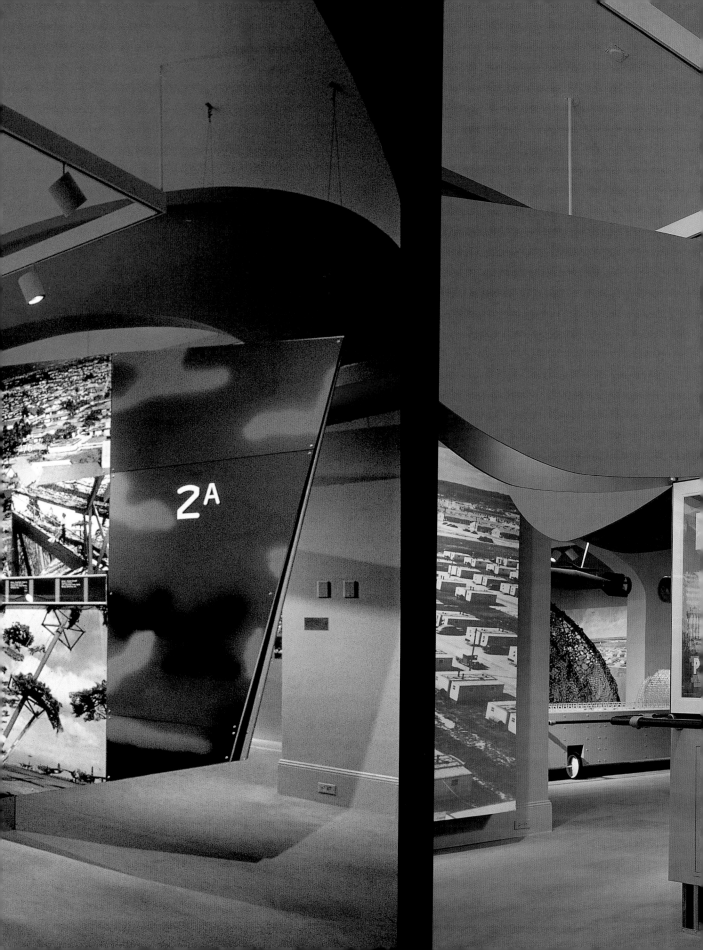

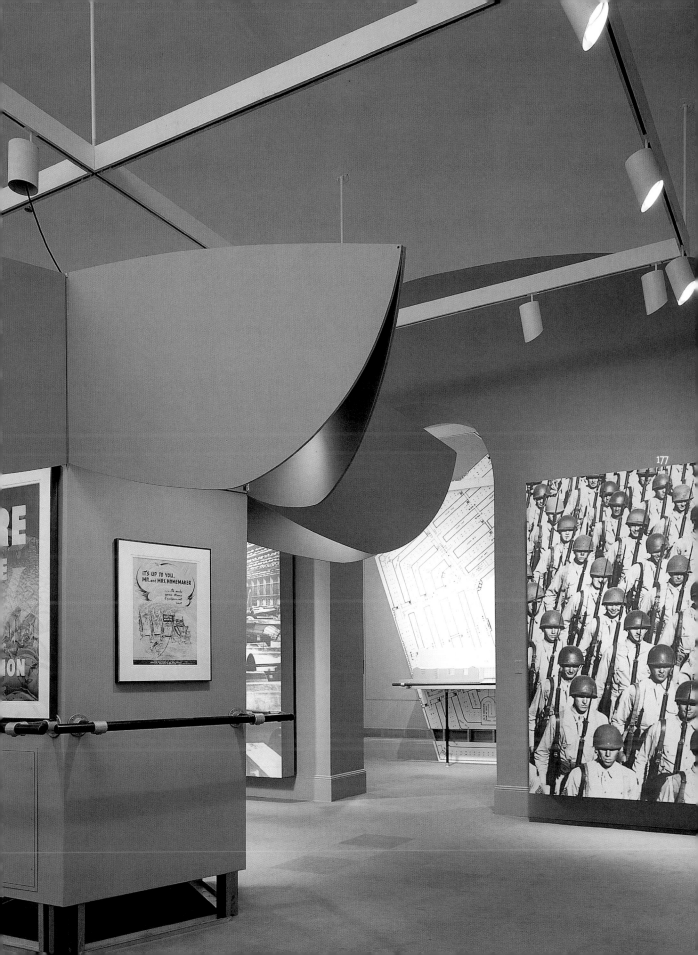

An exhibition of the winners of the first four cycles of the
Chrysler Design Award. The big freestanding discs seemed
appropriate to the sponsorship.

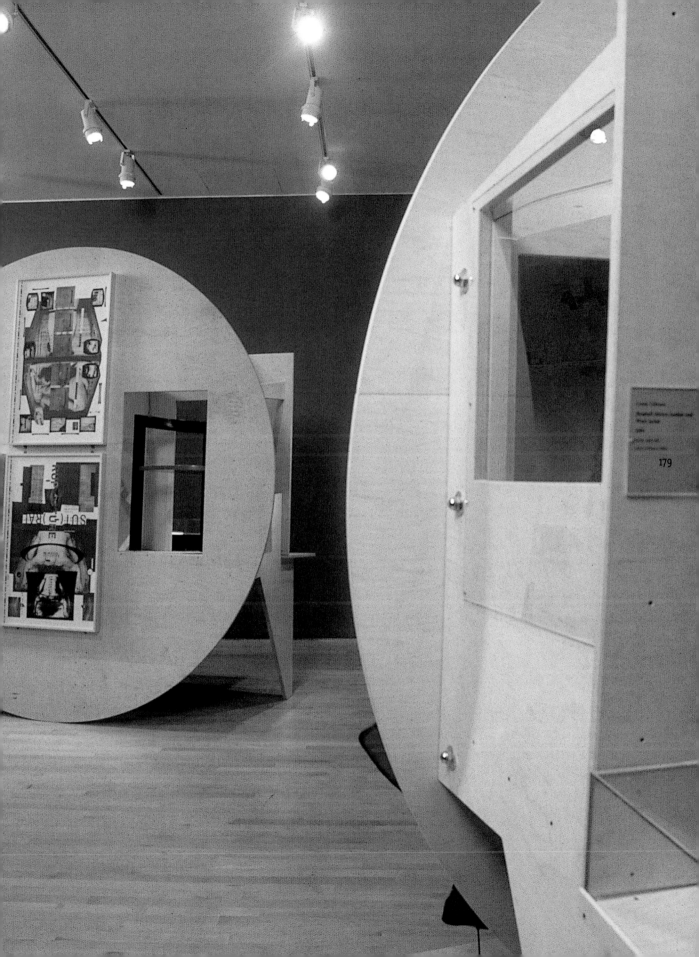

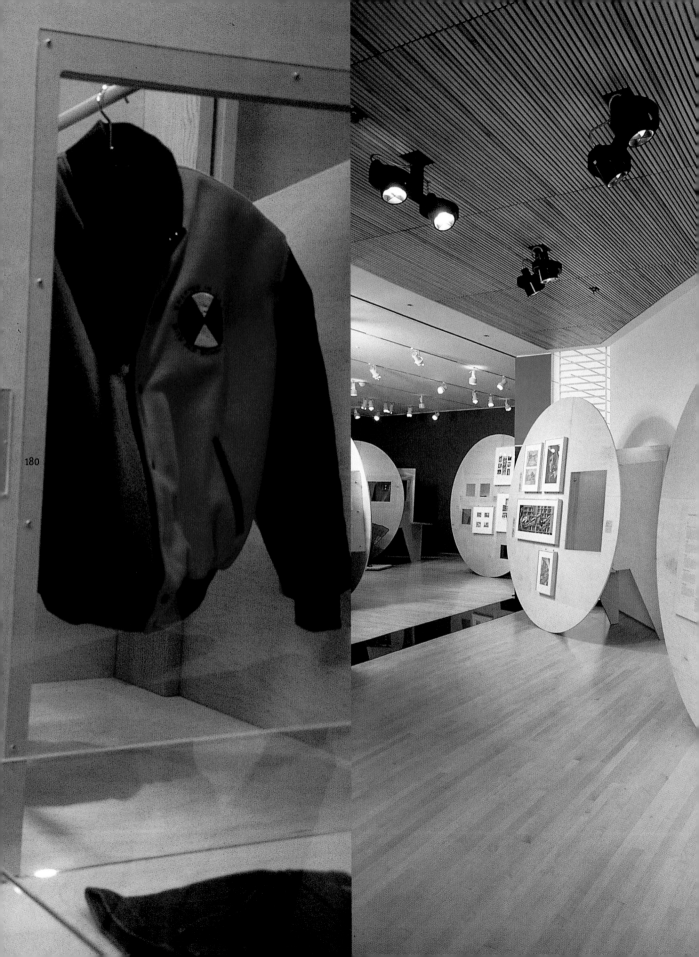

Two exhibitions of the Studio's work comprised of suspended plastic sheets on which color images have been printed. At Cornell, the sheets were suspended from hula hoops, which themselves hung from small motors that rotated the cylindrical hoops, casting patterns of color and light.

181

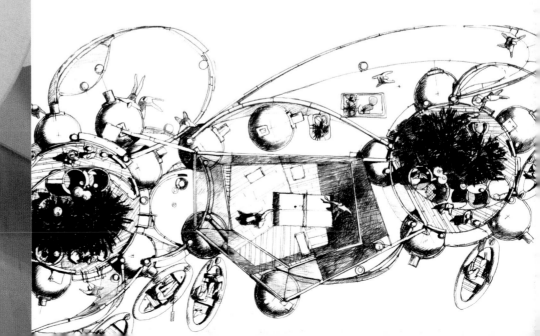

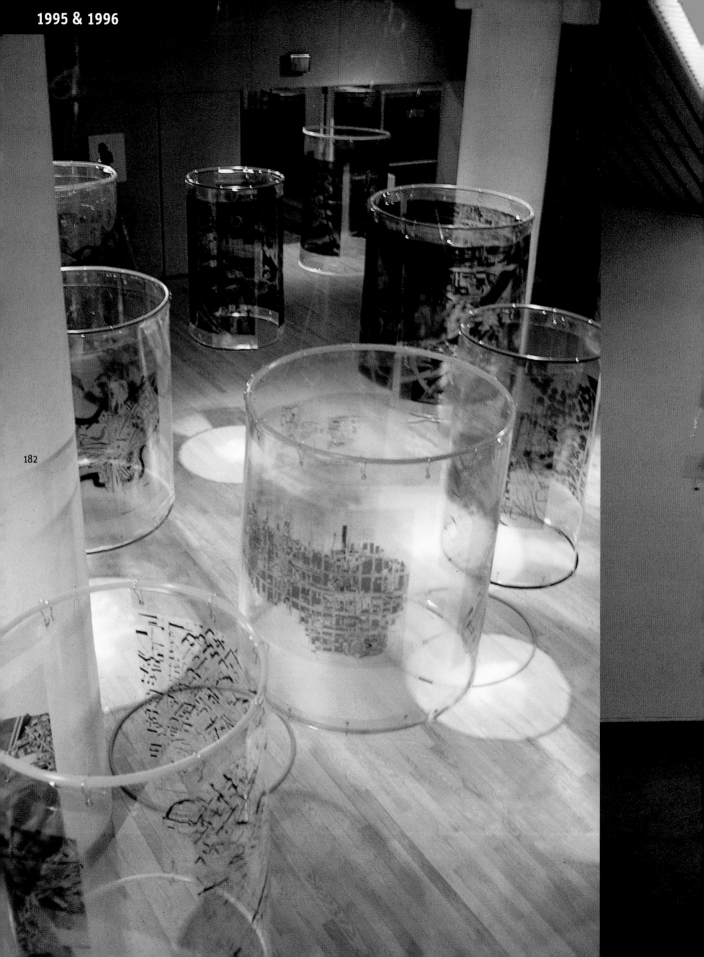

182

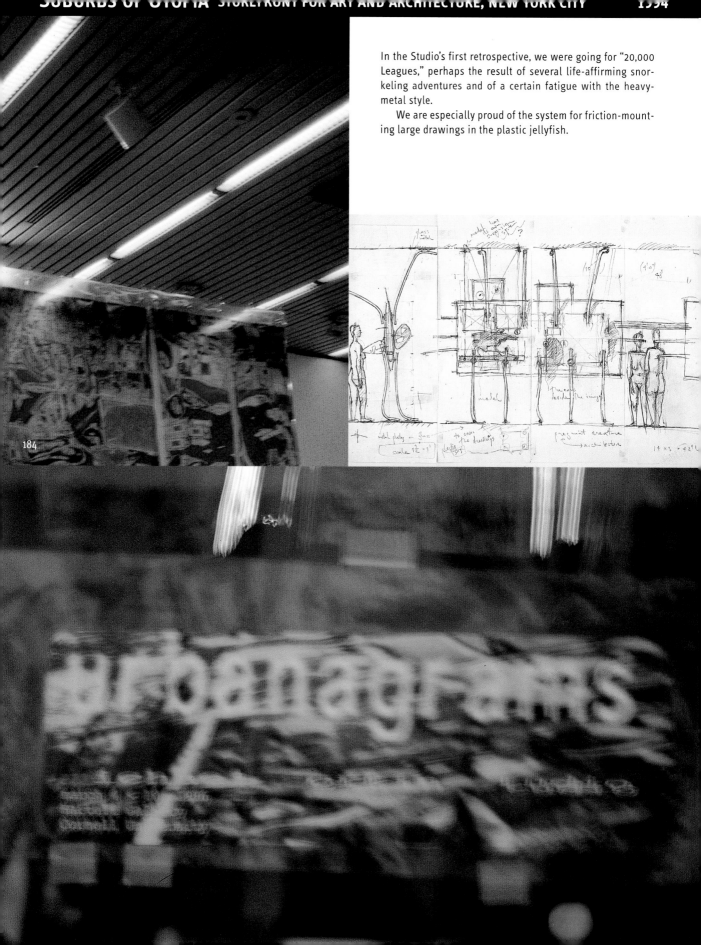

In the Studio's first retrospective, we were going for "20,000 Leagues," perhaps the result of several life-affirming snorkeling adventures and of a certain fatigue with the heavy-metal style.

We are especially proud of the system for friction-mounting large drawings in the plastic jellyfish.

184

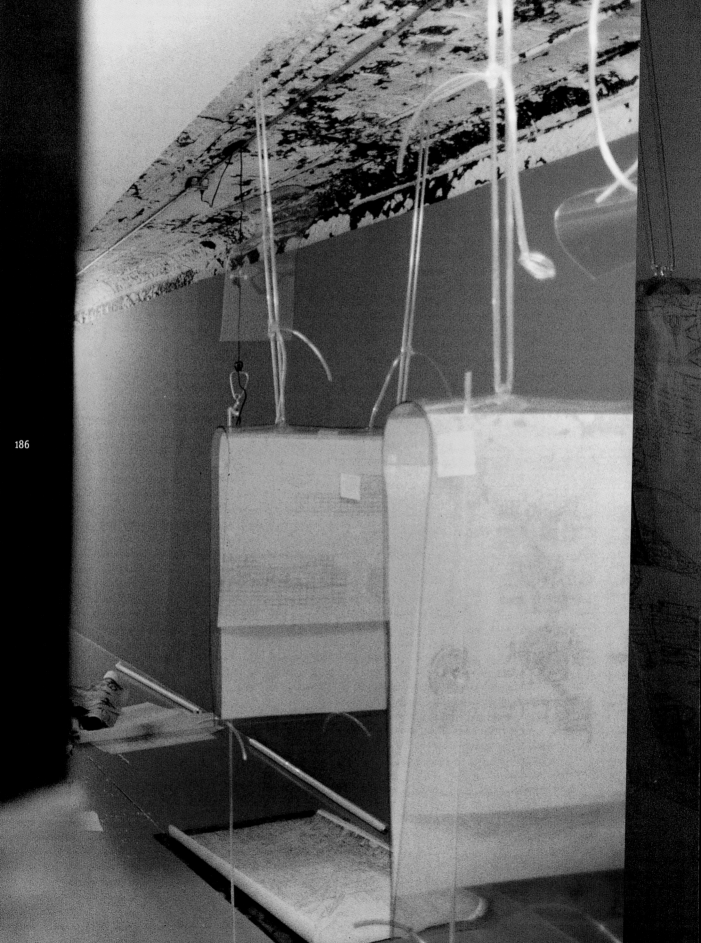

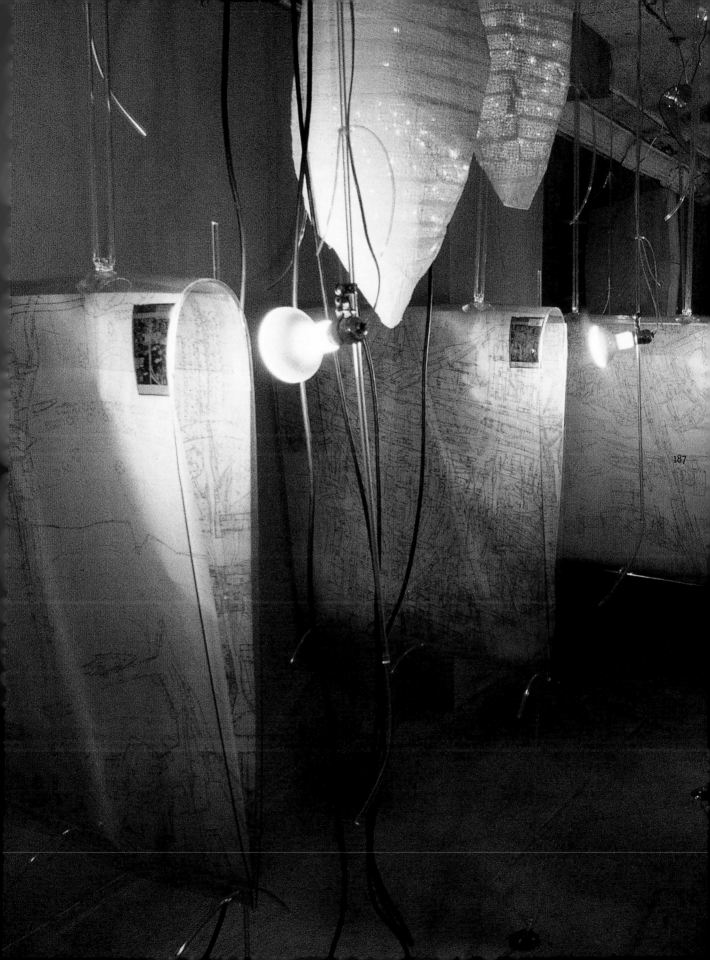

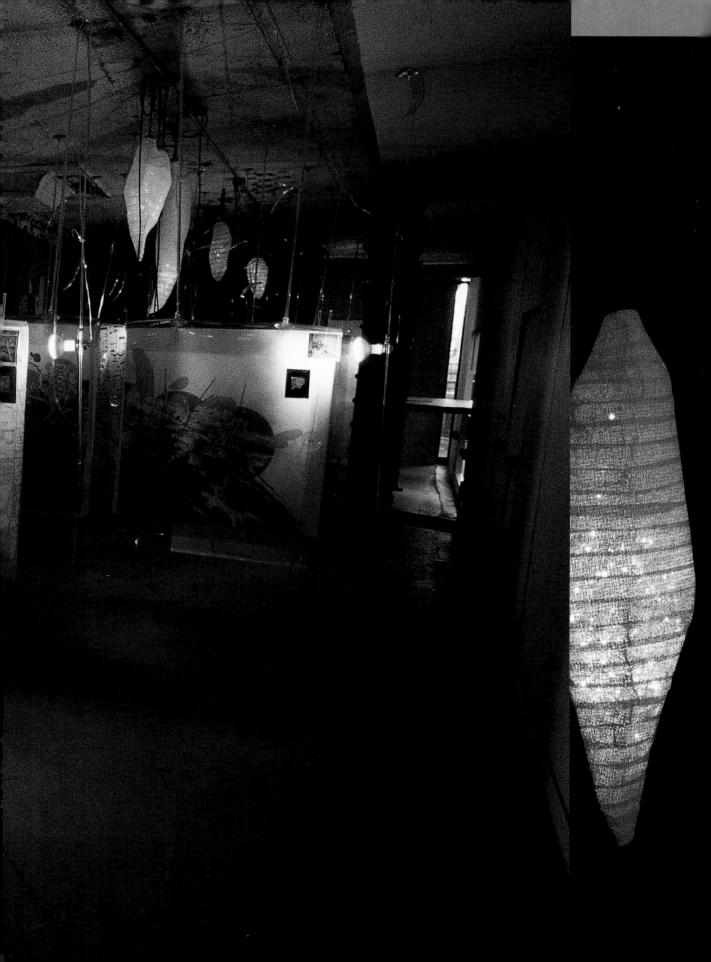

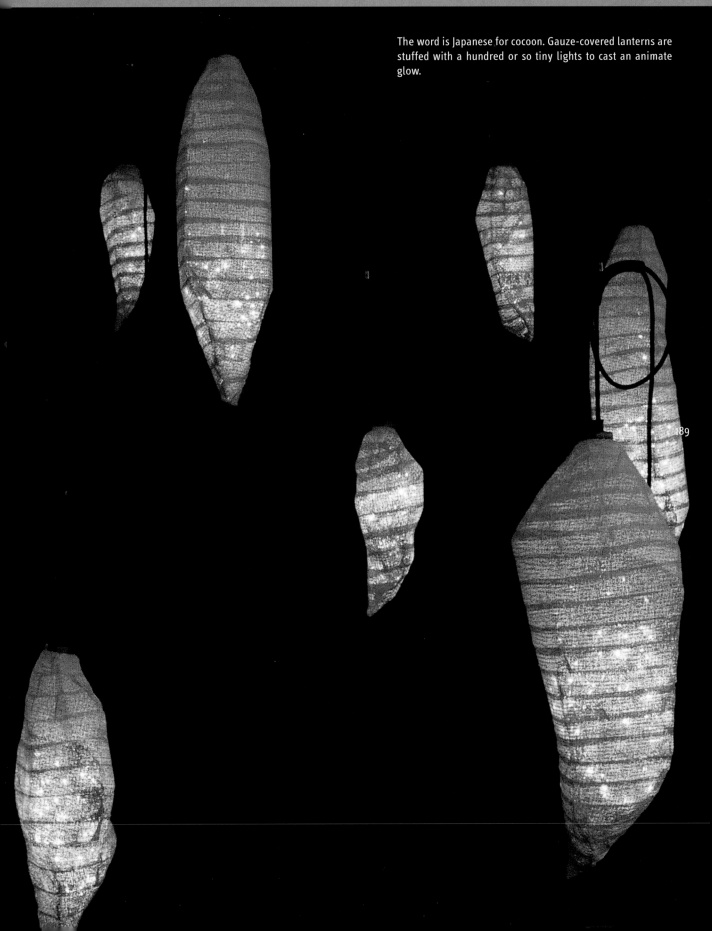

The word is Japanese for cocoon. Gauze-covered lanterns are stuffed with a hundred or so tiny lights to cast an animate glow.

189

A proposal for a piece of public art commissioned by the city of Hamburg. Located on the Binnen Alster, a lake-sized body of water in the middle of the city, these floating green islands—"life-boats"—were meant to move lazily in the wind and currents, sometimes lashed together to form larger surfaces for use. A number of these islands were to be "living machines," bio-remediation devices that would clean the water to a swimmable standard.

190

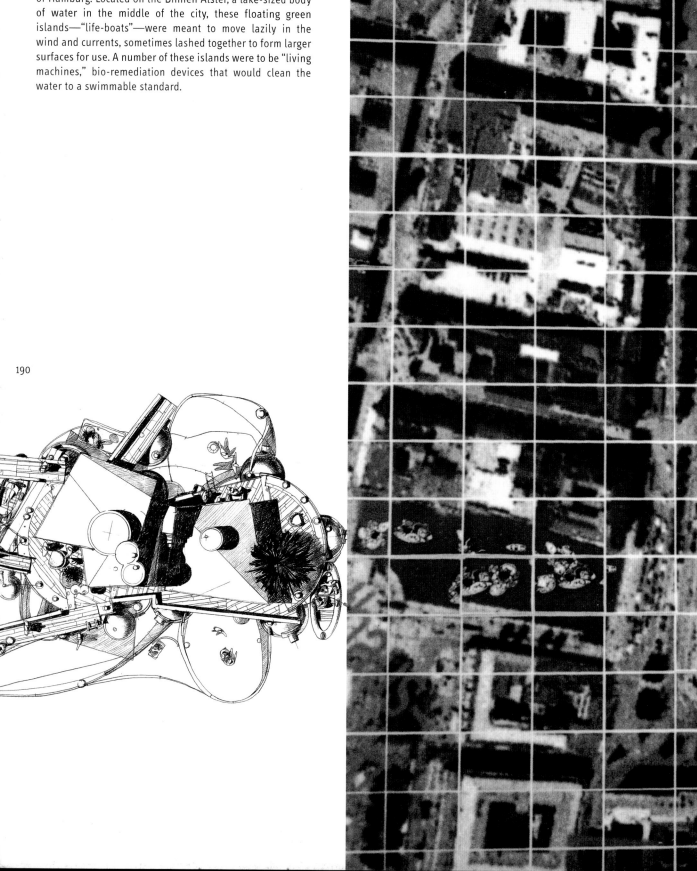

Michael Sorkin Studio

Michael Sorkin
Andrei Vovk
Yukiko Yokoó
Mitchell Joachim

Emeritus:
Doug Bergert
Kent Hikida
Peter Kormer

With A Lot Of Help From Our Friends:
Silva Adjamian
Stuart Bassaches
Patrick Clifford
Celine Condorelli
Ame Engelhart
Jordan Geiger
Jeffrey Johnson
Maitland Jones
Lawrence Ko
Carolien Lichtenberg
Aaron MacDonald
Robert Mantho
Benjamin Marcus
Michael Marshall
Victoria Marshall
Solam Mkhabela
Matthew Mueller
Tanya Naumova
Rebecca Parker
Roy Roth
Amanda Schachter
Stefan Seemuller
Brian Swier
Tomo Tanaka
Joel Towers
Ingemar Vollenweider
Michael Wetstone
Jim Wilson
Zingg

And many more . . .

Photography:
Dorothy Alexander: **Tracked Houses**
Ben Blackwell: **Subjects & Objects**
Todd Conversano: **Miira**
Philip Greenberg: **Moscow Metro**
Frank Hilsbomer: **Suburbs of Utopia; Weed, AZ**
Ilisa Katz: **Rancho Mirage**
Peter McClennan: **Model City**
Robert Morrow: **Tracked Houses**
Seth Rubin: **Beached Houses**
Maurice Sherman: **flatwork**
Paul Warchol: **WWII and the American Dream**

Project Collaboration:
TEN Arquitectos: **Parque Los Olivos**
Steve Lewis & John Young: **Mass Movement**
Barbara Glauber: **Moscow Metro**
Design Writing Research: **WWII and the American Dream**
George Sexton Associates: **WWII and the American Dream**

Book Design:
Michael Sorkin Studio

With Thanks To:
Paul Hamburger

Patience Beyond Reason:
Gianfranco Monacelli
Andrea Monfried
Steve Sears

Money When It Counted:
The Graham Foundation